THE MANUAL OF
SCULPTING
TECHNIQUES

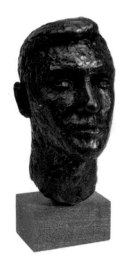

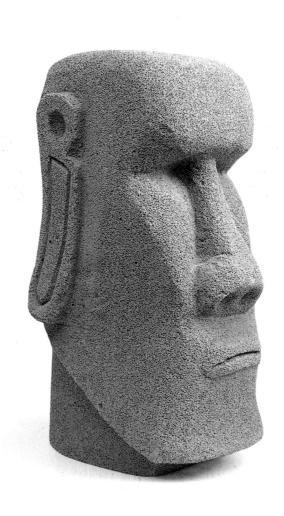

THE MANUAL OF
SCULPTING
TECHNIQUES

A&C Black • London

A QUARTO BOOK

Published in the United Kingdom in 2003
by A & C Black Publishers Limted
37 Soho Square
London W1D 3QZ

ISBN 0-7136-6580-7

QUAR.ESC

This book was designed and produced by
Quarto Publishing plc
The Old Brewery
6 Blundell Street
London N7 9BH

Senior Editor Sally MacEarchern
Editor Anna Selby
Senior Art Editor Mark Stevens
Designer Geoff Manders
Photographers Paul Forrester, Colin Bowling
Picture Manager Giulia Hetherington
Picture Researcher Jo Carlill
Art Director Moira Clinch
Editorial Director Sophie Collins

Typeset by Genesis Typesetting, Rochester, Kent
Manufactured in Singapore by Bright Arts Pte, Ltd.
Printed in Singapore by Star Standard Industries (Pte) Ltd

CONTENTS

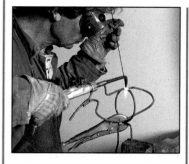

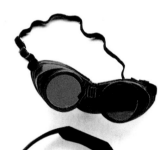

INTRODUCTION

TECHNIQUES

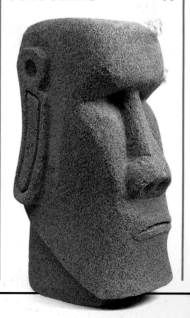

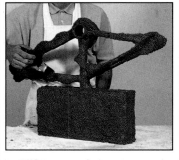
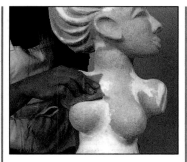
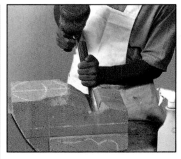
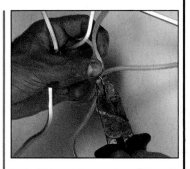

THEMES

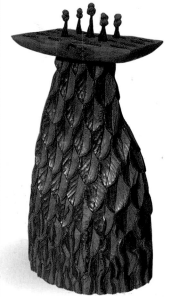

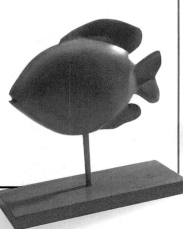

PUBLISHER'S NOTE

Some sculpting techniques can be dangerous, welding in particular. Always exercise caution when using power and hand tools or other equipment, read instruction manuals carefully and wear appropriate protective and safety gear. Some of the chemicals are poisonous and/or corrosive. This means that you must take precautions when handling them: always follow the manufacturer's instructions; always store chemicals securely in clearly marked non-food containers and keep them well out of the reach of children. Read the safety tips before undertaking any of the techniques. Some of the materials, equipment and finished pieces will be heavy, so make sure that you lift correctly, minimizing the strain on your body.

As far as the techniques mentioned in this book are concerned, all statements, information and advice given are believed to be true and accurate. However, neither the author, copyright holder, nor the publisher can accept any legal liability for errors or omissions.

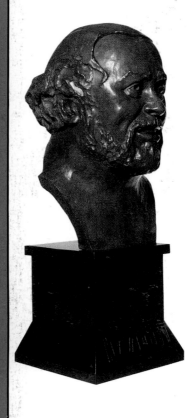

INTRODUCTION

Making sculpture – the art of manipulating material to create three-dimensional form – is an extremely pleasurable, intense and rewarding experience. It is an activity that is intrinsic to human nature, dating from prehistoric times when stone was first carved.

Carving and modelling are the traditional techniques used in sculpture. However, since the early years of this century, new techniques and materials have been introduced, greatly expanding the range of possibilities available to the sculptor.

The techniques described in this book are based on my experience of teaching them to students and provide a solid foundation on which to build your sculpture-making skills. If

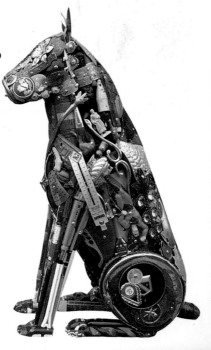

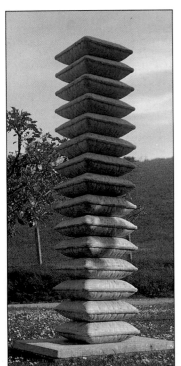

you have never made a sculpture before, there will be a technique you can use that will start you on the road to making sculpture, while more experienced sculptors will discover the possibilities of other materials and techniques. The process of making a sculpture is both labour-intensive and time-consuming. You will find yourself engaged in tasks that are not creative. You may even ask yourself why you started in the first place. However, you won't feel overwhelmed if you plan out all the steps involved before you start and carry them out methodically. Certainly, you will find it well worth it in the end – as my experience of teaching these techniques to students has shown over the years.

MATERIALS

The materials you will require fall into five general categories: sculpting; mouldmaking; joining and fixing; repair; colouring. A selection from each category is shown on pages 8–11.

Sculpting materials include: clay, papier mâché, wood, stone, aerated concrete block, casting plaster, mild steel, and sheet steel. Constructed sculptures can be made from soft wood in a variety of shapes and sizes with either a prepared (planed) or rough (sawn) surface, split canes and plywood. Assemblages use everyday material such as plastic coathangers, empty tin cans and plastic bottles.

In addition to glue, you may need some of the following fixing materials: wood dowelling for joining pieces of wood; screws; a rawlplug inserted into a drilled hole in masonry keeps the screw firmly in place; coach bolts are good for joining large pieces of wood; washers, nuts and threaded steel rod provide an adaptable method of joining diverse materials; netting staples fix aluminium wire to a modelling board or a vertical wooden head armature support.

There are two recommended types of clay: a clay with added particles of fired clay (grog) suitable for large sculptures; **1** smooth clay suitable for modelling onto an armature where the sculpture will be cast in another material, fine detail and small-scale sculpture. **2** Clay slip is a mix of clay and water. **3** Sandstone is easy to carve and shape. **4** Papier mâché is made from newspaper strips and wallpaper paste.

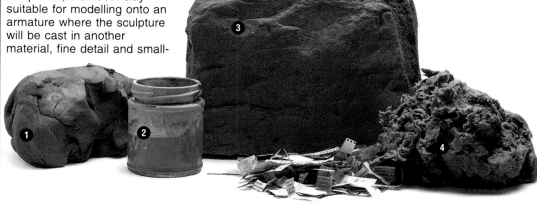

5 Jelutong is an excellent choice of wood for the first time carver as it is easy to carve and shape.

6 Laminating resin has to be mixed with **7** hardener to enable it to set hard (cure). To this mix fine particles of **8** metal filler can be added or a coloured pigment. This mix is used for the first coat of the cast and ensures that the surface is coloured. Subsequent coats of ordinary resin mix are used with **9** fibre glass matting to reinforce the casting material.

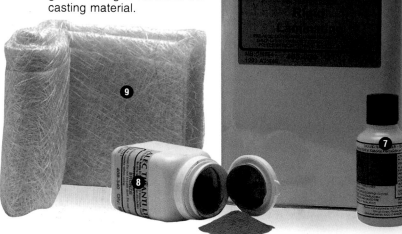

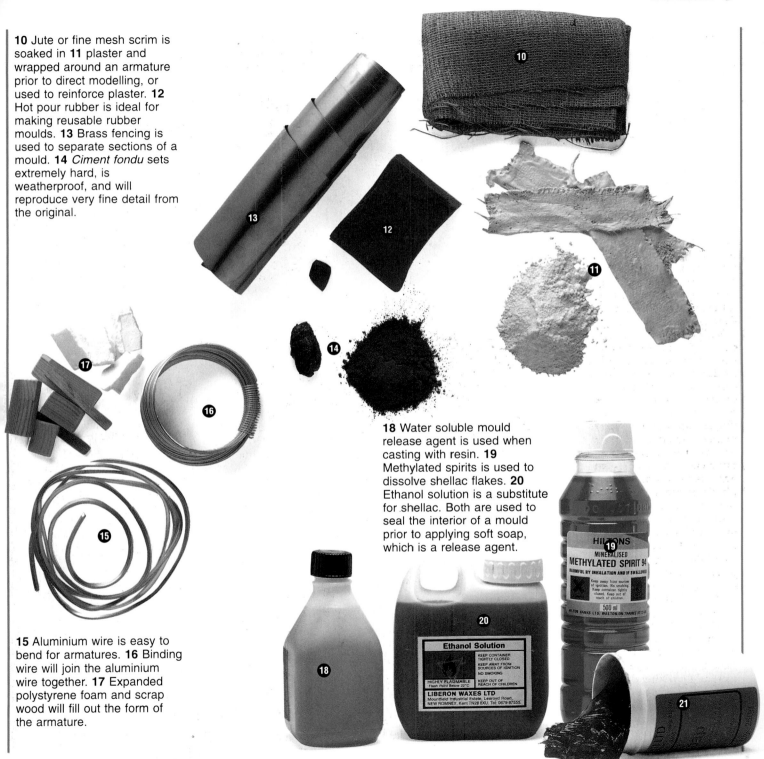

10 Jute or fine mesh scrim is soaked in **11** plaster and wrapped around an armature prior to direct modelling, or used to reinforce plaster. **12** Hot pour rubber is ideal for making reusable rubber moulds. **13** Brass fencing is used to separate sections of a mould. **14** *Ciment fondu* sets extremely hard, is weatherproof, and will reproduce very fine detail from the original.

18 Water soluble mould release agent is used when casting with resin. **19** Methylated spirits is used to dissolve shellac flakes. **20** Ethanol solution is a substitute for shellac. Both are used to seal the interior of a mould prior to applying soft soap, which is a release agent.

15 Aluminium wire is easy to bend for armatures. **16** Binding wire will join the aluminium wire together. **17** Expanded polystyrene foam and scrap wood will fill out the form of the armature.

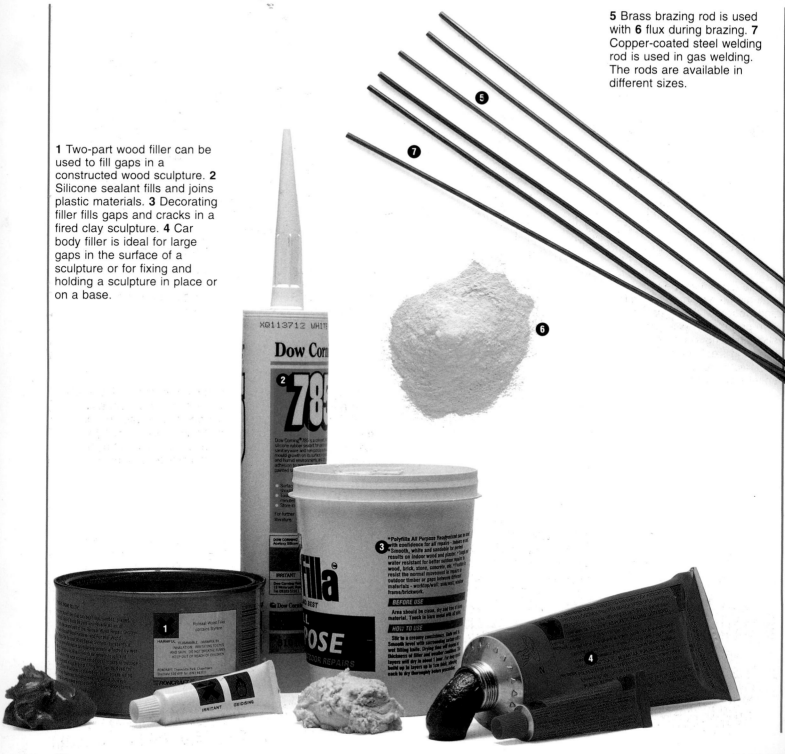

5 Brass brazing rod is used with **6** flux during brazing. **7** Copper-coated steel welding rod is used in gas welding. The rods are available in different sizes.

1 Two-part wood filler can be used to fill gaps in a constructed wood sculpture. **2** Silicone sealant fills and joins plastic materials. **3** Decorating filler fills gaps and cracks in a fired clay sculpture. **4** Car body filler is ideal for large gaps in the surface of a sculpture or for fixing and holding a sculpture in place or on a base.

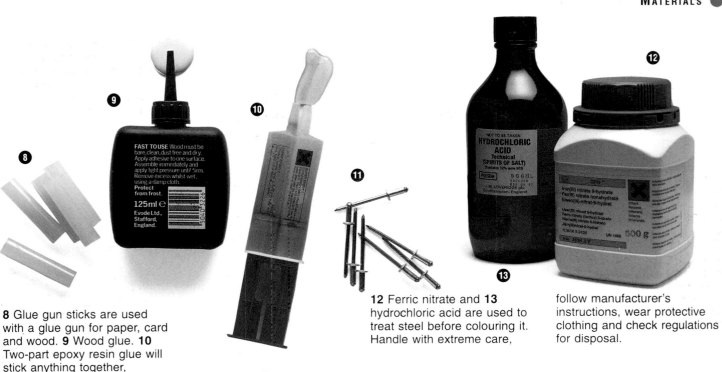

8 Glue gun sticks are used with a glue gun for paper, card and wood. **9** Wood glue. **10** Two-part epoxy resin glue will stick anything together, including steel and stone. **11** Pop rivets are used to fix sheet steel or tin.

12 Ferric nitrate and **13** hydrochloric acid are used to treat steel before colouring it. Handle with extreme care, follow manufacturer's instructions, wear protective clothing and check regulations for disposal.

14 Powder pigments can be obtained in a wide range of colours. **15** Woodstain is absorbed by the wood and so enhances the grain. **16** Beeswax will enhance the grain of a carving. **17** Varnish will seal and highlight any surface and is available in matte or gloss finish. **18** Oil paint can be used straight from the tube or thinned.

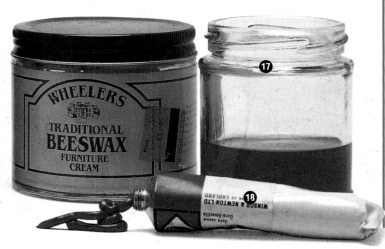

Materials and their uses

The beauty of making sculpture today is that you can choose from such a wide variety of materials, not all of them with a specifically sculptural use. Of course, some materials are used purely for a single sculptural technique and have no other function. Other materials cross the boundaries of several techniques. There are other indispensable items that could be regarded as the basic stock of a sculptor's studio. Similar to the contents of a kitchen cupboard, they may not be the main ingredient of a dish but, without them, the recipe would fail. These items include shellac, PVA glue, scrim, masking tape, soft soap, clay slip, white spirit, binding wire, screws and nails.

MATERIAL	TECHNIQUE	AVAILABILITY
Clay	Modelling	An economical fine clay and one with added grog are the two essential types
Plaster	Mouldmaking, Direct modelling, Carving, Casting	Casting plasters are graded according to their strength when set and range from very hard, very white plaster through to a less hard, off-white and more economical plaster.
Wood	Carving, Construction	The two categories of hard and soft wood refer to the strength of the wood and the ease with which it can be cut and shaped. Sheet material is obtained from a timber merchant, as are lengths of wood which are either prepared with a planed smooth surface, or sawn, with a rough surface.
Stone	Carving	Types of stone vary in terms of their colour, their surface texture and the ease with which they can be carved. Like wood, stone is available in different grades of hard and soft and also in a variety of colours and surface textures.
Papier mâché	Direct modelling	This is prepared using small pieces of newspaper or shredded paper and wallpaper adhesive or diluted PVA glue.
Polyester resin	Casting, Direct modelling	This is a synthetic liquid chemical product which sets hard with the addition of a catalyst.
Ciment fondu	Casting, Direct Modelling	A powdered cement that needs to be mixed with sand or an aggregate and water to set hard.
Found objects	Assemblage	As the name suggests these are always available so keep your eyes open, and always be ready to pick up objects with potential.
Mild Steel	Welding, Brazing, Riveting	Mild steel is available from a stockholder in a variety of forms – rod, bar, pipe and sheet – all in different sizes to suit the job in hand. Hunting around scrapyards is also a fruitful way to locate interesting shaped pieces.
Aerated concrete block	Carving	Though this is a building material, it is extremely soft to cut and shape and ideal for making sculpture, leaving a very interesting surface finish.
Rubber	Mouldmaking, Casting	Rubber is available both as a hot pour compound, which needs to be melted down, or in the now more popular form of room temperature vulcanizing rubber (RTV) which is used cold.

CONSIDERATIONS	TIPS
A clay with grog added is suitable for large kiln-fired sculptures. Fine clay is used for sculptures to be cast in another material and when fine detail is needed in the modelling.	Break dry clay into small pieces, put into a watertight container and completely immerse in water. After a while the dry clay will absorb the water to produce a sludge. Lay this on a flat surface to dry out a bit (but not too much), and you will be able to use it again.
The lowest grade is suitable for making moulds. The higher grades will produce quality plaster casts and sculptures where structural strength is important.	Always store plaster in a dry place so it does not absorb moisture from the atmosphere. This will retard the rate at which it sets and affect its final strength.
Prepared and sawn timber is suitable for constructed sculptures, the latter for those jobs where the visual quality of the wood is not as important as the structural quality. The relative hardness or softness of a piece of wood is particularly important when carving.	Check your source to make sure that you are not using endangered or protected hardwood. Discarded wooden furniture is a good source of hardwood, especially if you need to prepare a base for a sculpture.
Granite is a very hard material to carve and should be left to experienced carvers. Sandstone is softer and suitable for those with less experience.	Demolition sites can be a good source of stone.
As papier mâché takes a long time to dry, it is better to build it up in layers, especially for vertical and overhanging surfaces.	When it is dry, it is extremely hard and resistant and can be sanded and smoothed down.
Careful and exact measurement is essential.	Save old jars and tin cans to mix the resin in.
Ciment fondu is extremely strong and hard-wearing. You can use it for hollow cast sculpture suitable for siting out of doors.	A block of *ciment fondu* makes a good base for a sculpture.
Deciding how to fix disparate objects together can be a problem. You may need to make several trials before you hit on the best solution.	Aluminium drink cans which have been cut and flattened out make ideal sheet material to join with pop rivets.
Always use all safety precautions when working with steel.	The mild steel casing of domestic appliances, such as washing machines, are a very good source of sheet material.
Aerated concrete is a brittle material and care must be taken while carving to avoid breaking the block.	Ask on building sites for damaged blocks that will not be used.
Follow the manufacturers' recommendations carefully and make sure you use the right sort of rubber for the job.	Most rubber moulds will keep for a long time so store them safely and securely until they are needed again.

EQUIPMENT

In addition to the more specialist items shown on pages 14–21, you will find it useful to have the following general equipment: felt-tip pens, pencils and chalk for drawing and marking; steel tape measure, straight edge ruler, set square and square for measuring; masking tape; scissors; scales for weighing resin accurately; a food mixer for pulping up papier mâché mix; a gas torch for welding and bending plastic; a selection of paintbrushes; appropriate vices; a modelling board.

Jars and tin cans are always needed for mixing and storing. A toothbrush, sponge and scrubbing brush are good for cleaning out moulds and casts. Plaster should be mixed in a plastic bowl or a bucket: Cling film or polythene will prevent clay from drying out. A water spray will keep dust down and moisten clay. A sand-filled inner tube will support and protect awkward shapes. Rubber strips of inner tube will hold pieces of a mould in place. A sheet of glass or formica is good for mixing epoxy resin glue or car body filler.

1 Clear goggles protect you from airborne pieces of material when carving, sanding or grinding. **2** Welding goggles have darkened glass to enable you to look directly at the flame when brazing or welding. **3** An arc welding mask should be worn when electric arc welding. This protects both eyes and face from the intense light of the electric arc.

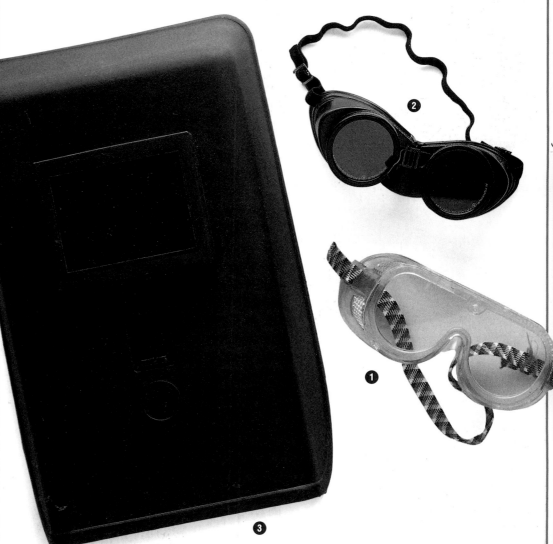

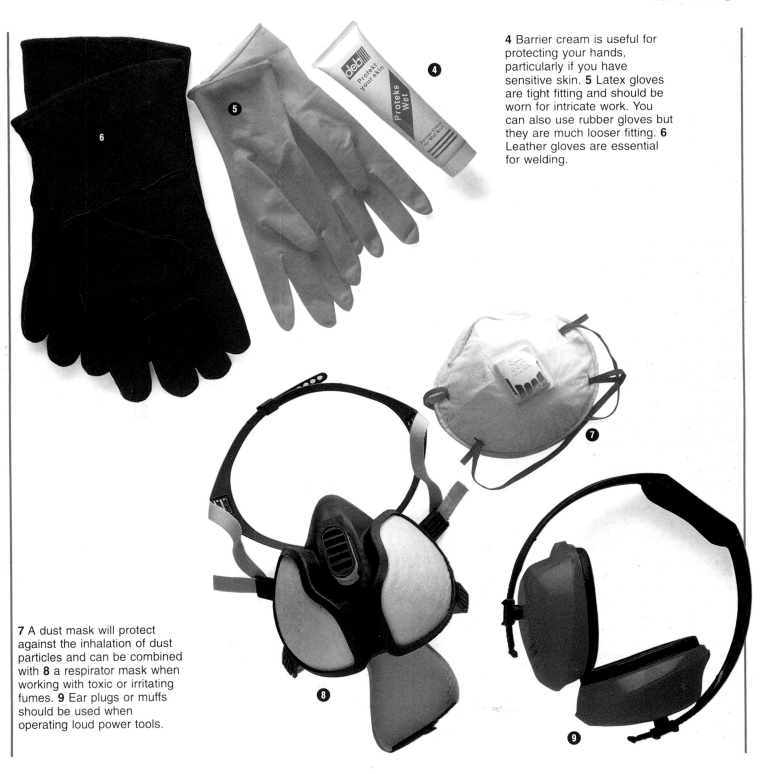

4 Barrier cream is useful for protecting your hands, particularly if you have sensitive skin. **5** Latex gloves are tight fitting and should be worn for intricate work. You can also use rubber gloves but they are much looser fitting. **6** Leather gloves are essential for welding.

7 A dust mask will protect against the inhalation of dust particles and can be combined with **8** a respirator mask when working with toxic or irritating fumes. **9** Ear plugs or muffs should be used when operating loud power tools.

15

1 Oxy-acetylene equipment consists of an oxygen cylinder marked blue and an acetylene cylinder marked red. **2** On top of each cylinder are two gauges, the left one indicates the gas pressure in the cylinder while the gauge on the right indicates the pressure of gas flowing out of the cylinder. This pressure is controlled by the regulator valve located in between each of the gauges. **3** Spark lighter ignites the acetylene gas.

4 Combination spanner used to fit the gauges to the cylinders, to open and shut the cylinder valves and to fit hoses to the torch or valves. **5** On the torch are a red and a blue valve, corresponding to the hoses which run from each cylinder to the torch. **6** Steel cutting attachment for torch. **7** Welding or brazing attachment for torch. **8** A range of nozzles with different sized openings. **9** Files for cleaning nozzle openings.

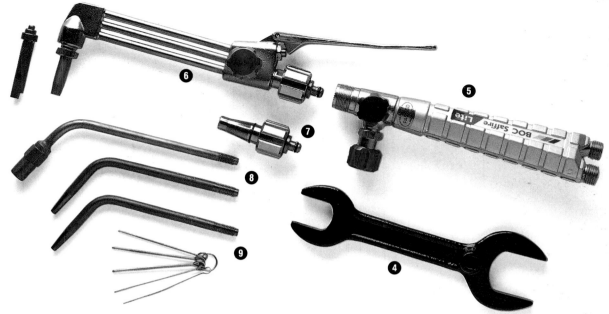

The electric arc-welding unit **10** is plugged directly into the mains. The handle adjusts the strength of the electric current. Below this are two terminals. The lead of the electrode holder **11** is attached to one terminal and the earth clamp **12** to the other.

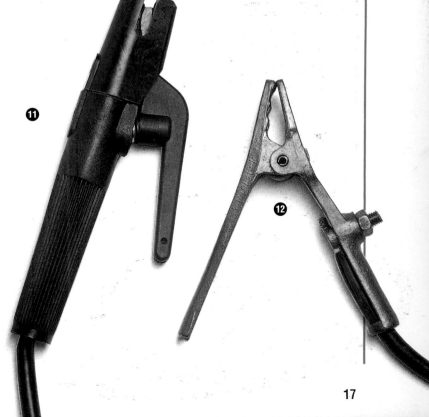

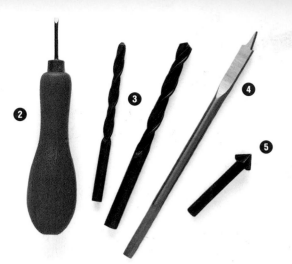

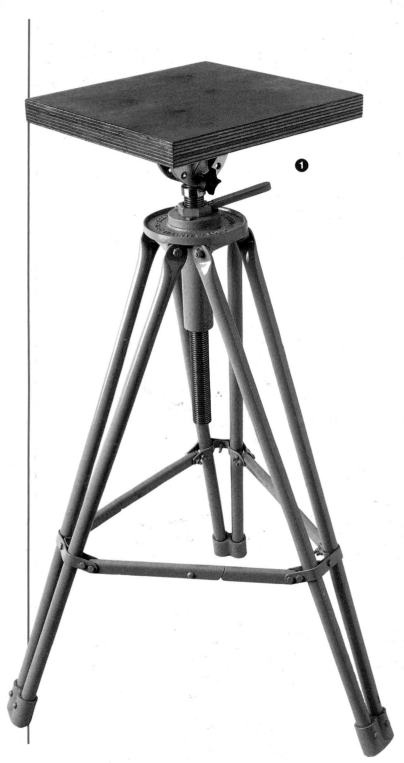

2 A bradawl is a hand-held tool for marking the position of holes to be drilled. It is especially effective on softwood and card. **3** Drill bits for wood and thin gauge steel.

4 Zip bit for large diameter holes in wood. **5** Counter sink bit to countersink a hole that has already been drilled in wood.

1 A modelling stand is very useful for modelling a portrait or life figure as you can adjust the height.

6 Electric melting pot used for melting rubber to make a mould. A thermostat controls the temperature.

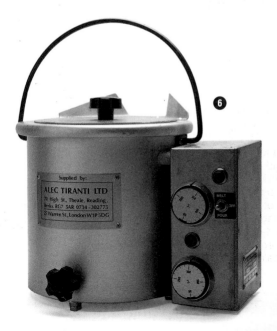

Supplied by:
ALEC TIRANTI LTD
70 High St., Theale, Reading,
Berks. RG7 5AR 0734 -302773
27 Warren St., London W1P 5DG

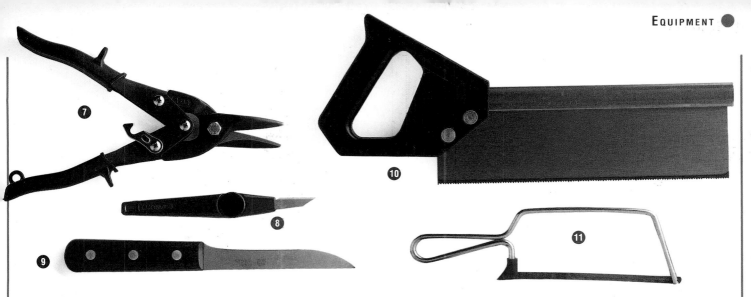

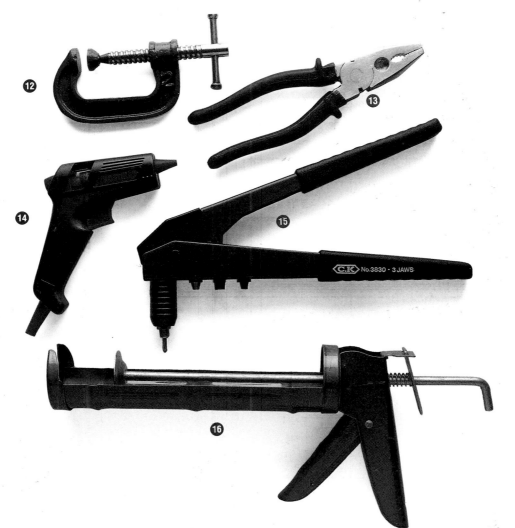

7 Tin snips cut steel wire, aluminium armature wire, sheets of tin and aluminium. **8** A craft knife serves as a general cutting implement. **9** An old kitchen knife has many uses, especially when working with plaster. **10** A tenon saw is useful for diagonal cuts or small dimension work. **11** A junior hacksaw is suitable for found objects. You will also need a hacksaw for steel rod and pipe.

12 A G-clamp holds work securely to the work surface. **13** Pliers are useful for bending wire, pulling out nails and holding material while you work. **14** An electric glue gun is used with glue sticks. **15** A rivet gun is used with pop rivets when joining sheet metal. **16** A sealant gun is used with a tube of silicon sealer.

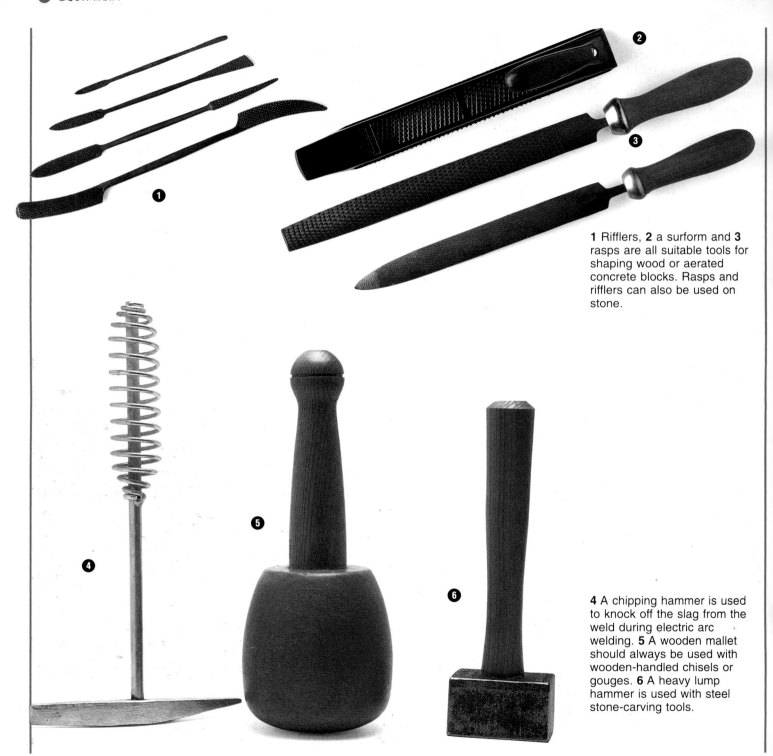

1 Rifflers, **2** a surform and **3** rasps are all suitable tools for shaping wood or aerated concrete blocks. Rasps and rifflers can also be used on stone.

4 A chipping hammer is used to knock off the slag from the weld during electric arc welding. **5** A wooden mallet should always be used with wooden-handled chisels or gouges. **6** A heavy lump hammer is used with steel stone-carving tools.

7 Wooden-handled carving gouges with curved and shaped cutting edges are used for carving wood. **8** Stone-carving chisels come with a variety of cutting edges. Use a nylon mallet for tools with a rounded handle and a lump hammer for the others.

9 Plaster and **10** clay wooden and wire-ended modelling tools come in a myriad of shapes and sizes and are absolutely essential when modelling, as they allow you to shape and define the sculpture in finer detail.

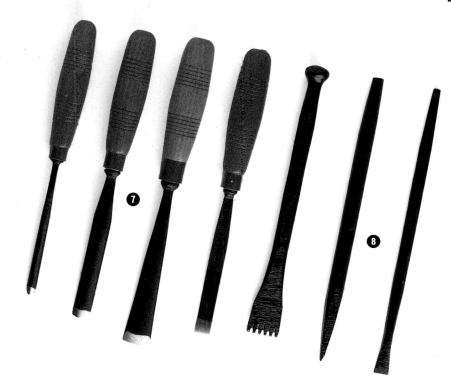

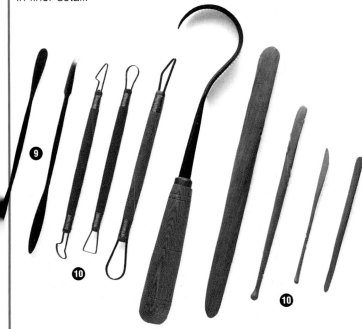

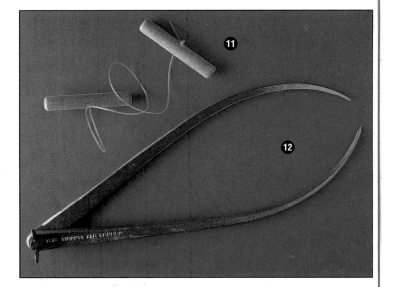

11 A clay-cutting wire is the most efficient way of cutting clay. The method is similar to cutting cheese. **12** Calipers are used to transfer measurements from a life model to your sculpture.

GETTING STARTED

When you have the material and equipment necessary to make a sculpture, you may find yourself wondering how to begin – this is a common problem and sculpture can seem a mammoth undertaking. But there are ways to get started. Some decisions need to be pre-planned while in some instances the technique itself determines the final form.

Drawings

Drawing has a role to play, but it is important to understand its limitations when making sculpture. Whether you are making a figurative or an abstract sculpture, drawing should be used only as a way to understand and develop the form you wish to sculpt. Being two dimensional, it can never produce an equivalent of the sculpture that you wish to make, and it is far better that the important decisions regarding a sculpture's form are made in three dimensions.

For instance, when modelling a figure from life in clay, it is of enormous benefit to make drawings of the figure in order to gain a better knowledge of its forms and the way that they articulate

Armature design for the cast life figure (see pages 26–8 and 61–3).

one against another. This knowledge will help you when you start modelling the clay. However, it will be the successful making of the armature that enables you actually to start modelling in clay.

Drawing can play a part in the making of an abstract or stylized sculpture. A drawing from direct observation – a figure, a building, a landscape – can be used as the model for another drawing or drawings which would be abstractions of some or all of the forms in the original. Similarly, a photograph can form the original model to produce a similar set of drawings.

Drawing can be used in constructed or assemblage sculpture to plan out the possible positions of the various parts and how they relate to one another.

Carving is, perhaps, the most problematic technique in terms of getting started. Because of the amount of time and energy expended in disposing of waste material, it is advisable to make a simple profile drawing on paper of the sculpture, which can then be transferred on to the face of the block by means of a grid.

This is not the only way to start a carving, however.

Material can be carved directly without any decisions regarding the form of the sculpture being made before-hand. This type of carving is very dependent on the material itself being of such a configuration that it suggests a possible form or set of forms to be carved. This is far more likely to happen with odd shaped branches, tree trunks or broken pieces of stone than with geometrically cut lumps of material. If you do decide to embark on a carving in this way, take care to avoid whittling the material away to nothing.

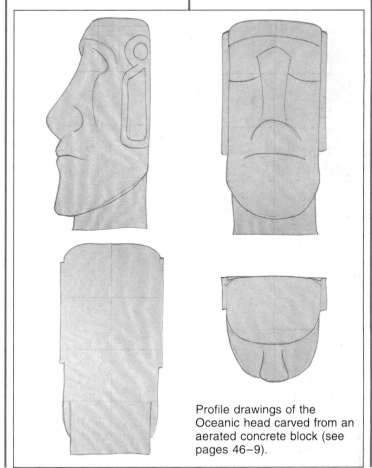

Profile drawings of the Oceanic head carved from an aerated concrete block (see pages 46–9).

Detailed drawing indicating the proposed shape and final colouring of the kiln-fired torso (see pages 86–9).

Maquettes

Making a maquette of a sculpture is a very useful exercise, and helps you to judge whether the form you have in mind for your sculpture will actually work three dimensionally. A maquette is a small version of a sculpture – though it is a rough and ready one, so don't spend too much time making it. Clay is a very useful material to use for maquettes, especially if your final sculpture is also to be modelled in clay.

A clay maquette is also another way to start a carving. You model a rough approximation of the sculpture to be carved and transfer the basic information regarding the location of forms on to the block of material to be carved.

Card and wire are useful materials to use when making a maquette, too, especially for constructed sculpture. You can use wire to try out different configurations when making an armature, especially when it is a permanent one and will need to stay inside the sculpture. Card cut to shape is useful as a template when you need to cut more than one shape of the same size from sheet material.

There are aspects of the construction and assemblage techniques which are totally reliant on the combination of the nature of the material and your own perceptions.

As you can see, there is no prescriptive method for starting a piece of sculpture. It is dependent on many things – the material, the technique being used, whether it is abstract or figurative. There are many variables involved but I firmly believe that the best way to start a sculpture is by manipulating or "pushing" material around. This activity in itself acts as a catalyst and will help you generate ideas.

Clay maquette for the abstract plaster carving (see pages 50–2).

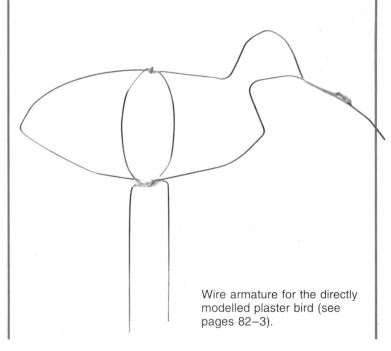

Wire armature for the directly modelled plaster bird (see pages 82–3).

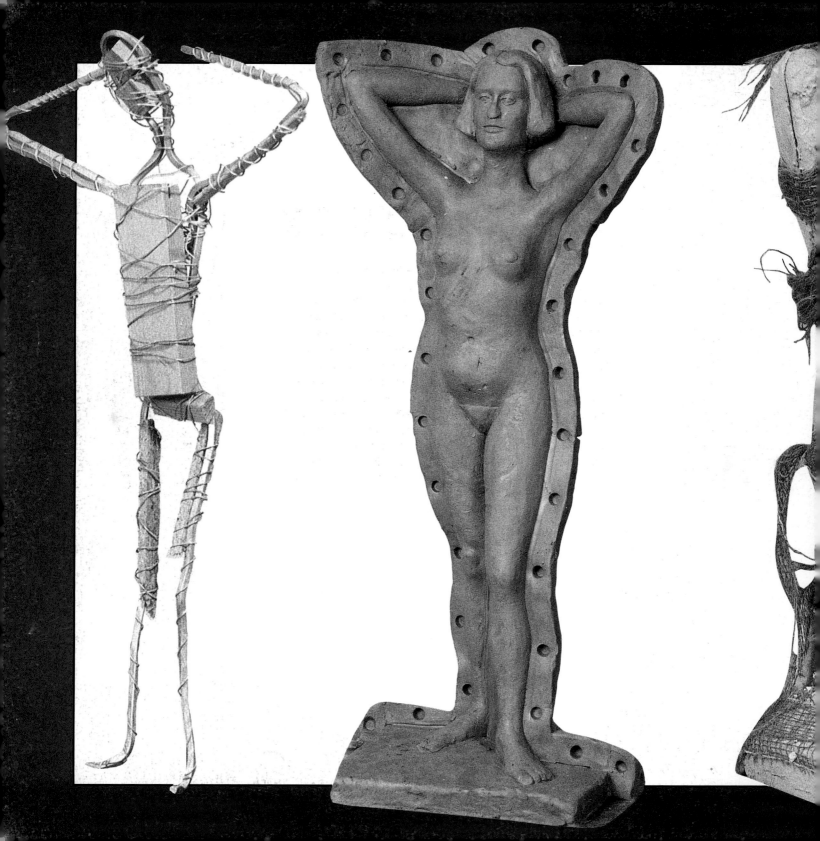

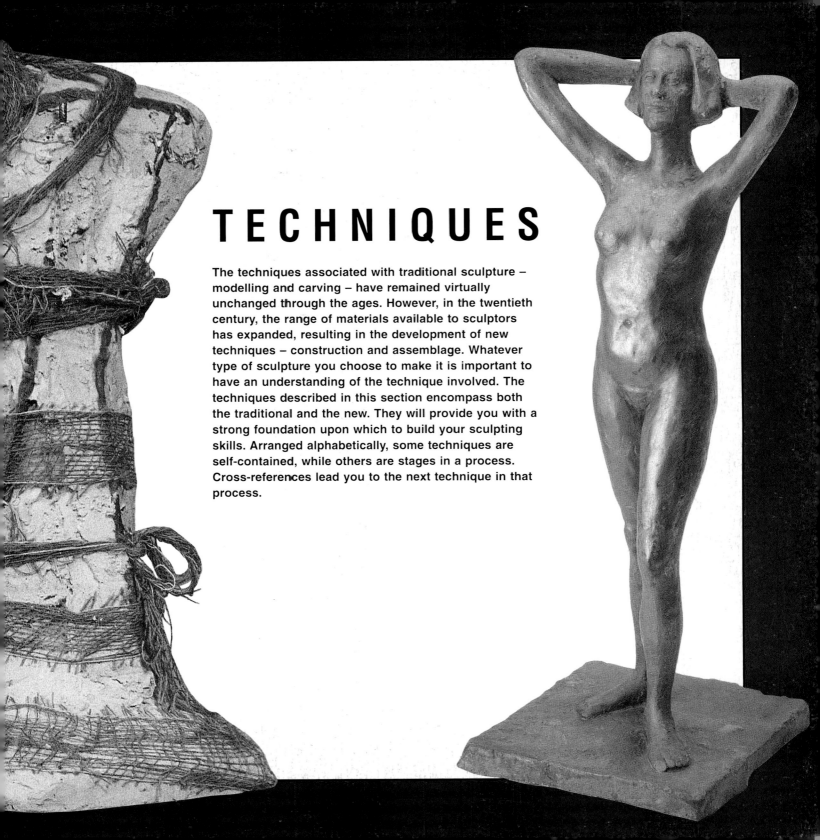

TECHNIQUES

The techniques associated with traditional sculpture –
modelling and carving – have remained virtually
unchanged through the ages. However, in the twentieth
century, the range of materials available to sculptors
has expanded, resulting in the development of new
techniques – construction and assemblage. Whatever
type of sculpture you choose to make it is important to
have an understanding of the technique involved. The
techniques described in this section encompass both
the traditional and the new. They will provide you with a
strong foundation upon which to build your sculpting
skills. Arranged alphabetically, some techniques are
self-contained, while others are stages in a process.
Cross-references lead you to the next technique in that
process.

ARMATURE

In sculpture, the armature performs the same function as the skeleton of the body – it is the structure that supports an outer covering of material. It is used only with the modelling method of making sculpture, using materials such as clay, plaster and papier mâché. Because of the malleable nature of these media, they lack any inherent structural strength and so you are greatly limited in the size and form of sculpture you are able to make unless you use an armature.

Still thinking of the skeleton, it is important to realize the close relationship that exists between the armature and the final form of the sculpture. It is essential to plan the armature carefully. This will make it easier when you start to add material to it and develop the form of the sculpture itself. It is also difficult – and usually impossible – to make changes to the armature once you have started modelling.

An armature can be used in two ways. First, it can be permanent and remain inside the finished sculpture. The WELDING section will show you how to make a permanent steel armature that is used in the DIRECT MODELLING section. This section also has a sculpture that uses a ready-made permanent armature.

The other way an armature is used is as a temporary support structure for a modelling medium. This allows you to model a sculpture with clay prior to it being cast in another material (see the MODELLING, MOULDMAKING and CASTING sections). The example on page 31 shows a type of temporary armature to use when making a sculpture that will be fired in a kiln.

The following three techniques show the preparation of an armature for a life figure, a portrait head and a simple armature suitable for a kiln-fired sculpture. Two sculptures will be cast in another material and use flexible aluminium armature wire which can be bent easily when making the armature initially and also when it is time to remove the sculpture from the plaster mould.

Life figure

It is important to have the armature the right size from the start, as changes are difficult – if not impossible – to make later. This is especially true when making an armature for a figure, in this case one-third life size.

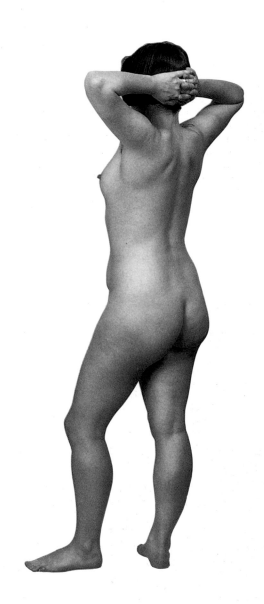

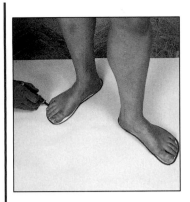 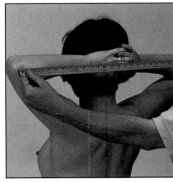 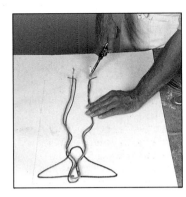 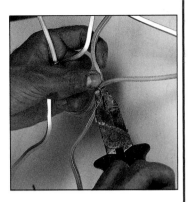

1 Once the pose has been established, mark the position of the model's feet on a sheet of cartridge paper with a felt-tip pen. This will enable the model to resume the same position after rests and also help in taking accurate measurements.

2 Make as many measurements as you want, as they will all help when it comes to modelling the figure. At this stage, however, you are concerned with measurements that will help you to construct the armature. These are the vertical measurements from the floor to the waist, the shoulders, the elbows, the top of the head, and the measurement across the arms from elbow to elbow.

3 Divide the measurements by three for the clay figure. The measurements for the armature will be slightly less to allow for the added layer of clay. Draw the design of the armature on paper, remembering to use the minimum number of lengths of wire possible. The fewer joins, the stronger the armature will be. For this pose two lengths are sufficient. Using the drawing as a guide, bend the wire into the proposed design.

4 Fix the arms onto the body with binding wire. Hold the pieces to be joined in position and wrap a short piece of binding wire around the two pieces of armature wire. Twist the binding wire round once with your fingers. Then, using pliers, grab the two ends of the binding wire and pull and twist both pieces of wire as tightly as possible. This produces a very secure fixing which will be sufficient to hold the two pieces of armature wire in place.

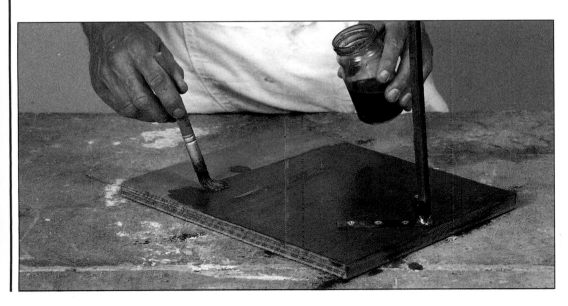

5 Paint the base board for the fixed iron armature support with three coats of shellac, allowing time to dry between coats. This prevents the board from drawing the water out of the clay, which can otherwise dry out and crack.

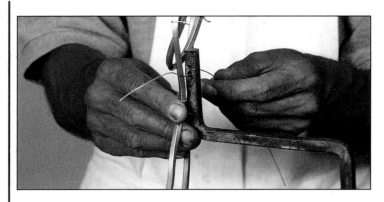

6 Fix the armature to its iron support, making sure that the feet of the armature are 1.2cm (½in) above the base board. Use the binding wire and twisting technique to fix the armature, at the waist, firmly to the iron support.

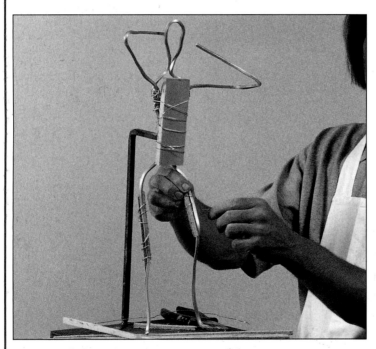

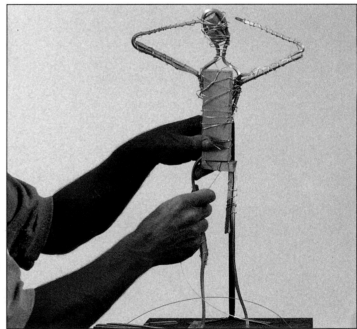

7 Pad out the torso area with a block of wood, holding it in place with binding wire wrapped tightly around the wood and the armature wire. Strips of wood can also be placed on the upper arms, upper legs and a piece in the head section, bearing in mind the size of the form that is going to be modelled around it. This wood strengthens the figure, absorbs water from the clay and expands, exerting an outward pressure on the clay that surrounds it.

8 Finally, wrap binding wire loosely around the entire armature to help the clay to grip.

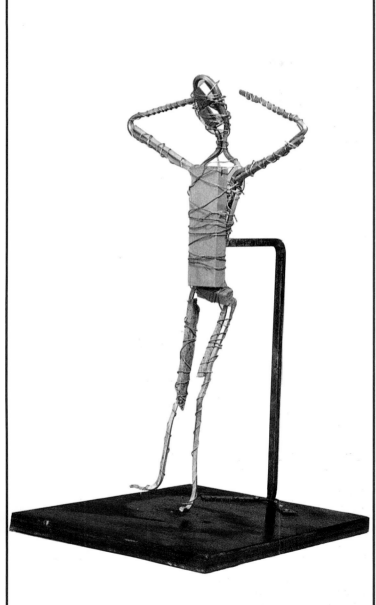

Head

This armature is for a life-size head and is designed so that you can model the head well above the surface of the base board.

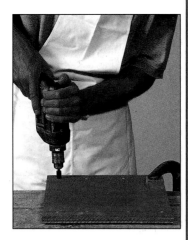

1 Cut the plywood and softwood to size. Clamp the base board to the bench and countersink the drilled holes. Measure and mark the centre of the board and drill a hole the same diameter as the shaft of the coach bolt.

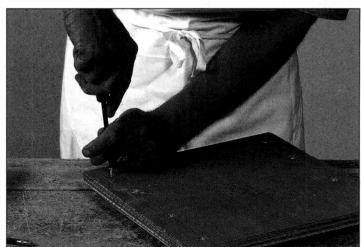

2 Position the two small slats of wood underneath the board on opposite sides and screw them firmly into position. Raising the base board up in this way allows you to move the armature more easily when the clay head has been modelled onto it.

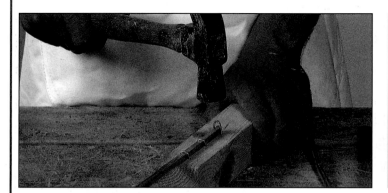

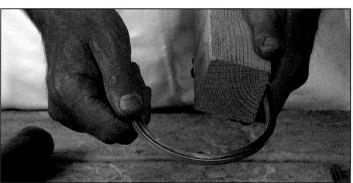

3 Taking a 30cm (12in) length of aluminium armature wire, use netting staples to fix one end to the vertical shaft.

4 Bend the aluminium wire around in an even curve and use netting staples to fix the other end of the aluminium wire to the shaft.

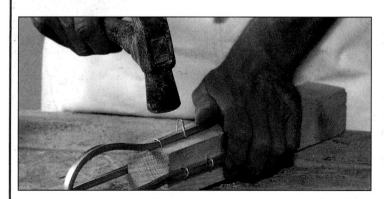

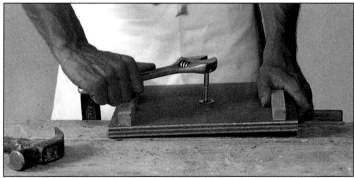

5 Repeat this process, adding the aluminium wire to the other two sides. This configuration holds together the mass of clay that forms the basis of the head.

6 Position the shaft of the armature in the vice so that the aluminium wires are pointing downwards, and the square section at the other end of the shaft is level with the bench top. Drill a hole in the centre of this section, slightly smaller than the smallest diameter of the coach bolt. Drill down 10cm (4in) into the shaft. Place the inverted base board over the top, matching up the two holes, and use a spanner to screw the coach bolt tightly home. The armature is now ready.

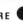

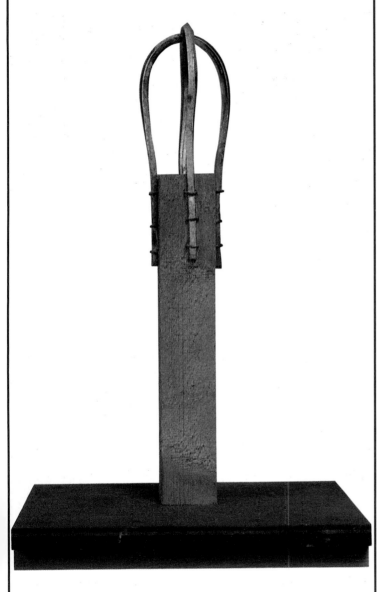

Simple armature

A simple armature for a large clay sculpture can be made using a broom handle. The one shown is suitable for the KILN FIRING technique. Construct a double modelling board by taking two boards 40 × 40cm (16 × 16in) and drill a hole in the centre of each, the diameter of the broom handle. Place two pieces of timber 5 × 5 × 40cm (2 × 2 × 16in) in between the boards on opposite sides and screw into place. Cover the board with cling film to stop the clay sticking to it, and hold it in place with tape. Now, with a mallet, gently hammer the broom handle vertically right through the hole in the top board and down into the hole in the bottom board. This arrangement will hold the armature pole steady and stop it moving from side to side under the weight of the clay. Make sure that the armature pole is not lodged too tightly in the hole. You should just be able to rotate it. Wrap cling film around the pole.

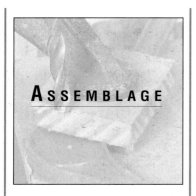

ASSEMBLAGE

Assemblage was pioneered earlier this century and uses found or everyday objects, bringing them together to make a sculpture. A successful assemblage focuses our perception on what the sculpture represents or is doing and not on the identity or function of the original objects.

Inevitably with everyday objects, you will be dealing with a variety of shapes and materials, so it is helpful, when considering the format of the sculpture, to think carefully about the ways in which these disparate items are going to be joined and fixed. It is also a good idea to keep to a minimum any cutting and shaping of the objects.

Creating the sculpture
By its very nature, assemblage requires that you use your imagination a great deal, identifying the sculptural potential that exists in the objects that surround you. The examples shown introduce you to this potential and to some fixing and joining methods, though whichever method you choose will always depend on the type of materials you are joining.

The first example is a representational assemblage of a bird. The main catalyst for this sculpture was the plastic container of household detergent. Other objects were then collected to provide the rest of the bird and a drawing was made to plan how they all fitted together.

The second example is a simple repetition of the same object, plastic coat hangers. Their shape makes them ideal for arranging in a spiral formation around a central axis, a threaded steel rod, to produce a sense of movement, a conventional theme of abstract sculpture.

Abstract sculpture
When making an abstract sculpture you will need to pay attention to the shape of the individual parts and the relationship these parts have to one another within the form of the sculpture.

YOU WILL NEED

plastic coat hangers • G-clamp • junior hacksaw • electric drill • pencil • scrap wood • bradawl • gas torch • leather gloves • felt-tip pen caps • threaded steel rod • vice • nuts • pliers

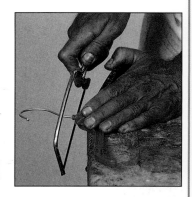

1 Cut off the metal hooks from all the coat hangers using a G-clamp to hold them steady. With a junior hacksaw, cut the metal shaft as close to the plastic coat hanger as possible.

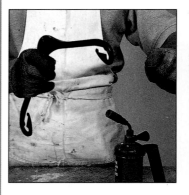

3 Gently heat the hangers so they bend easily. You will need a controllable heat source with a gentle, slow flame, such as a gas torch with the flame turned as low as possible. Plastic softens very quickly, so don't hold the hanger still in the flame. Wearing leather gloves and making sure that the flame is blowing away from you, gently wave the part of the hanger to be bent in the flame.

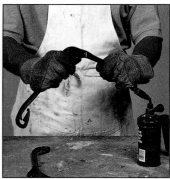

4 Once the plastic has softened, turn off the gas and bend the arms of the black hangers at 90 degrees in opposite directions.

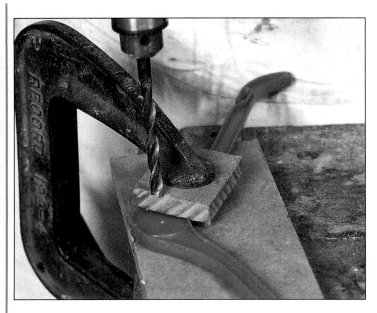

2 Drill central holes of the same diameter in each of the hangers. The most efficient way to do this is to use one of each type of hanger as a template. Take one black and one yellow hanger and mark the central point of each with a pencil. Clamp the first hanger to the bench, using blocks of scrap wood to distribute the pressure of the clamp evenly. Then drill a 3mm (⅛in) hole.

Repeat with the other hanger. Using a hanger as a template, place it on top of another of the same colour, then push a bradawl through the drilled hole to mark the position of the hole to be drilled. Repeat with all of the black and yellow coat hangers, then drill a 9mm (⅜in) hole in each one, making sure that the hanger is securely clamped to the bench as before.

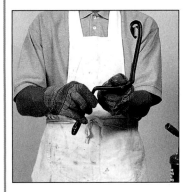

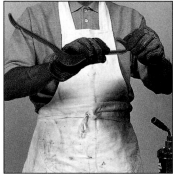

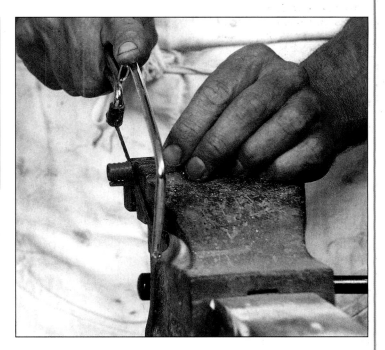

5 Hold the hanger in position until the plastic cools. Once cool, you will find the hanger will stay firmly in its new configuration.

6 The tips of the arms of the yellow hanger need to be bent into the most acute angle possible. Warm them as before, remembering not to hold the hanger still in the flame.

7 Felt-tip pen caps have an interior diameter slightly larger than that of the steel rod.

Place each in a vice and cut to the required length to use as a spacer between the hangers.

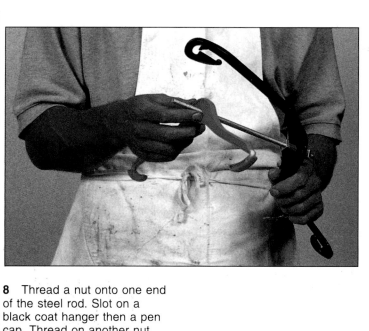

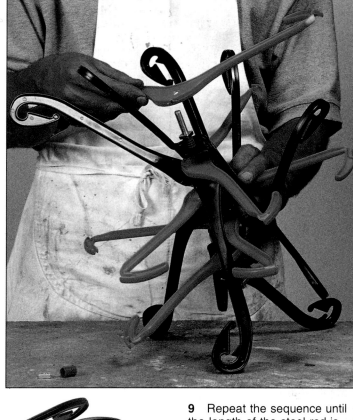

8 Thread a nut onto one end of the steel rod. Slot on a black coat hanger then a pen cap. Thread on another nut, followed by a yellow hanger.

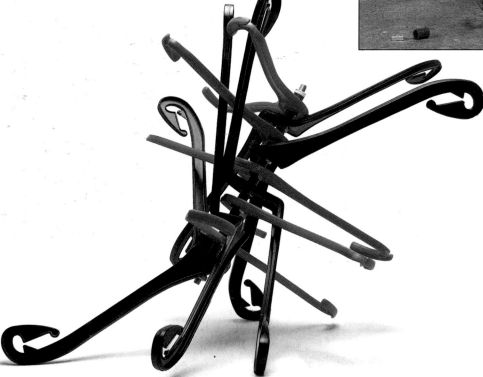

9 Repeat the sequence until the length of the steel rod is covered. Finish off with a nut, screwed down tightly with pliers to hold all the components together.

Figurative sculpture

This figurative sculpture of a bird was inspired initially by the plastic container shape. Other everyday materials were then found to make the other parts of the bird.

YOU WILL NEED

paper and felt-tip pen • plastic household liquid containers • craft knife • old knife • gas torch • masking tape • plastic coat hangers • pliers • screws • screwdriver • electric drill • G-clamp • bradawl • wood • silicone sealer • sealant gun • saw • riffler • latex gloves • epoxy resin putty • modelling tool

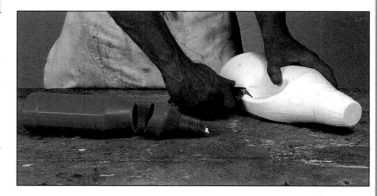

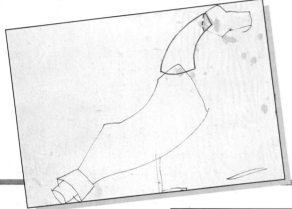

1 Make a drawing of your planned sculpture. Then mark the parts of the plastic containers that you require and, using a craft knife, cut them away.

SAFETY

When using the craft knife, always hold the container firmly on the bench and draw the blade of the knife away from you. It is essential to work this way to avoid unpleasant accidents.

2 The neck is joined to the head by melting and blending the plastic together. Heat the tip of a knife in the flame of a gas torch. Hold the two parts to be joined securely in position. Melt the plastic of the first container with the hot knife, then pull the knife across to the other container, so that the plastic melts and blends together. Repeat all the way around the points of contact. Once the head and neck have been joined together, they can be fixed onto the main body, using the same method. Parts that need to be joined in this way can be held in place with masking tape while you are working with the torch.

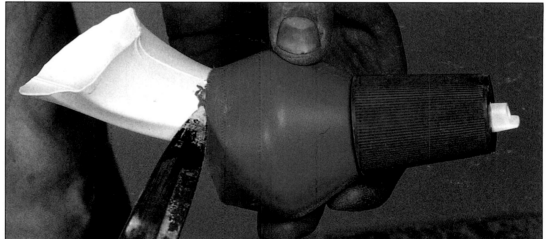

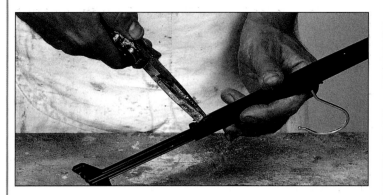

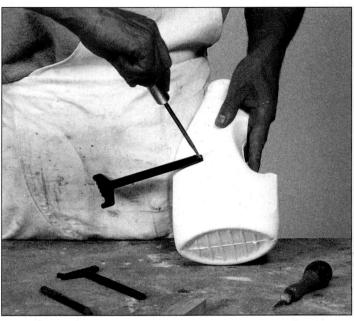

3 The legs of the bird are made from the ends of a coat hanger. Remove them with pliers.

4 Drill a hole 3mm (⅛in) into the top of the leg. Use this hole as a template to make a corresponding hole in each side of the body with a bradawl. Measure the interior width of the body, saw a block of wood to this size and insert it. Screw the legs to the body.

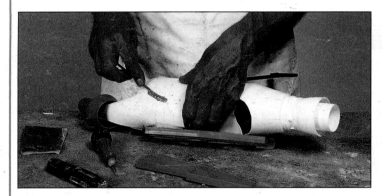

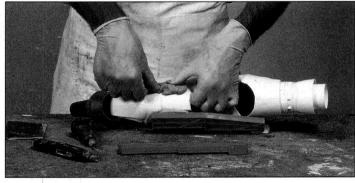

7 Using a riffler, roughen the surfaces of the body and wings where they are to be attached.

8 Wearing latex gloves, knead the epoxy resin putty to produce an even colouring (see REPAIRS). Press it firmly onto the roughened surface of the body.

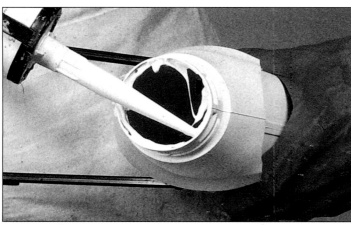

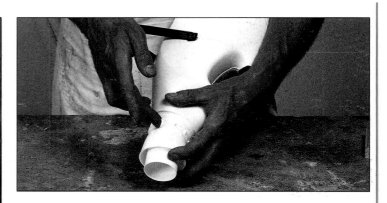

6 Push in the inverted top, wiping off any excess sealer with your finger. Hold the top in position with masking tape until the sealer has cured (set).

5 The cap of the container is inverted and placed into the top opening to make the bird's tail. Use the silicone gun to apply a bedding of silicone sealer around the top edge of the opening.

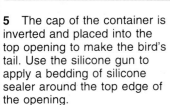

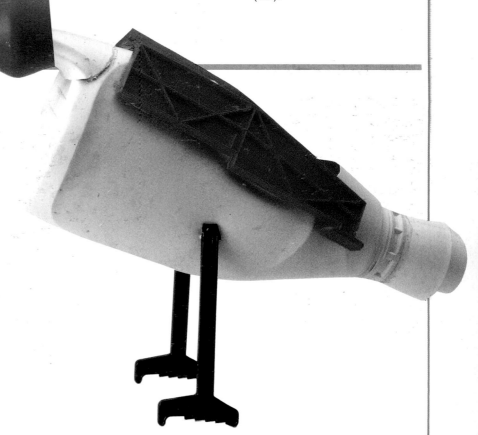

9 Now press the first wing down onto the putty, trimming and levelling the putty neatly all the way round with the modelling tool. Hold the wing in place with masking tape until the putty has set. Repeat the procedure with the other wing.

BASES

The main function of a base is to support a sculpture. Most sculptures require a base, although there are some exceptions. The welded steel construction, for instance, will, by virtue of the technique used to make it, provide its own support.

Sometimes, a base is an absolute necessity. Adding a base to sculptures like the cast of the portrait head and the carving of the fish allows them to be seen to their best advantage. The base of the figurative wooden construction is an integral functional part of the sculpture itself and its weight keeps the sculpture in position. A base can, however, act as a purely compositional element. By using a base to define the space within which the cast plaster sculpture is seen, it produces a far greater sense of scale.

Traditionally, a base was made from stone or wood. Nowadays, ready-made materials such as the concrete paving slab are available. Alternatively, you can cast your own base in a casting jig, in materials such as *ciment fondu*, plaster or resin.

Portrait head

YOU WILL NEED
car body filler and hardener • rubber gloves • sheet of glass or plastic coated surface • filling knife • sand-filled inner tube • 2 × 1.5cm (5 × ½in) metal pipe • riffler • cast iron grate polish • toothbrush • soft cloth • wooden base • electric drill • 7mm (⅝in) zip bit • two part epoxy resin glue • palette knife • blocks of wood

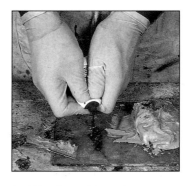

1 Wearing rubber gloves throughout, put some car body filler on a sheet of glass. Squeeze out some hardener of roughly equal length. (Do not add too much hardener as this will speed up the setting time of the car body filler.)

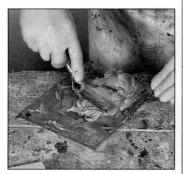

2 Mix the two parts together so they have an even and consistent colouring.

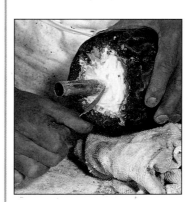

7 Level off the filler to the neck of the sculpture with a riffler.

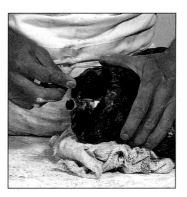

8 Apply the grate polish to the filler surface with a toothbrush, brushing it in well. When dry, buff with a soft cloth.

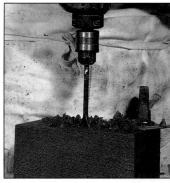

9 Position the head on the wooden base to mark the position of the pipe. Drill down 7.5cm (3in) into the wooden base with the zip bit.

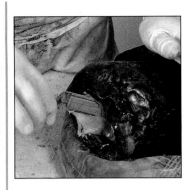

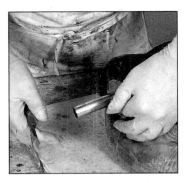

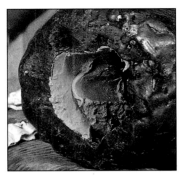

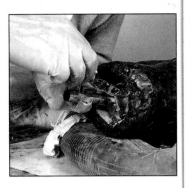

3 Support the head in a sand-filled inner tube. Add the body filler to the front wall of the neck cavity, working as quickly as you can.

4 Position the metal pipe centrally to the front of the neck and parallel to the front of the face before the mix sets. Press the pipe into the mix and hold it until it sets.

5 Take the metal pipe out. This leaves an impression of the pipe in the filler. Mix some more body filler.

6 Hold the metal pipe in its impression so that 6.5cm (2½in) is left outside the neck. Apply more filler around the pipe in the neck cavity and allow it to set, holding the pipe in place. Make another mix of filler and fill the opening to the neck cavity. Leave to set.

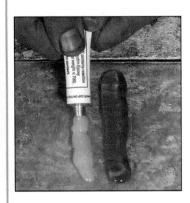

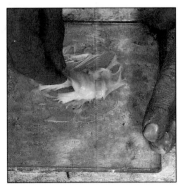

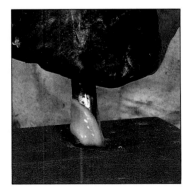

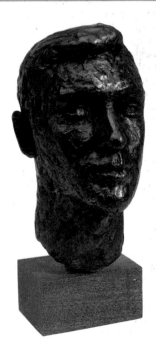

10 Squeeze out equal lengths of epoxy resin glue onto the glass sheet.

11 Using the plastic spatula that comes with the glue, mix the two parts together to obtain an even colour. Put some glue in the hole with a palette knife, coating the interior surfaces well.

12 Put some more glue around the exposed pipe on the head, then place it in the hole on the base. This hole is slightly bigger than the pipe so you will be able to position the head easily. Keep the head supported with blocks of wood while the glue dries.

Fish carving

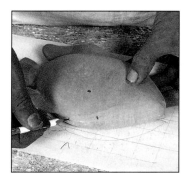 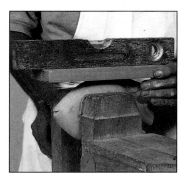 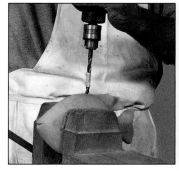

1 Lay your carving on the original drawing and mark the centre point on the underside of the fish.

2 Place the carving in a vice, using a spirit level to check that it is level.

3 With the drill bit at right angles to the underside of the carving, drill down 4cm (1½ in), using masking tape on the drill bit as your depth guide.

Plaster cast

The residue of plaster that has set in the bottom of a bucket is used here as a base.

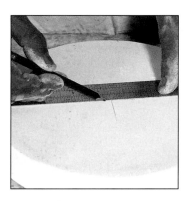 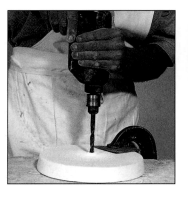 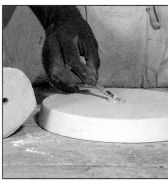

1 With a ruler, find and mark the centre point of the plaster.

2 Clamp the base to your bench and drill a 8mm (⅜in) diameter hole into both the base and the bottom of the sculpture at its approximate centre point.

3 Fill the centre hole in the base with decorating filler.

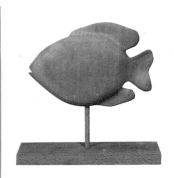

4 Mark the centre point of the base, clamp it to the bench and drill a hole. Gently tap the dowelling down into it. Fit the carving onto the dowelling and push it down as far as you can.

Wooden figurative construction

YOU WILL NEED

electric drill • 6mm (¼in) drill bit • countersink bit • 45 × 15cm (18 × 6in) concrete paving slab • square • bradawl • 6mm (¼in) masonry bit • 2 rawlplugs • 2 4cm (½in) No. 8 screws

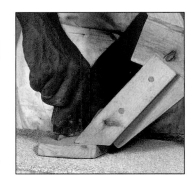

1 Drill two holes in the foot section of the constructed sculpture with the drill bit. Countersink both holes. Place the sculpture on the base, using a square to ensure that the heel section lines up with the end edge of the base and the sculpture is centrally placed. With a bradawl, mark the position of the two drilled holes onto the base.

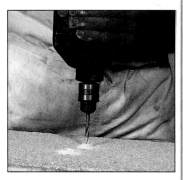

2 Using a masonry bit in your electric drill, drill two holes the depth of the base, and place a rawlplug in each of these holes. Once coloured, the sculpture can be screwed in place. (See the COLOURING and REPAIRS sections of this book.)

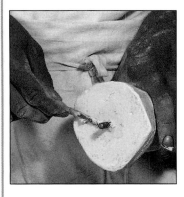

4 Cut the steel rod to length (it should be just shorter than the combined depths of the two holes). Fill the hole in the sculpture with decorating filler and insert the steel rod. Pack the filler tight around the steel rod.

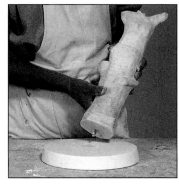

5 Before the filler sets hard, insert the rod into the hole in the base and set the sculpture vertically on the base. Adjust the sculpture so that it sits centrally on the base. Leave the filler to set.

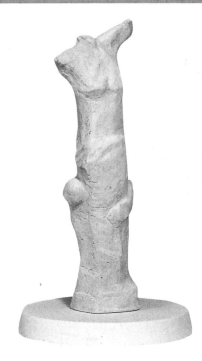

BRAZING

Brazing is a technique that uses molten brass to join two pieces of mild steel together at a low temperature. It is especially suitable for thin sheet and small diameter steel rod and bar, which would be more likely to burn away, expand and buckle under the higher temperature used in WELDING. Brazing makes a strong join though not so strong as a welded join.

For gas welding and brazing the heat source used is the combination of two gases, oxygen and acetylene (oxy-acetylene), acetylene being the inflammable gas. The gases are stored in cylinders, which have an on/off valve operated by a cylinder spanner. Fitted to the top of each cylinder are two gauges and a regulator valve. One gauge indicates the pressure of gas in the cylinder, the other indicates the pressure of the gas leaving the cylinder to the torch. Oxygen is denoted by the colour blue and acetylene by red. Each cylinder is connected to the torch by a rubber hose. The torch itself has two valves – one red (acetylene) and the other blue (oxygen). With these you can control the mixture of gases for the correct flame. The size of the torch nozzle determines the size and intensity of the flame. As a guide, a nozzle with a small opening is suitable for brazing, while larger ones are suitable for welding. The gas pressures you require will depend on the nozzle size and the thickness of the mild steel being joined. Read the instruction manual carefully.

The sculpture being made in this section is a fish that forms part of a four piece wall-based sculpture. The flame of the torch is used to cut out shapes from a sheet of steel. The parts of the fish are then brazed together. Brass is used to form a decorative effect within the sculpture.

Obtaining correct flame

This flame is suitable for both brazing and welding. When using oxy-acetylene equipment always work in a well-ventilated area, away from flammable items. If possible, work on a concrete floor and always work on a steel surface. Always wear overalls, leather gloves, a leather apron, welding goggles and heavy duty boots or shoes when using this equipment.

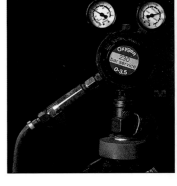

1 The oxygen gauges and regulator. The right-hand gauge indicates the level of oxygen pressure in the cylinder, while the left-hand gauge shows the oxygen pressure flowing to the torch.

5 As you increase the amount of oxygen, the flame changes colour to blue and you will see it has three parts – a small cone near the tip of the welding nozzle, an area of flame around this and a much larger area of flame that surrounds both of these.

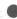

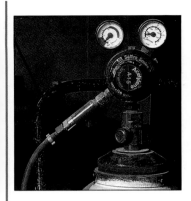

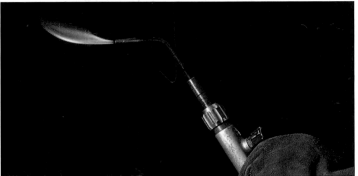

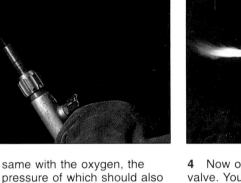

2 The acetylene regulator and gauges. The right-hand gauge shows the acetylene pressure in the cylinder and the left-hand one the pressure flowing to the torch. Establish the correct pressure of each of the gases flowing through the torch, starting with the acetylene – being the inflammable gas, it is the first one you turn on and the first you turn off.

3 Use the cylinder spanner to open the acetylene cylinder valve. Open up the acetylene regulator at the cylinder, then open up the (red) acetylene valve on the torch. Gas will now be escaping from the welding nozzle, cleaning the hoses and nozzle. Adjust the cylinder regulator to obtain the required pressure on the left hand gauge (in this case 2lb/in^2) and close the acetylene valve on the torch. Do the same with the oxygen, the pressure of which should also be 2lb/in^2. Turn on the acetylene valve slightly and ignite the gas with a spark lighter, with the flame pointing away from you. Open up the acetylene valve more and stop just at the point where the black smoke, given off by the burning gas, disappears.

4 Now open up the oxygen valve. You will notice that the flame immediately becomes more powerful.

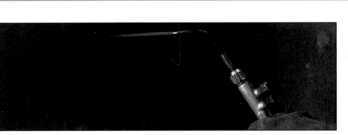

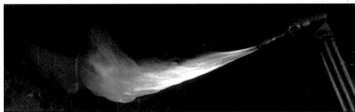

6 Keep increasing the amount of oxygen until the middle part of the flame is eliminated. You are now left with a flame in two parts, a small white cone at the tip of the nozzle and a blue area of flame that surrounds it. To shut off the flame close the acetylene valve on the torch first, then close the oxygen valve.

7 The cutting attachment can be screwed onto the torch after the welding nozzle has been removed. Fully open the oxygen valve on the torch – there is an oxygen valve on the cutting attachment which is used to control the oxygen pressure. Increase the pressure to 30lb/in^2. Open up the oxygen valve on the cutting attachment and adjust the oxygen regulator at the cylinder until this pressure is shown on the gauge. The acetylene pressure remains the same. Light the torch and obtain the same acetylene flame as before. The resultant flame will be harsher as there are more outlets at the tip of the cutting torch.

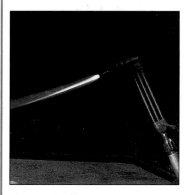

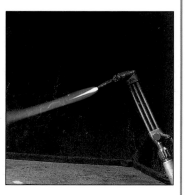

8 Open up the oxygen valve.

9 Increase the oxygen until you obtain a three-part flame.

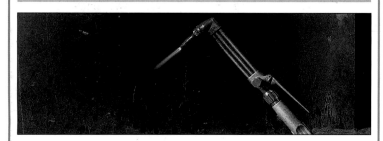

10 Continue until you have a two-part flame, making sure

that each of the cones of flame are consistent.

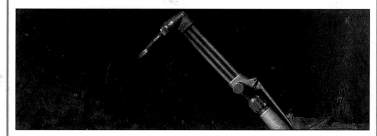

11 Finally, depress the lever on the cutting attachment to let oxygen out of the central opening, and adjust the oxygen valve to the correct type of flame. To turn off, close down the acetylene valve on the torch, followed by the oxygen valve on the cutting

attachment. When you have finished working with the equipment, close both of the cylinder valves with a spanner. Then, one at a time, open each valve on the torch to expel any gas in the hoses; when the gauges register zero, close both of the regulators.

Wall hanging sculpture

The steel that is near to the flame will be hot for some time after you have finished work – so, don't touch or move it without leather gloves. Wear protective clothing throughout: leather apron, welding goggles, overalls and stout boots or shoes.

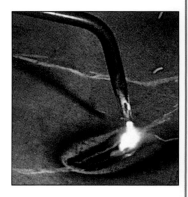

1 Using chalk, mark out the profile of a fish tail on the sheet steel. Carefully follow the chalk outline with the flame until the shape is completely cut from the steel.

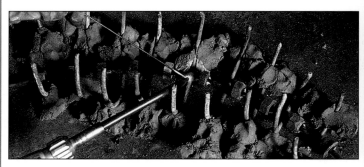

4 The central spine of the fish is a length of 6mm (¼in) steel rod which is easily bent by hand. Thread on some nuts. Alternate curved sections of steel rod with the nuts. The curved sections are held in place with clay, the central curved rod touching all of the

small curved sections. The curved sections have been made using small lengths of rod, heated and then bent to shape (see WELDING). When everything is in position, clean the areas to be brazed, then braze together.

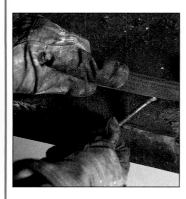

2 A good brazed joint depends on both of the surfaces being clean, so clean the surfaces with a wire brush, wire wool or file beforehand.

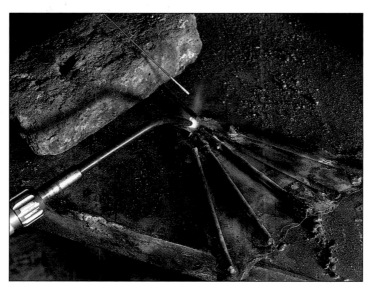

3 The pieces of 6mm (¼in) steel rod in the tail section are held in position by applying molten brass. Apply heat evenly to the area around the two pieces of steel to be joined (there should be a slight gap between them), until they reach red heat. At the same time, a brass rod which has previously been dipped into a powdered flux to stop oxidisation, needs to be introduced into the outer flame. When the steel reaches red heat (the melting point of brass), bring the brass rod into the area to be joined. The heat generated will enable the brass to melt and flow in and around this joint. Withdraw the rod, and turn off the gas. As the joint cools the brass also cools, holding the two pieces of steel together.

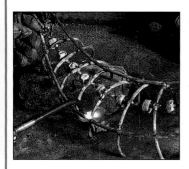

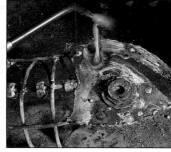

5 With the head and tail section brazed onto the central spine, add two more curved sections of steel rod either side of the central spine. Braze into position where they come into contact with the small curved sections.

6 Finally, heat up an area of the face and brass rod. Drop molten brass onto the surface – this has a very pleasing decorative effect.

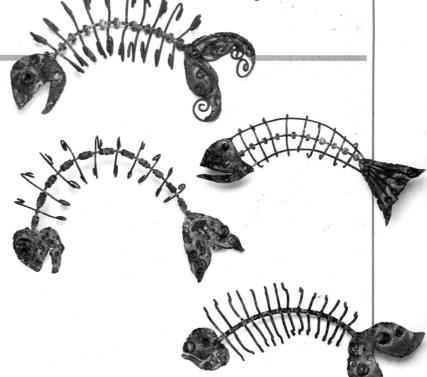

CARVING

Unlike modelling, which builds up a sculpture, carving is a reductive process, cutting a sculpture out of a block of stone, wood or other material. This makes carving a very disciplined activity because, once material has been carved away, it cannot be replaced and so careful planning is essential.

Begin with a drawing or a small model of the proposed sculpture made from clay, called a maquette, and take this with you when you select your carving material. Try to match your material as closely as possible to the size and shape of your planned sculpture. Your first task will be to dispose of as much waste material as quickly and efficiently as possible so you will want to keep this to a minimum, especially if you are working with a hard material.

Starting carving
In this section there are three examples of carving, each using a different material. The first is an aerated concrete building block. This is a very soft material that can be cut and shaped using basic tools. The sculpture is an Oceanic Head, like those found on Easter Island, and this fits well within the geometry of the building block – so there will be a minimum of waste material to cut away.

The second exercise uses a block of plaster, another material that is easy to carve, especially in its wet state, using basic tools. This abstract sculpture is based on a clay maquette and the result is very different from the geometry of the block from which it is carved. Variations in surface textures are also an important part of this sculpture.

The final carving is in wood. This is a more complex material to carve because of the grain. This stylized fish form is carved with particular attention to creating a smooth surface which highlights and accentuates the form of the sculpture. This exercise will also introduce the use of conventional woodcarving tools.

Aerated concrete block
Concrete blocks are a readily available material that is ideal for those new to carving. The surface texture of the carving is well suited to this Oceanic head.

YOU WILL NEED
aerated concrete block • set square • water spray • goggles • dust mask • protective clothing • tape measure • chalk • wood saw • wooden mallet • carving gouge or flat chisel • rasp • surform with semi-circular blade • long nail • riffler • sandpaper

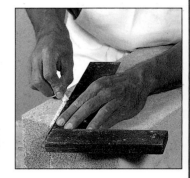

1 Measure and mark a vertical centre line on the front, back and side faces of the block. On the top, mark two centre lines from opposite sides of the block. Referring to your drawings for the sculpture, draw the side profile on each of the side faces of the block. Now draw the profile of the front on the front face of the block.

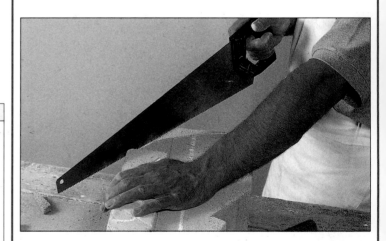

5 Cut away the material around the curved jaw using a series of straight cuts. The depth is shown by the profile drawn on the back of the block.

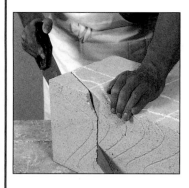

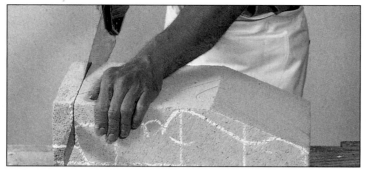

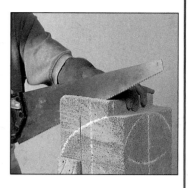

2 You are now ready to discard the first area of waste material by making a vertical cut with a saw across one of the corners of the block. This diagonal plane will form the basis of the forehead of the sculpture.

3 Next, saw off a section of material on the bottom and front faces of the block to form the basis of the chin and a recessed neck that will become the plinth on which the sculpture will stand. This means making two saw cuts, taking great care not to go over the guide marks, as this would result in a saw cut on the surface of the sculpture. However, if necessary, you can smooth down saw cuts later

with a rasp if they are not too deep. Staying on the side faces of the block, mark out a rectangular section for the ear. Saw away the surrounding area in four saw cuts. The depth of the cut is determined by the drawn profile of the sculpture on the front of the block. There will now be, on each side, a raised area that will form the ears of the sculpture.

4 As areas of waste are cut away, it is important to redraw the centre lines. Draw the profile of the face on both sides of the block and cut away the "v" section of eye sockets. Make a diagonal cut from the back of the block to prepare for the jaw area.

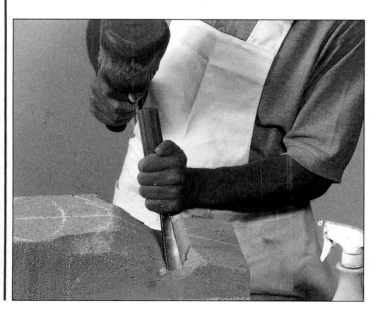

6 All the waste material that can be sawn has now been disposed of and you are ready to start carving the sculpture. Initially, you will need a wooden or plastic mallet and either a flat chisel or a carving gouge. Do not hit the chisel too hard with the mallet or the material is liable to shatter and you could knock a large lump off the block! In fact, you should keep the use of the mallet to a minimum and you will find that you can carve the

material quite adequately just using the power of your hand to push the chisel. If you are using the chisel in this way, keep both hands behind the cutting blade. Remember that when you are carving, always cut away less rather than more, reducing the surface of the block in stages and not in one go. Begin by carving away the waste material around the nose and eyes, releasing a raised nose area from the surrounding material.

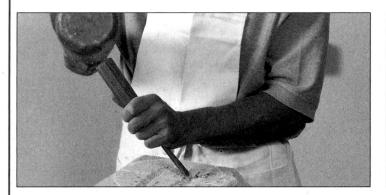

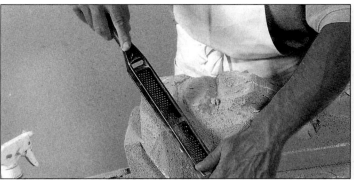

7 Continue carving around the nose and deep into the eye cavities. You can now carve away the areas around the mouth and so start to form the chin. Remember that the tip of the nose is the highest point, the eye cavities are the deepest and the raised mouth area is midway between the two.

8 The sculpture is really starting to take shape and your most useful tools now are a surform or rasp, with a little help from a hand-held chisel. Because of the softness of the material, the surform or rasp are very efficient ways to shape the broad areas of the back, top, forehead, cheeks and chin. This is when a lot of dust is thrown up, so be ready with your water spray. A hand-held chisel can help to further define the mouth, nose and eye cavities.

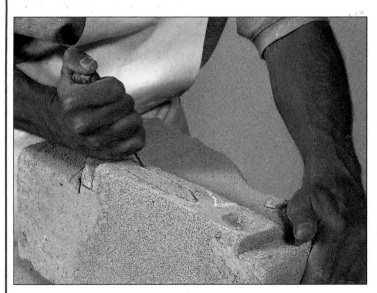

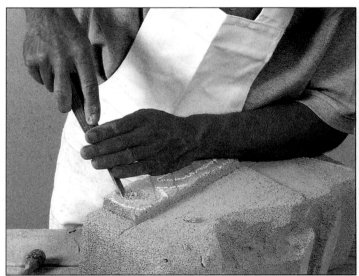

10 Use a bradawl to define the stylized linear marks that form the ears.

11 Refine and shape the ears further with a hand-held chisel and a riffler, a very small rasp that comes in a variety of shapes which will allow you to get into hitherto inaccessible areas.

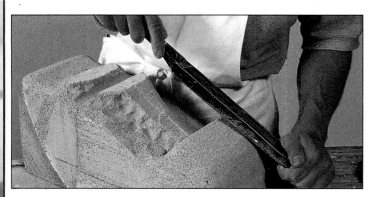

9 The surform quickly defines the rounded form of the top of the head.

12 The mouth, nose and eye sockets can also be further refined using a riffler. Once these areas have been shaped and defined, finish by giving the whole sculpture a final rub down with sandpaper.

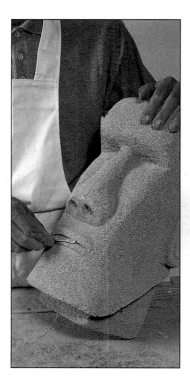

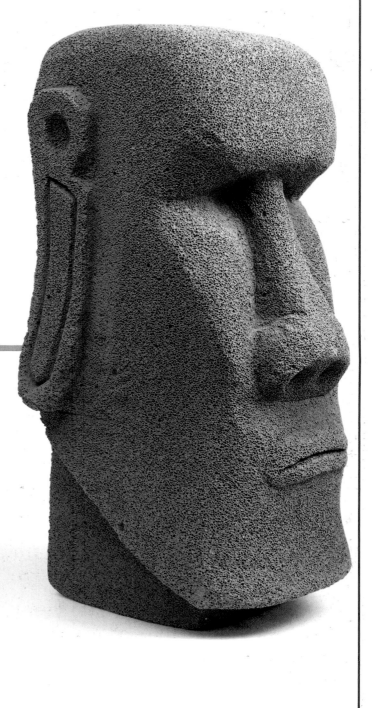

Abstract plaster form

This abstract plaster sculpture is based on a clay maquette. It is a very different shape from the original plaster block, so a great deal of waste material must be cut away.

YOU WILL NEED

casting jig • bucket • goggles • barrier cream • base board • nails • casting plaster • pencil • flat or carving gouge • chisel • wooden mallet • wood saw • knife with serrated edge • filling knife • tape measure

SAFETY AND TIPS

• Always use goggles when carving.

• Use barrier cream when working with plaster.

• Plaster-impregnated tools deteriorate very quickly unless they are cleaned immediately after use. Use old tools and get rid of set plaster with a wire brush. If water is used to clean steel tools, dry them thoroughly or rust will form on them very quickly.

1 Set up your casting jig on a base board. Use a tape measure to determine the size of the jig, which in this case is 23 × 23 × 23cm (9 × 9 × 9in). Use a plastic-coated board, such as melamine, to ease the final removal of the casting jig. Alternatively, use soft soap or oil on all the surfaces of the boards that will come into contact with the plaster. Secure the boards where they meet the base board with nails and pour the plaster in slowly – too fast and the pressure of the plaster may force the casting jig apart.

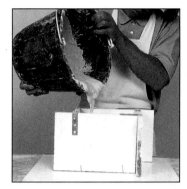

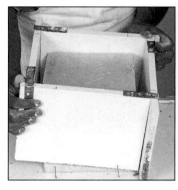

2 Once the plaster has set, gently pull the jig apart and away from the plaster block.

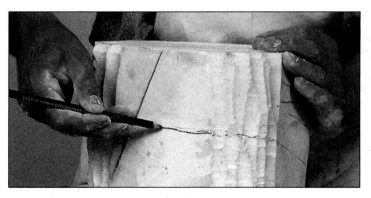

5 You now have a rough cylindrical shape. Referring to the clay maquette, draw the profile of the wedge shape that runs through the spiral on roughly opposite sides. These lines need to correspond with the oblong already drawn on the top. Now, draw a spiral line around the cylinder from the top to the bottom. This will indicate the areas of waste material between the spiral form.

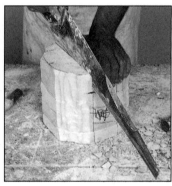

6 Using the saw, make a vertical cut to release the wedge shape. You are only able to go so far into the plaster before it gets very difficult. This is because of the high water content in the plaster.

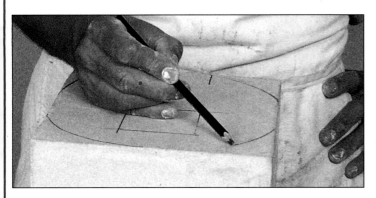

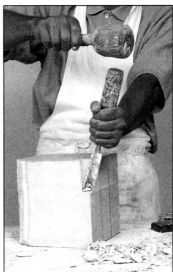

3 Look at the clay maquette to decide the areas of waste material on the plaster block. Mark out a circle on the top of the block that touches all four sides. This corresponds to the widest point of the spiral. Next, mark the oblong section corresponding to the one on the maquette on top of the plaster block.

4 Use a carving gouge and mallet to cut vertically down through the plaster to remove the four corners of the block. Plaster in its wet state is very easy to cut through and offers no resistance to the blade. Don't become too confident and hit the chisel too hard, though, as you may cut away more than you intended, or even fracture the block.

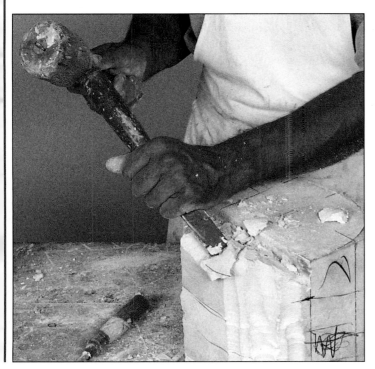

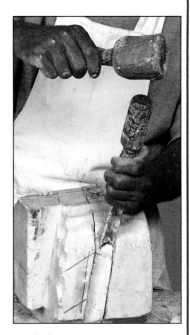

7 Carve away the plaster with the gouge to the depth of the saw cut. Then continue with the saw again. Alternate tools, in this way, until the top of the geometric form stands above the spiral form.

8 Use the same sawing and carving method to carve away the waste areas in between the spiral forms. This is best done initially by turning the sculpture on its side. However, parts of the sculpture will be sticking out, so be careful not to hit the chisel too hard. Just tap gently.

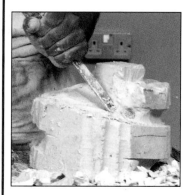

9 With the sculpture now the right way up, and the spiral forms now prominent, start to develop the form of the spiral, carving very gently through the plaster. Follow the spiral around the sculpture.

10 By this stage it will not be necessary to use the mallet and the shaping of the spiral can be done with a hand-held chisel, always keeping both hands behind the cutting edge. Use the flat chisel to level the faces of the geometric form that runs up through the spiral, too. Other tools, such as a knife blade, can be used to shape the plaster. One of the advantages of plaster is the variety of tools that you can use to work it, but always remember to use them safely.

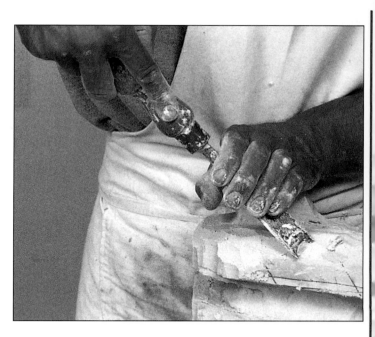

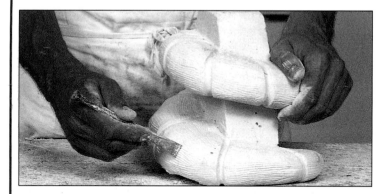

11 With the geometric and spiral forms well defined, attention can now be paid to the details. The jagged edge of a stone carving chisel is used to produce the indented lines that run around the spiral.

12 The deep indentations that fan out around the spiral are made with the round head of a large nail. The faces of the geometric shape are scraped flat with the blade of a filling knife.

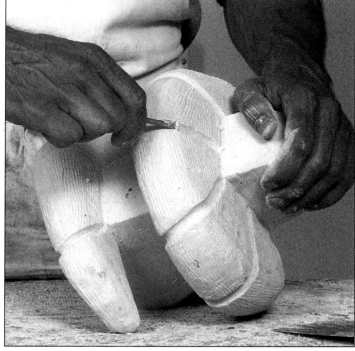

Fish

The wood being carved in this section is called *jelutong*. It has a fine close grain and is very easy to cut and shape – an ideal carving wood.

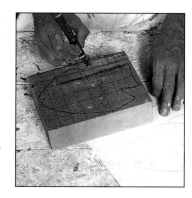

1 Mark out two grids, one on your plan of the sculpture, the other on the surface of the wood. Transfer the drawing to the grid on the wood, using a felt-tip marker.

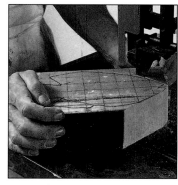

2 Using the bandsaw, cut along the line of the fish. Wear clear goggles and keep both hands well away from the saw blade.

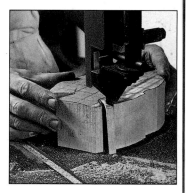

3 You will need to make a series of small cuts between the tail and the fins on the top and bottom of the fish to dispose of waste material.

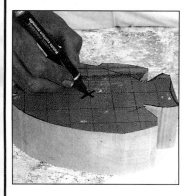

4 Mark the centre point on each side of the fish by placing your drawing over the cut-out fish and lining it up. Then use a bradawl to pierce the centre point of the drawing, marking the centre point of the wood.

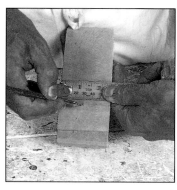

5 Measure and mark the centre of the side at equidistant points around the fish.

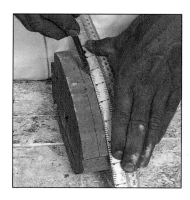

6 Using a flexible ruler, join up these points and mark a line all the way around. On either side of this line draw another, to give the width of the two fins and the tail, the position of which can now be marked out.

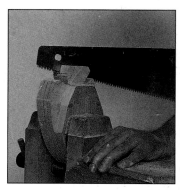

7 Secure the fish in a vice and, with a saw, cut away the waste material either side of the fins and tail. Make a vertical cut first, being careful not to cut into the body of the fish, but sawing down to the drawn profile.

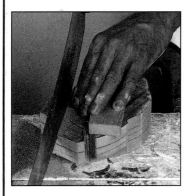

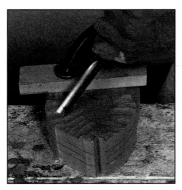

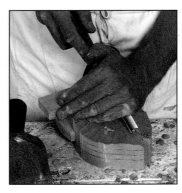

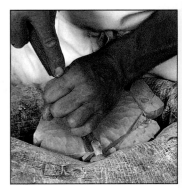

8 Lay the fish down onto the bench and clamp it securely in position. Make a series of diagonal saw cuts at right angles to the existing ones, so that the waste areas of wood fall away to reveal the tail and fins.

9 Making sure not to carve too much wood away, use a mallet and gouge to carve from the centre point on each side of the fish down to the centre line. Keep the carving consistent to establish an even curvature from the centre down to the edges. Start by carving away the edges down towards the centre line and work slowly back to the centre.

10 As the carving progresses, discard the wooden mallet and hold and push the gouge with your hands. Make sure that you keep both hands behind the cutting edge.

11 With one side of the fish carved it now becomes difficult to clamp it safely to the bench. A sand-filled inner tube will hold it in place, while you use a wooden mallet and gouge to carve the curvature on this side.

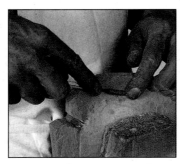

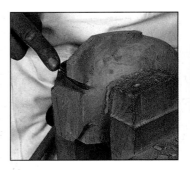

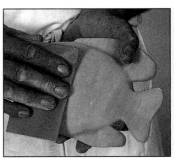

15 Carefully carve away the waste material with a hand-held gouge to establish the curves in the fin.

16 Define and smoothe out the surfaces of the fin with a riffler.

17 Use the riffler to shape and smooth the area between the fin and the tail. Mark out a curve on the tail and the other fin and shape each with a hand-held gouge and the riffler.

18 Use the riffler over all the fish to eliminate all the gouge marks and undulations in the surface. Sand the surface, starting with a rough grade of sandpaper and moving through the grades to a fine one until you have a smooth surface over the whole fish.

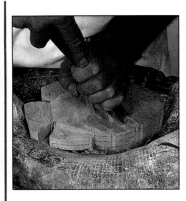

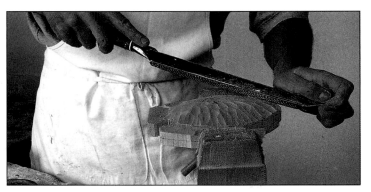

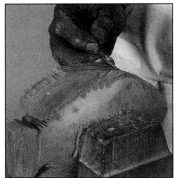

12 The inner tube is very useful for holding the sculpture when you need to carve the wood down to the base of the fins.

13 Place the fish in a vice and smooth out each of the carved sides with a surform. Keep a consistent curvature from the centre of each side down to the centre line all the way around the fish.

14 With the shape of each side now roughly defined, place the fish in the vice and mark out a wavy configuration on the top of the fin.

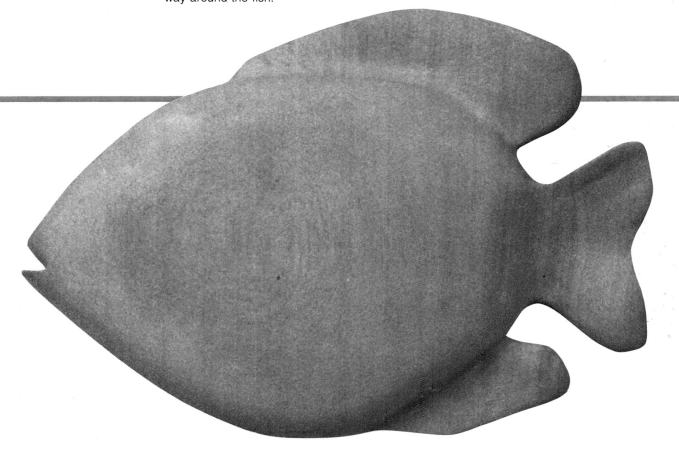

CASTING

With casting you can make copies of a sculpture. Usually, the sculpture will have been made using the modelling technique, although it is also possible to make casts of constructed sculpture. Casting produces sculpture in a variety of permanent and durable materials and MOULDMAKING is the necessary preparation for it. Making a cast cannot be hurried – it is time consuming and labour intensive but well worth it in the end.

Traditionally, modelled sculpture was cast in bronze, a technique not dealt with in this book. However, casting in resin mixed with powdered bronze produces what is known as a cold cast bronze. It has exactly the same surface as a bronze sculpture but is a lot lighter than a traditional bronze cast. You should always identify the sculpture as a resin cast, because it is difficult to distinguish it from a traditional bronze cast.

Resin is a very adaptable material. If you add powdered substances, known as fillers, to it, you can reproduce the qualities of materials such as stone and slate. A number of metal fillers are also available – iron, copper, brass,

aluminium and bronze. A variety of pigments can be used with resin to produce coloured and opaque surfaces.

Another casting material is *ciment fondu*, used here for a portrait head. Once set, it is extremely hard and durable. When used for a hollow cast it is very light in weight. *Ciment fondu* is excellent at picking up fine detailing from the mould and so reproducing a very good cast of the original.

Ciment fondu

This is a hollow cast, made with a process known as lamination, in which the *ciment fondu* is built up in layers to a thickness of approximately 0.6cm (¼in). The *ciment fondu* is reinforced on the final layer with fibreglass matting.

YOU WILL NEED

soft soap • paintbrushes • scrubbing brush • lubricating oil • steel rod • scrim • plaster • ciment fondu • rubber gloves • sponge • bucket • soft sand • jar or mug • rag • fibreglass matting • steel tool • modelling tool • riffler • chisel • wooden mallet • hammer • sand-filled inner tube/cushion • wire brush • scissors • palette knife

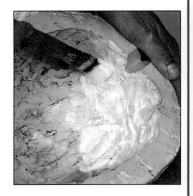

1 To prevent the cast from having a "bloom" on its surface (a white deposit from the plaster) soak the mould in water and paint on soft soap, scrubbing it around to work up a lather. Let it dry, then repeat. Next, work a small amount of lubricating oil into a dry brush and coat the inside of the mould. When applying the soft soap and the oil, do not let puddles form, as this will impair the quality of the cast.

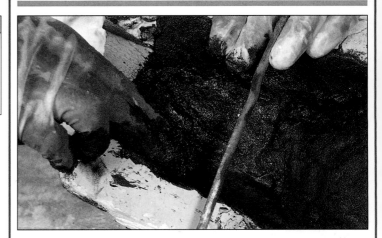

6 Apply the mixture across the whole surface of the mould, to a thickness of 3mm (⅛in). Make sure that the sand and *ciment* mixture is flush with the seam. On vertical surfaces, there can be a tendency for the mixture to drop down and, if this is likely, leave these areas until after the initial application has cured (set).

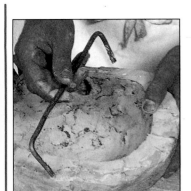

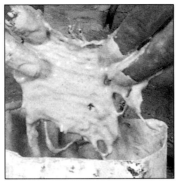

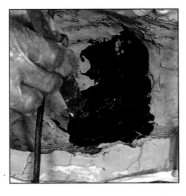

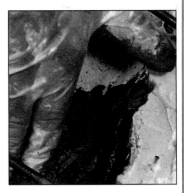

2 The mould needs to be kept wet while casting in *ciment fondu* as dry plaster will draw moisture from the *ciment fondu* and affect the setting time and its final strength. To prevent the wet mould warping and distorting under its own weight fix some steel bracing across the top of the mould, using lengths of steel rod.

3 Push these "irons" tightly into position, making sure that they rise above the surface of the mould seam. Use scrim and plaster to fix them to the exterior of the mould. Once the plaster has set, the irons will hold the mould firmly in position.

4 Working on one half of the mould at a time, mix some *ciment fondu* with water to the consistency of single cream. Paint this slurry onto the mould interior without it getting onto the seams of the mould. If any does, wipe it off immediately with a sponge.

5 Wearing gloves, mix together 3 parts sand to 1 part *ciment* in a bucket. Use an old mug or jar as a measure. Mix together well, then add water until the mixture has the consistency of soft cheese. Take a small amount of the mixture and place it gently onto the slurry tamping (compacting) it down with a patting motion. The slurry will be pushed out in front of the sand and *ciment* mixture.

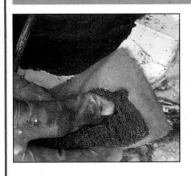

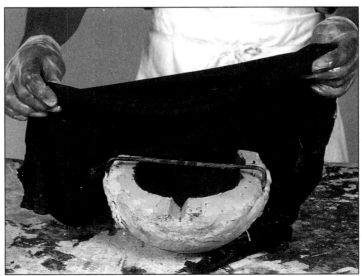

7 With the interior of the mould now fully compacted with sand and *ciment*, clean the mould seams thoroughly so that the two halves of the mould will fit together satisfactorily.

8 Leave the mould to stand overnight, supporting it if necessary, and covering it with a damp rag. Repeat the whole process with the other half of the mould.

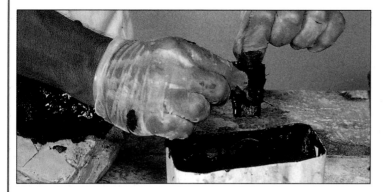

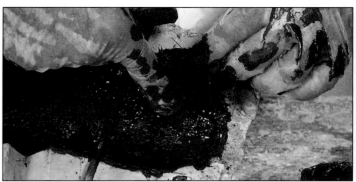

9 The next day, the first layer will have cured. Thoroughly soak both halves of the mould for about 30 minutes, removing any excess water with a sponge. Cut enough fibreglass matting into strips 2.5 × 5cm (1 × 2in) to cover the interior surface of the mould twice. Mix up some *ciment fondu* slurry and paint this on the inside of the mould. Take a piece of the fibreglass matting and dip it into the slurry. It should be fully impregnated but any excess should be wiped off.

10 Lay the fibreglass onto the mould surface, going up to but not above the seam of the mouth. You need to keep the top edge of the cast level with the mould seam.

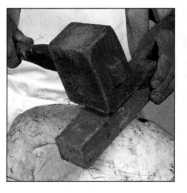

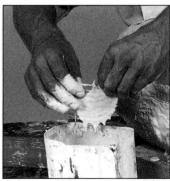

14 Once the two halves fit together satisfactorily, apply a bead of slurry along the seam of the cast using a modelling tool or palette knife.

15 Apply the slurry to both halves of the mould so it stands just proud of the seam. Keep the slurry contained to the seam of the cast and do not let it get onto the seam of the mould.

16 Join the two halves together, locking them into the correct position. With the bottom half of the mould supported either side, gently tap the top half down so that the two halves are well and truly squeezed together.

17 To keep the two halves in position, join them together along the seam using scrim and plaster.

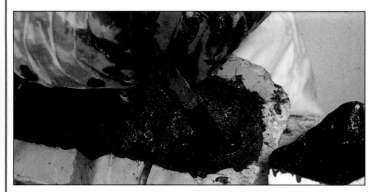
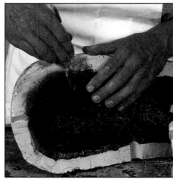
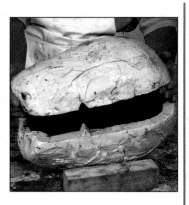

11 Overlay the pieces of fibreglass matting to cover the surface of the mould. Use a brush and a stippling action to push the fibreglass down into the slurry. Mix up a sand and *ciment* mixture and tamp it down on to the surface as before, making sure that the cast seam remains level with the mould seam. This mixture need not be so wet, because as you tamp it down onto the surface, it will draw out moisture from the slurry and fibreglass matting. Clean the mould seams, cover with a damp cloth and leave to stand overnight. Repeat the process with the other half of the mould.

12 On the third day, remove the irons from both halves of the mould and run your finger carefully along the seam edge to see whether there are any areas of the cast seam that rise above the level of the mould seam. Use a riffler to level these areas down.

13 The two halves of the mould should fit together snugly. If, when looking through the neck opening you can see daylight, or you are able to rock the top half of the mould on the bottom half, you will know that there is still an area of the cast seam that rises above the level of the mould seam. Use the riffler to level this off.

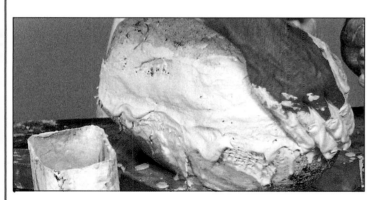

18 Make sure that the scrim is soaked with plaster and leave it to set overnight. Alternatively, the seam of the cast can be traversed with slurry-impregnated fibreglass matting and backed up with a sand and *ciment* mixture, again left overnight to cure. This method is used for moulds or parts of moulds, where you are able to reach inside them to the seam.

19 On the final day, soak the mould thoroughly for about 30 minutes. Then chip off the plaster putting the mould onto an inner tube filled with sand for support. Start by knocking off plaster from around the neck area until you reach the layer of blue plaster. Once you reach this you know that you are right next to the surface of the cast.

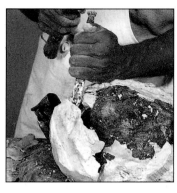

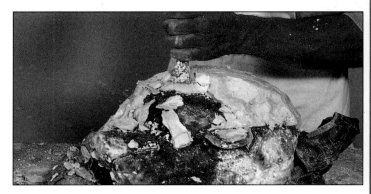

20 When you chip off this blue layer of plaster, tap the chisel very gently, or you may accidentally damage the surface of the cast.

21 With an area of the cast revealed, you will have some idea of where the cast lies within the mould and so you will be able to chip the plaster off accordingly. Because of *ciment fondu*'s aversion to plaster, large chunks of the mould will be displaced at a time.

22 With the mould of the back chipped off, turn the head over and chip the plaster from the side up to the highest point of the cast, the tip of the nose. Chip away around this area, with great caution.

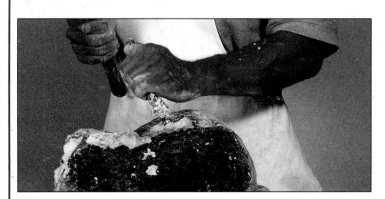

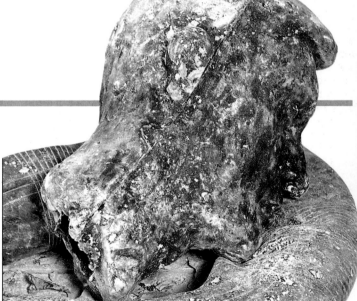

23 As chunks of the mould come away from the cast, you will find that plaster is lodged behind and in the ears, so gently chip at these areas.

24 There will still be areas of the sculpture impregnated with plaster, especially the rough texture of the hair. There will also be a slight bloom on the surface. Place the head under running water and give it a good clean with a scrubbing brush. For stubborn areas, use a wire brush.

Life figure

The temperature of your work area will affect the length of time it takes for the resin to cure or set. Immediately before setting, it starts to gel (takes on the consistency of jelly) and it is essential that you finish working with it before it reaches this state. A higher than average room temperature will make the resin set quickly and, conversely, it will set more slowly in a low temperature. Try to avoid working in a draught or a damp atmosphere.

When making a cast with resin, the mould needs to be absolutely dry as water prevents the resin from curing properly. A liquid hardener or catalyst is added to enable it to cure, and accurate measurements of both resin and hardener are essential for the success of the mix. When the hardener and resin are mixed together, there is an exothermic chemical reaction and heat is generated. If too much hardener is added, the exothermic reaction increases, and the resin becomes dangerous, so the manufacturer's instructions should always be followed carefully.

The resin cast is built up in layers using a combination of resin and fibreglass matting, a technique known as laminating. The first layer of the cast is called the gel coat. In this cast, finely powdered bronze is added to the gel coat to produce a bronze finish.

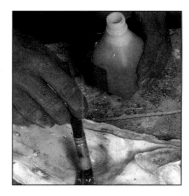

1 Generously paint the surfaces of the whole mould with a release agent, without letting it collect in pools. Leave it to dry.

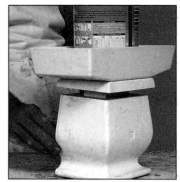

2 Meanwhile, prepare the gel coat which is a mix of resin and bronze filler. Place a mixing tin on the scales and put the indicator arrow to 0.

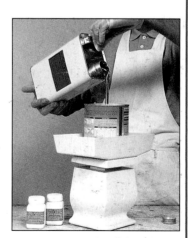

3 Weigh out enough resin for all three pieces of the mould – in this case 225g (8oz).

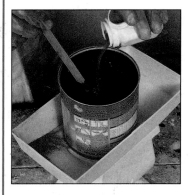

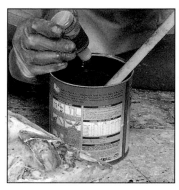

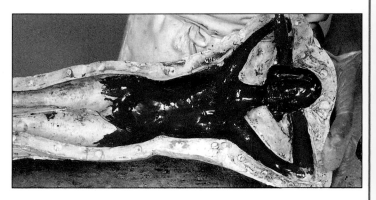

4 The bronze filler is now added and mixed with the resin, in the proportion of 7 parts of bronze filler to 1 part of resin (or as recommended by the manufacturer). Stir thoroughly. The bronze content of this gel coat, the weight of which is now 1,575g (56oz), will now be consistent for each part of the mould.

5 Work on one piece of the mould at a time. Weigh out half the amount of gel coat 787g (28oz) and add 50 drops of hardener. Stir thoroughly.

6 Paint the gel coat onto the interior surface of the mould as quickly as you can. If any resin gets onto the seam clean it off immediately before it has a chance to cure.

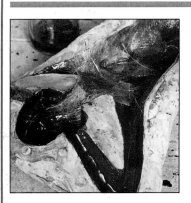

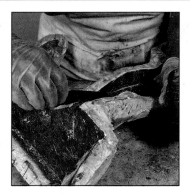

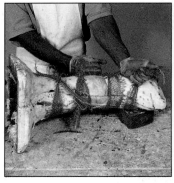

9 Lay down and overlap strips of fibreglass matting in the resin as soon as you have painted it in, allowing the matting to soak up the resin.

10 Apply more resin onto the matting with a stippling action (hard vertical strokes) to ensure that the resin is pushed well into the fibreglass matting and then repeat the process. Two layers of matting are enough for a sculpture of this size and you can add the second before the first layer has cured.

11 The cast can now be joined together. Apply a thick bead of a resin and bronze mix with a palette knife along the seam of the cast in the main part of the mould. Do not get any of this mix on the seam of the mould.

12 Add the other two sections to the main mould, adding a bead of resin and bronze mix along the adjoining seam. When all three parts of the mould are positioned correctly, tie them in place with scrim or string and leave for at least 24 hours to allow the resin to cure.

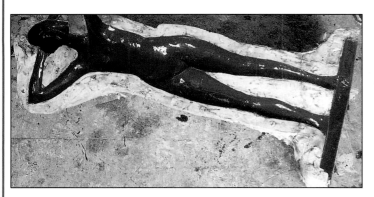

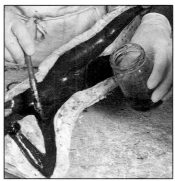

7 Apply a thicker layer of gel coat to the face and breasts, to ensure that all of the detail in these areas is captured. Finish applying the gel coat before the resin starts to gel. Leave it to cure and repeat with the other parts of the mould.

8 Cut some fibreglass matting into strips 4 × 2.5cm (1½ × 1in) – enough to cover the surfaces of each mould piece twice over. Weigh out 100g (4oz) resin and add hardener. Don't weigh out more or it may start to gel before you have had a chance to use it all and you can always mix some more up, if necessary. Coat an area of the mould with the resin, avoiding the seam.

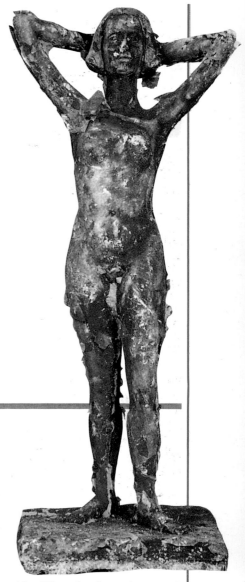

13 Soak the mould in water overnight to dissolve the release agent. You can now start to chip away the plaster from the cast with a chisel.

14 Chip off the plaster until you reach the blue layer, taking care not to damage the surface of the cast. Extreme care needs to be taken when you are removing the plaster from the features of the face.

15 Use a pointed tool to remove plaster from awkward cavities or areas that are too small to use a chisel.

16 When the figure is released from the mould repairs may be needed to parts of the seam where the join was inadequate. This is an essential part of the finishing process and any discrepancies are easily made good (see REPAIRS section).

Using a rubber mould

Rubber moulds are very useful as they not only are excellent at picking up detail, they can be used over and over again.

YOU WILL NEED

rubber mould • brushes • shellac • rubber ties • dowelling • bucket • plaster • filling knife • mallet • chisel • saw • modelling knife • sandpaper

1 Clean the rubber mould with a brush, paying particular attention to areas of detail.

2 Apply three coats of shellac to the opening at the end of each plaster case, which is the pour hole for the plaster.

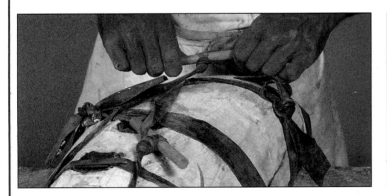

5 You will need to tighten the rubber ties further to prevent the mould from splitting open when plaster is poured into it. Insert short lengths of dowelling under each of the ties and twist them round as many times as possible. Finally hold the dowel in place by tucking it under the tie to produce a tourniquet.

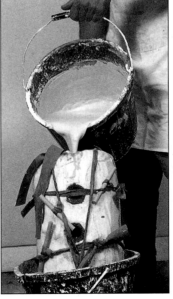

6 Support the mould, with the pour hole uppermost, in a bucket. Pour plaster slowly into the mould as soon as it has been mixed. The plaster will start to go off if you leave it, and will not pour smoothly and consistently. Let the plaster settle and gently tap the sides of the mould to ensure that it is evenly distributed and to force any air bubbles to the surface. Top up with plaster if necessary. Leave the mould undisturbed while the plaster goes off.

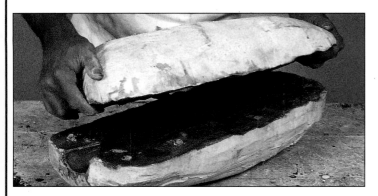

3 Put the two parts of the mould together, making sure they fit snugly.

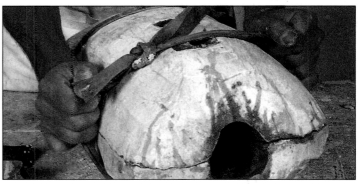

4 Hold the two halves firmly in place with rubber ties (strips of rubber cut from car inner tubes). Put these on as tightly as possible.

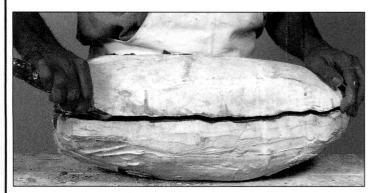

7 Place the mould on the work surface and remove the rubber ties. Gently separate the two parts of the mould by placing a filling knife blade into the seam in two or three places.

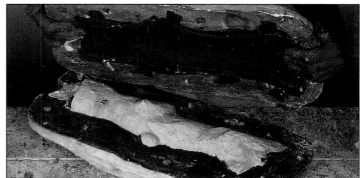

8 Lift off the top of the mould to reveal the cast. You will notice a small amount of plaster left in the pour hole.

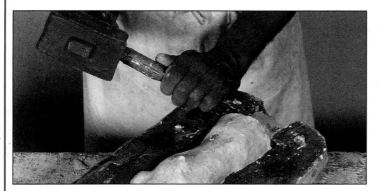

9 Chip away the plaster from the surface of the pour hole.

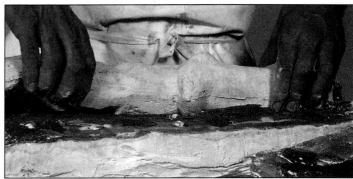

10 The cast of the sculpture can now be removed easily from the bottom of the mould. Lift it out gently and do not put undue pressure on delicate parts of the cast.

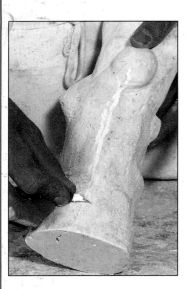

12 There will be a small amount of raised plaster from the mould seam. Using the blade of a modelling knife, cut this back, level to the surface of the sculpture.

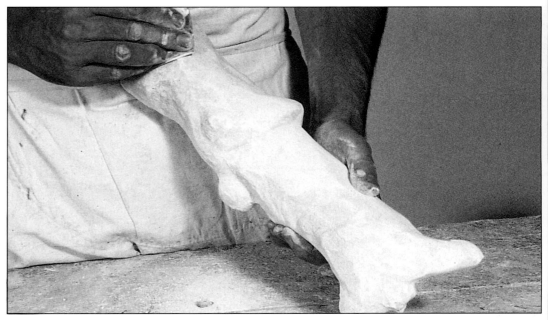

13 Smooth the seam down with sandpaper to produce a consistent surface.

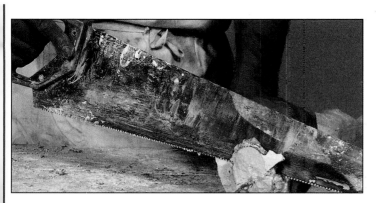

11 Saw off the remains of the pour hole from the base of the sculpture, levelling the surface so the sculpture will stand.

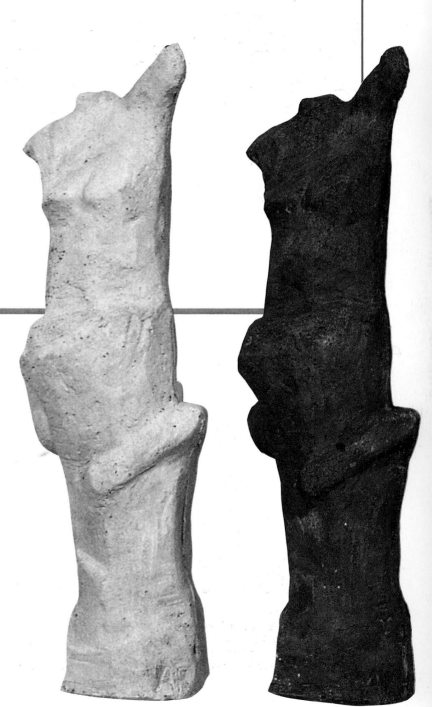

14 Rubber moulds pick up all the details from the originals and produce excellent casts. You can repeat the technique and make as many casts as you want.

COLOURING

Colour can affect a sculpture in many ways. It can be an important compositional element; it can be purely functional; it can be an integral part of the technique; it can create the illusion that the sculpture is made from a different material, or it can be used to cover up mistakes and repairs.

The wooden figurative construction and the welded steel sculpture use colour to unite their separate parts. The dark colour of the spatial construction gives the impression that it is heavier than it is. Colour accentuates different parts of the constructed mobile sculpture. The sealing of the plaster bird is purely functional, in that it helps to keep it clean and to enhance the integrity of the material – similar to the use of beeswax on the wooden carving. The plaster relief has a colour disguise, giving the impression of patinated metal. The plaster cast, on the other hand, has been unashamedly painted to produce a powerful sculptural statement. Various colours have been added to the carved plaster sculpture to enhance the dynamics of its forms. The resin surface of the life figure sculpture is broken

to reveal the bronze – a necessary procedure in this type of casting technique. The stylized torso uses colour as another element in the overall composition. The *ciment fondu* of the portrait head has been darkened to cover up repairs, as well as give a more consistent surface.

All these examples prove that there are really no hard and fast rules. The important thing to remember is that colour is a way to complement the form of the sculpture – it never takes precedence over it. Whatever your choice, it is always a good idea to experiment with colour first on a piece of spare material.

Wooden construction

YOU WILL NEED

wood stain • rag

1 Rub the stain well into the wood with a rag, paying particular attention to all the corners. The wood will soak up the first coat quickly, so add another as soon as it is dry. The more coats you apply, the darker the colour will become.

Direct modelling

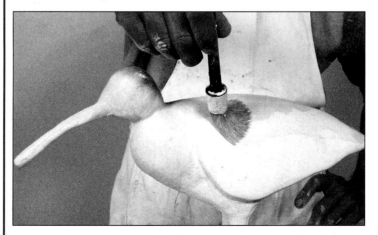

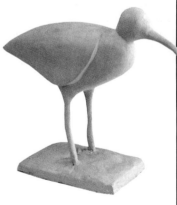

YOU WILL NEED

PVA glue (diluted 50:50 with water) • paintbrush

1 Seal the surface of the plaster by painting on diluted PVA glue. Apply a second coat when the first is dry. Clean your brush with water.

2 By not colouring this sculpture, attention is focused on its figurative form and the material and process by which it was made.

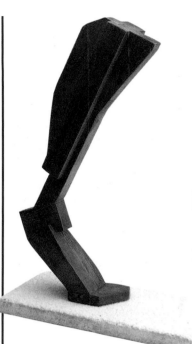

Spatial construction

Always work in a well-ventilated area, preferably outside, when using an aerosol spray can, and wear rubber gloves. Not all of the spray will hit the sculpture – it might land on the surrounding area – so protect nearby surfaces with newspaper.

YOU WILL NEED

aerosol spray paint • rubber gloves • newspaper

1 Hold the sculpture away from you and spray, turning continually to ensure an even covering of paint.

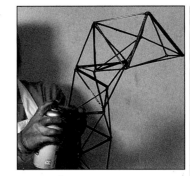

2 The grey paint, combined with the sculpture's form, suggests a heavy industrial structure which belies the size and lightweight material of the sculpture.

Plaster cast

YOU WILL NEED

paintbrush • shellac • silver enamel paint • white spirit

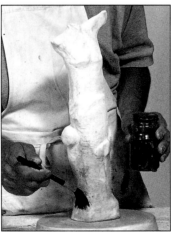

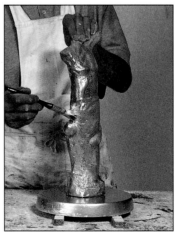

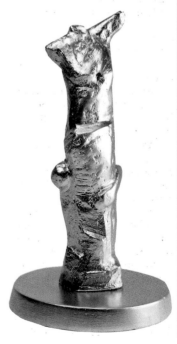

1 Paint on three coats of shellac to seal the surface, allowing each coat to dry before applying the next.

2 Paint the silver enamel paint evenly over the whole sculpture, taking care not to drip or splash. When dry, apply another coat. Clean your brush with white spirit.

Plaster carving

YOU WILL NEED

PVA glue (diluted 50:50 with water) •
paintbrush • a selection of oil colours
– e.g. burnt sienna, raw sienna, green,
cadmium red • rags • white spirit

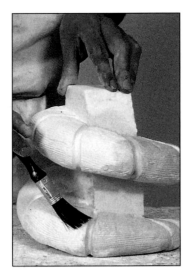

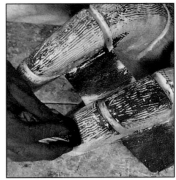

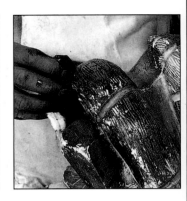

1 Seal the surface of the
sculpture with diluted PVA
glue. This makes the colour
stay on the surface so it is not
absorbed by the plaster.

2 Apply a colour direct from
the tube with a rag onto the
sculpture. Rub it well in to any
crevices.

3 Wipe off excess colour with
a rag and white spirit. Repeat,
adding a different colour each
time, until you have an
interesting combination.

Riveted sculpture

Use aerosol spray cans in a
well-ventilated area and, if
necessary, protect adjacent
work surfaces.

YOU WILL NEED

masking tape • newspapers • aerosol
spray paints

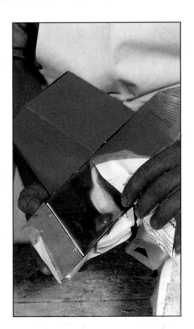

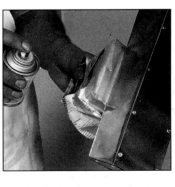

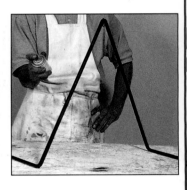

1 Spray the top half of the
sculpture with yellow paint,
masking off the bottom half
with newspaper and masking
tape. When the yellow paint
has dried, remove the
newspaper and tape.

2 Mask the upper (yellow)
part of the sculpture, placing
masking tape precisely at the
meeting point of the two parts
of the sculpture. Hold the
sculpture at arm's length and
apply an even coat of red.

3 Spray the steel stand and
hanging wire with black paint.

4 The mixed colour enlivens what was previously a bland material, enhances the forms and focuses attention on the contrast between the textured and smooth surfaces.

Plaster relief

shellac • paintbrush • methylated spirit • gold enamel paint • white spirit • matt black board paint • rags

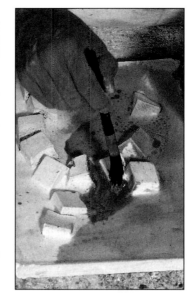

1 Seal the surface of the relief with a coat of shellac. When this is dry, apply another two coats. Clean your brush with methylated spirit.

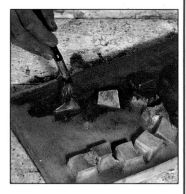

2 Apply a coat of gold enamel paint and leave to dry. Repeat, avoiding drips or pools of paint. Clean your brush with white spirit.

4 Aerosol sprays provide a very smooth flat area of colour, which blends in extremely well with the construction and joining techniques used in this sculpture.

3 When the gold paint is dry, completely coat the relief with matt black paint, ensuring that you reach all the crevices. Clean your brush with white spirit.

4 Before the black paint has a chance to dry fully, start to rub it off, so that the gold starts to show through. The raised parts of the relief need to have the black paint rubbed off completely to reveal a shiny gold highlight. The crevices and undercuts should remain darker than the edges of the cubes.

5 This technique is an economical way to simulate the effect of patinated bronze, and is especially effective, as in this case, on plaster or fired clay sculpture.

Carved fish

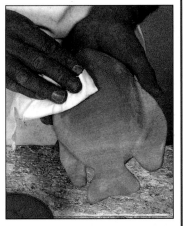

1 Rub beeswax well into the surface of the sculpture with a rag. Apply one or more coats of wax, depending on the porosity of the wood. Repeat with the wooden base.

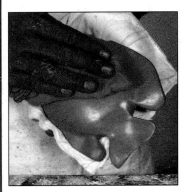

2 When the wood has absorbed the wax, polish the sculpture and base with a soft cloth to produce an even shine.

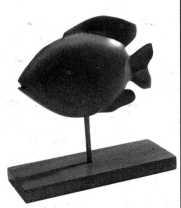

3 The close grained nature of the wood and the highly polished surface emphasize the forms of the sculpture.

Stylized torso

For steps 1–4, clean your brush with methylated spirit and use water to clean the brush used in step 5.

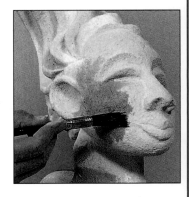

1 Cover the whole surface of the sculpture with three coats of shellac, leaving each coat to dry before adding another.

Papier mâché

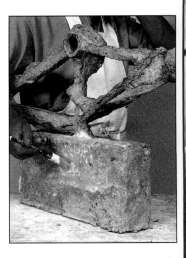

1 Seal the surface of the sculpture with diluted PVA glue.

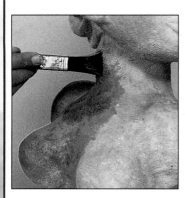

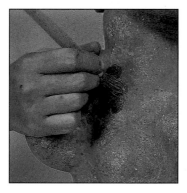

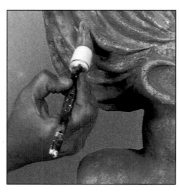

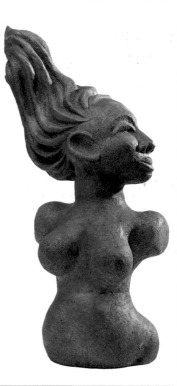

2 Mix the blue pigment with methylated spirits, to produce an opaque mix of an even consistency. Paint onto the sculpture and leave to dry.

3 Apply gold pigment (mixed with methylated spirit) to the surface with a stippling action – hold your brush at right angles to the surface and gently dab the surface. Cover the whole surface of the sculpture using this stippling action.

4 Paint the sculpture with diluted PVA glue to fix the gold and blue pigments in place.

5 Although colour is an important compositional element, it has been used very subtly. The result is a dramatic effect that does not detract from the forms.

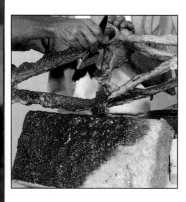

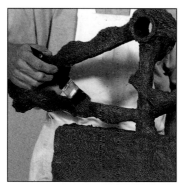

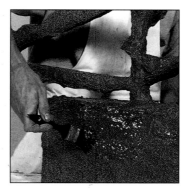

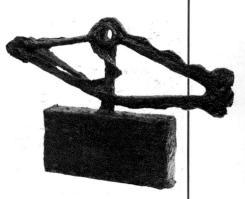

2 Paint on one coat of red oxide paint and leave to dry. Clean the brush with white spirit.

3 Load the brush with yellow acrylic paint. On a piece of paper, brush the paint out until the brush is nearly dry, then slowly drag the brush over the surface of the whole sculpture. The uneven surface means that yellow paint will be deposited on its higher points. Clean the brush with water.

4 When the yellow paint has dried, apply one coat of polyurethane gloss varnish over the whole sculpture with a brush. Leave to dry and clean your brush with white spirit.

5 The final coat of polyurethane varnish has added more definition to the textured surface and really brought the sculpture alive.

Portrait head

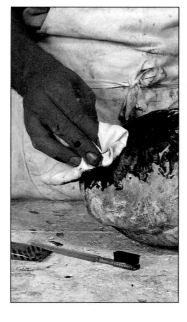

1 Rub the grate polish well into the surface of the head with a rag.

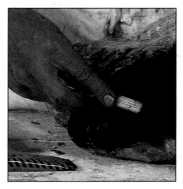

2 Use the polish on a toothbrush for any tricky areas and crevices on the head.

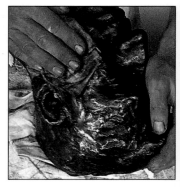

3 Once the polish is dry, buff up the surface of the sculpture to produce a dull shine.

Welded steel

Before you start work, make sure you are adequately protected – wear clear goggles, a respirator mask, long-sleeved overalls and rubber gloves. Protect your work area with a polythene sheet. When applying chemicals to steel, have a lightly loaded brush and use gentle strokes to avoid splashing. Clean the brushes with water immediately after use and dispose of the plastic sheet, having first rinsed it thoroughly under a running tap. Chemicals should be stored in containers which are specifically for their use and correctly labelled. Clean the brush used for the lacquer with the manufacturer's recommended solvent.

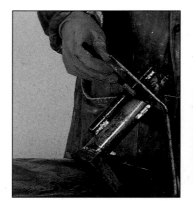

1 Carefully brush on the diluted hydrochloric acid to clean all the muck and grime off the steel. Rinse the acid off with water.

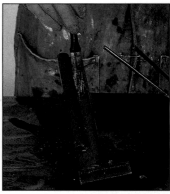

2 Paint on the ferric nitrate and leave the sculpture to rust – the longer you leave it, the rustier it will get. If necessary – if the ferric nitrate evaporates or the first coat did not get into all parts of the sculpture – apply more ferric nitrate.

4 Apply beeswax to the wooden base, working it well into the grain of the wood, especially the end grain. When the wax has been absorbed, buff the whole surface with a soft cloth (see pages 38–9 for finished head.).

Resin cast

1 Gently rub the surface of the sculpture with a wire brush to break through the resin and reveal the bronze.

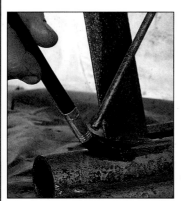

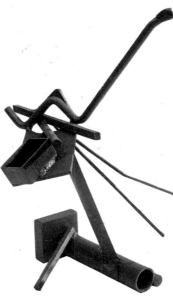

3 Once the sculpture has reached a suitable rusty state, brush on a coat of clear lacquer to seal the surface.

4 By speeding up and controlling the rusting of the mild steel, you are able to produce a consistent surface.

2 Rub over the whole sculpture with wire wool to buff up the bronze. Finally, apply some metal polish to the whole of the sculpture and polish with a soft cloth.

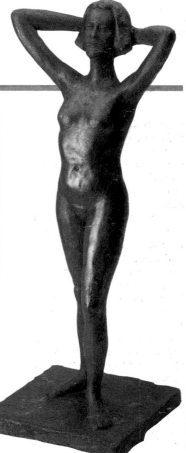

CONSTRUCTION

A constructed sculpture is one whose parts have been joined together using everyday fixing methods – such as glueing, screwing, dowelling, welding, riveting. What sets this type of sculpture apart from the everyday objects that surround us and which are made in a similar way is that the sculpture is non-functional or, more precisely, its function is purely visual. It is to be looked at.

As a generalization, it can be said that this now established form of sculpture has a particular feel or look to it – most notably that it is geometric and would tend towards an abstract sculptural format. The making of sculpture is not the primary function of the techniques and tools used in constructed sculpture.

The two sculptures made in this section use different construction techniques. The first is a spatial construction with an architectural form and a mass-production method of construction. The sculpture uses a repeated unit of the same size and form. The component parts are fixed together with a glue gun – an extremely useful tool for joining lightweight materials.

The other sculpture is the calf and foot of a leg. Whereas in the first example, the form is determined by the process of fabrication, in this sculpture the form is derived from drawings from life. Knowing that a constructed sculpture was to be made using standard sizes of wood, the drawing was modified to take this into account. This sculpture is made using a wood-dowelling and glue-joining technique.

Figurative sculpture
Although this is a constructed sculpture, it is taken from a life drawing. The drawing was modified to take into account the standard sized wood.

YOU WILL NEED

prepared softwood: 75 × 50mm (3 × 2in), 50 × 50mm (2 × 2in), 50 × 25mm (2 × 1in), 100 × 25mm (4 × 1in) • pencil • ruler • G-clamp • tenon saw • set square • vice • plane • sandpaper • masking tape • wood glue • 9.5mm (⅜in) dowelling • electric drill • wooden mallet • wood filler • wood stain • filling knife

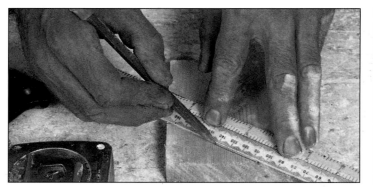

1 A piece of wood 100 × 75 × 25mm (4 × 3 × 2in) forms the toe section. With a pencil and ruler, draw lines to indicate the profile of the front of the foot.

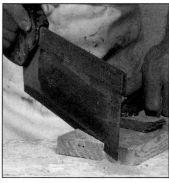

2 Clamp the wood securely to the bench and saw down the lines with a tenon saw.

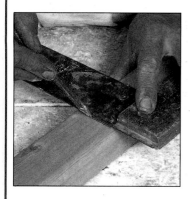

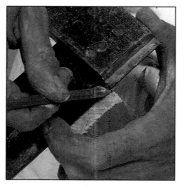

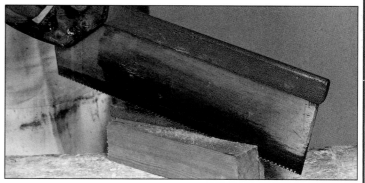

3 Cut a wedge shape from a piece of 50 × 50mm (2 × 2in) wood for part of the length of the foot. Measure 18cm (7in), then draw a line with a set square.

4 Mark a diagonal line on the face of the wood from a point 1.5cm (½in) in from opposite sides. Then, on opposite ends of the block, draw a line at right angles to the diagonal line on the face of the timber.

5 Clamp this block of wood to your workbench and use a tenon saw to make the cut.

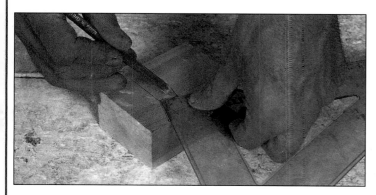

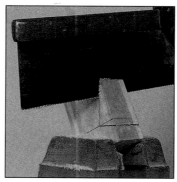

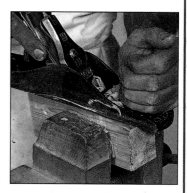

6 The heel section, a block of wood 75 × 50 × 100mm (3 × 2 × 4in), needs to have a wedge section cut out from it. Mark a line at right angles to the longest sides and 4cm (1½in) in from one end 'A'. On this line mark a point 'B' 2.5cm (1in) down. Then mark another point 'C' 2cm (¾in) in from 'A'.

Taking a set square, place the point of the right angle on 'B' and the short length of the set square on 'C'. Draw a line along both of the edges of the set square where they are in contact with the block of wood. Repeat on the other side of the block.

7 Place the block in a vice so that one of the drawn lines is vertical. Saw down to the apex. Reposition the block in the vice and again saw down to the apex so the wedge of wood is released from the block and falls away.

8 After each cut you may find the surface rough and not quite square. Place the block in a vice with the cut surface uppermost and level off with a wood plane.

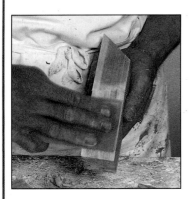

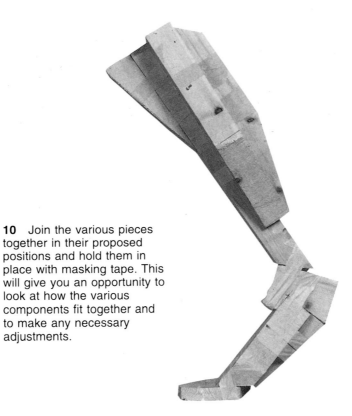

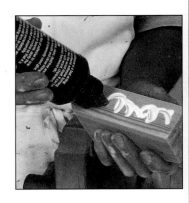

9 Sand down so that all the surfaces are consistently smooth.

10 Join the various pieces together in their proposed positions and hold them in place with masking tape. This will give you an opportunity to look at how the various components fit together and to make any necessary adjustments.

11 Join the parts together using wood glue and dowel. On one of the surfaces to be joined spread a thin layer of wood glue, applying it evenly and consistently.

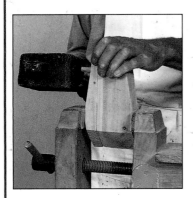

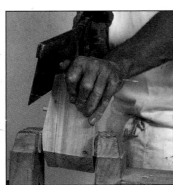

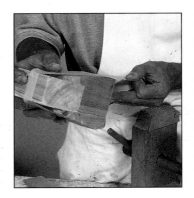

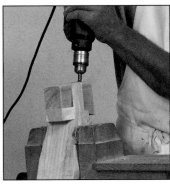

14 Gently tap a length of dowelling into each hole. The length of each should be slightly longer than the depth of the hole.

15 Cut off the protruding ends of the dowelling with a tenon saw.

16 Masking tape is one way to hold awkward shapes together securely. Apply the glue first and then bind the parts together with the masking tape.

17 With the heel section taped to the foot (which is held in the vice) drill the holes and insert the dowelling to join the two sections.

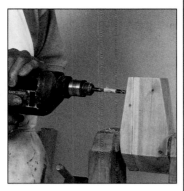

12 Position the two pieces together, and apply as much pressure as you are able with your hands. Then secure the two pieces in a vice.

13 Drill two holes the diameter of the dowelling in both of the pieces to be joined. Put some masking tape around the drill bit to indicate the depth of the hole to be drilled.

Spatial construction

This spatial construction with an architectural form can use as many of the triangular units as you choose. Use the jig to hold them in place while they are joined to make a sculpture that gets longer with each addition.

YOU WILL NEED

masking tape • piece of board • pencil • tape measure • split canes • tin snips • scissors • set square • Blutack • glue gun • modelling knife

SAFETY

When using the glue gun, take great care not to spill any of the hot glue on yourself.

1 Place a strip of masking tape on the board. Draw a line 60cm (24in) long, along the tape and mark each end. Divide the line into 20cm (8in) thirds. Now place each cane against the line and use it as a marker to divide the cane into three equal parts.

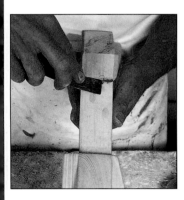

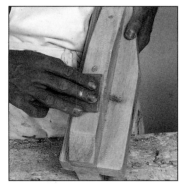

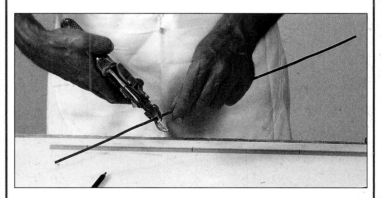

18 Fill any gaps with wood filler, first adding some wood stain to it. When you stain the whole sculpture, the filled areas will have more chance of blending in.

19 Once the filler has set, sand down the whole sculpture to a smooth and consistent finish.

2 Cut each cane into thirds with tin snips. These three canes are used to produce one triangular unit of the sculpture.

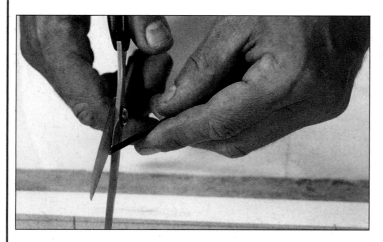

3 Using scissors cut a diagonal of approximately 30° as near to the end of each cane as possible.

4 As you are making a number of like units, you will need a jig. Take the centre 20cm (8in) section of the drawn line on the masking tape and mark the half way point. This is your base line. With a set square draw a vertical line from this point at right angles to the base. Align one end of a piece of cane with the mark at one end of the base line. Align the other end of the cane with the vertical line and mark.

7 Take another piece of cane and apply glue to both ends. Insert this cane into the jig and hold it in place until the glue has set. Gently lift the triangle out of the jig, turn it over, holding it in one hand. Apply more glue to each corner of the triangle.

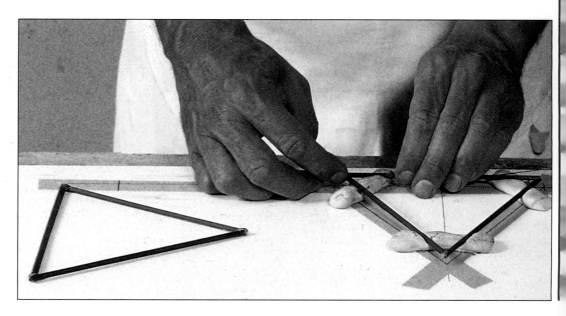

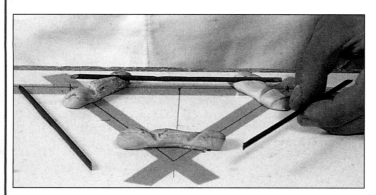

5 Stick two lengths of masking tape from the marks on the base line to the new mark on the vertical. Join up the marks with a pencil to produce a triangle. Put a lump of Blutack on each corner of the triangle. Firmly embed a piece of cane into each lump of Blutack, making sure that the canes meet to form a triangle that matches the one drawn on the masking tape. Carefully remove the canes. You will be left with an indentation in each piece of Blutack.

6 Apply glue to one end of the cane. Put the glue gun down, and quickly take another piece of cane. Place the two pieces in the jig to form the apex of the triangle. Hold the pieces in place for a few seconds until the glue sets.

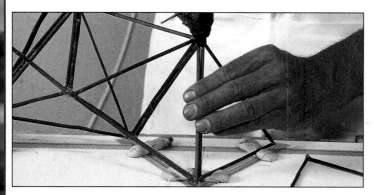

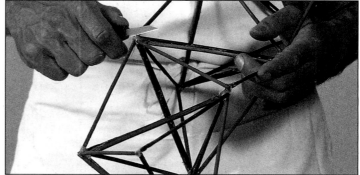

8 To join two units, put one side of each in adjacent positions in the jig so that they are vertical. Bring the tops together and glue the two lengths that touch. Glue each end of another length of cane and place it in the jig to join the bottom corners of the pyramid that is now created. Continue using the jig to add one triangle at a time.

9 Trim off any excess glue on the construction with a modelling knife.

DIRECT MODELLING

There are two important factors which set direct modelling apart from the traditional sculptural practice of MODELLING. Primarily, the material that you choose to model with is also the final material of the sculpture. Secondly, the ARMATURE to which this material is added is a permanent structure and remains within the sculpture, unlike a temporary armature.

Making the armature
The armature must be strong enough to support the modelling material and the materials used to construct it must remain stable. Wood or strong card (if used with plaster), *ciment fondu* or papier mâché, whose surfaces have not been sealed, will have a tendency to disintegrate because they will soak up the water in these materials. As with any armature, it is very important to plan out its configuration fully because once you have started to model it will not be possible to make any alterations to it.

The modelling material itself needs to be resilient and strong enough to last in its final state while being malleable and plastic enough

to model. The two materials used in this section are plaster and papier mâché. *Ciment fondu*, polyester resin and car body filler are also suitable.

The armatures in the plaster and papier mâché sculptures both have strong, rigid constructions and will not deteriorate. The shape of the armature for the plaster sculpture is based on a series of drawings of a wading bird. The major decisions regarding the final form of the sculpture have, therefore, already been made. The armature for the papier mâché sculpture is a found object, chosen for its stability inside the sculpture. However, this does not mean that the sculpture has a pre-determined final form. It can be developed further during the modelling process.

Plaster
Plaster is a very messy material to work with so bear this in mind when choosing your workplace. Plaster is best removed from tools and work surfaces by letting it dry and then scraping it off. It will lift up easily.

YOU WILL NEED

steel armature (see welding) • electric drill • base board • paintbrush • shellac • expanded polystyrene foam • wire brush • barrier cream • plaster bandage (fine mesh scrim) • plaster • plaster modelling tool • small kitchen knife • filling knife • scissors

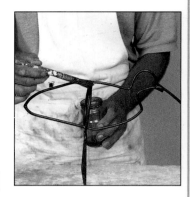

1 The steel armature comes from the WELDING section. Drill a hole into the base the same diameter as the steel rod and push in the vertical leg of the armature. Paint three coats of shellac onto the base and the armature, letting the shellac dry between coats to seal the surface. If wet plaster comes into contact with untreated steel, rust will form and bleed through to the surface of the plaster, eventually weakening and rotting the plaster.

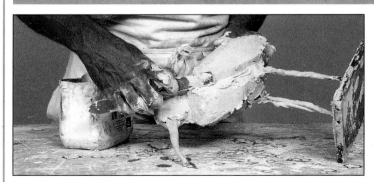

6 Next, gradually build up and develop the wings, head and body areas of the sculpture, making sure that the sculpture remains symmetrical.

It can be very easy to lose sight of this, so continually check from all angles and make adjustments where necessary.

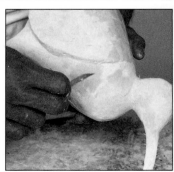

7 The body of the bird is shaped with the serrated edge of a kitchen knife.

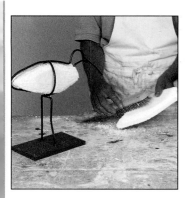
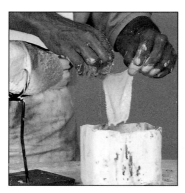
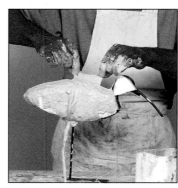
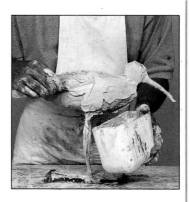

2 Pack out the armature so that it starts to resemble the sculpture you intend to make. This reduces the amount of plaster you need and makes the sculpture lighter. The best material to use is expanded polystyrene foam. This is easily shaped with a wire brush and can be jammed inside the armature. Once inside, the polystyrene can be shaped further, if necessary, with the wire brush.

3 Before using plaster, apply barrier cream to your hands. Mix the plaster (see MOULDMAKING). Using scissors cut the bandage into small strips, mixing up small quantities of plaster at a time. Each strip is then dipped into the plaster, so that it becomes fully impregnated, then pulled out taut and quickly laid flat on to the sculpture. Be careful when you pull the bandage out of the plaster as it can very easily wrinkle and screw up.

4 Cover the whole sculpture with the plaster-impregnated bandage, taking special care when you wrap it around the legs as it will tend to bunch up. Keep the bandage smoothed out, working on top of the sculpture first and then, when the plaster has set, turn it upside down and lay the plaster bandage flat on the underside of the sculpture – this way, it does not have to defy gravity! Carry on until you have covered the whole surface of the sculpture, including the base.

5 Mix up a very small quantity of plaster and wait for it to set to the consistency of cream cheese. Using a plaster modelling tool, apply this plaster to the sculpture quickly until it is completely covered. You only have a short time to work with the plaster before it becomes too stodgy. Now go back quickly over the surface you have just worked, cutting back and shaping the plaster where necessary. Once set, plaster is difficult to remove, so the golden rule is to keep the surface of the sculpture under control.

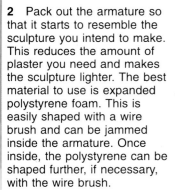
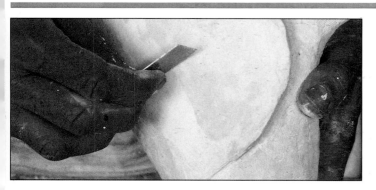
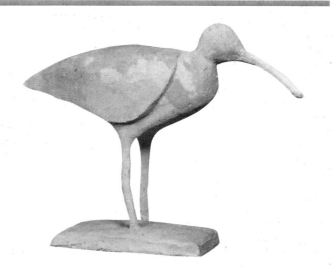

8 The wings are given a smoother finish with the flat edge of a filling knife. Any undulations or imperfections in the surface can be corrected by applying a small quantity of plaster and letting it set before scraping it back to the required shape.

Papier mâché

This abstract papier mâché sculpture uses the shape of its armature as an inspiration for developing forms on it.

YOU WILL NEED

newspapers • scissors • wallpaper paste • bucket • food mixer • found object/bicycle frame • electric drill • aerated building block • wooden mallet • dowelling • sandpaper • paintbrush • PVA glue

1 A good strong papier mâché is made by leaving small pieces of newspaper to soak in a mix of wallpaper paste in a bucket. Leave the paper until it is well soaked and starting to disintegrate. This will take at least 48 hours. Then use a food mixer to mix and break it up thoroughly to produce a pulp. It is then a very good modelling medium, with the feel of clay and used in much the same way.

2 The armature, a bicycle frame, is now mounted on its base which also becomes part of the sculpture. Drill a hole the same diameter as the saddle opening into an aerated concrete block. This has sufficient weight and stability to support the bicycle frame.

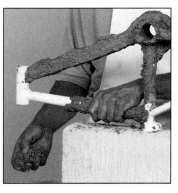

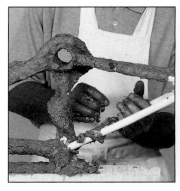

5 Lightly abrade the surface of the armature with sandpaper and coat it with diluted PVA glue. This will help the papier mâché adhere to the armature.

6 Apply a thin layer of papier mâché, compressing it firmly onto the armature. Use the configuration of the armature as inspiration to model forms while applying the papier mâché.

7 Papier mâché will not defy gravity so parts of the sculpture, especially built-up, overhanging areas, will have to be modelled in layers, leaving the papier mâché to dry out overnight. Apply a coat of diluted PVA to the dry paper mâché to help the new layer to adhere to the surface.

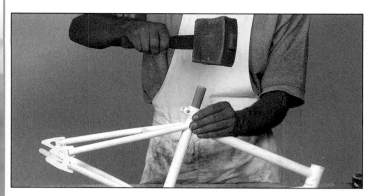

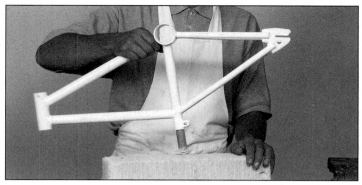

3 Hammer a piece of dowelling firmly into the saddle opening of the frame, leaving a length sticking out.

4 Place the dowelling in the hole in the aerated concrete block and push down firmly. You now have a permanent armature derived from a found object.

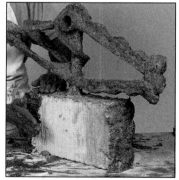

8 Seal the aerated concrete block thoroughly – otherwise it will act like a sponge and soon draw out the moisture from the paper mâché, rendering the wallpaper paste ineffective. Paint a few coats of diluted PVA glue onto the surfaces of the block, allowing time to dry between coats.

9 Apply papier mâché to the block, packing it down firmly. If any areas of the sculpture need to be made good, now is the time to do it. Leave the sculpture to dry out completely – it is very wet at this stage, and vulnerable to breakages. It will then dry to a very hard and compact finish.

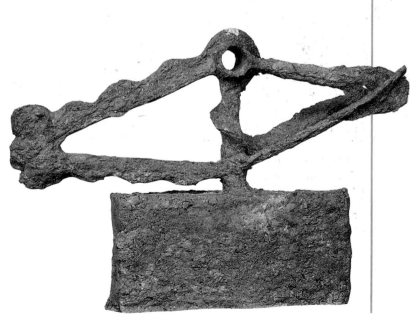

KILN FIRING

Kiln firing is a process similar to cooking something in an oven – except that the temperatures reached in a kiln are very high indeed. The sculpture is only fired when the clay has dried out completely. After firing, the clay is hard and permanent.

Kiln firing restricts you somewhat in the type of forms you are able to make. An armature cannot be left inside the clay during firing, so you need to use an armature system that is easy to remove. A system of single straight poles will support the clay during modelling and can be pulled out easily before the clay has fully dried out. The sculpture can then be hollowed out, in preparation for the sculpture being fired in the kiln.

The size of the kiln also determines the maximum size of the sculpture you can make. You can make a sculpture larger than the kiln, but you will need to model the parts separately and reassemble after firing with an epoxy resin glue.

Selecting a pole
Whatever size of sculpture you choose to make, there will be a type and size of straight pole for it – broom handles, wood dowelling of various diameters and, for small sculptures, particularly figures, wooden barbecue sticks are very suitable. Whatever the size, the principle remains the same. The poles can be vertical, diagonal or even horizontal, depending on the configuration of the sculpture, but they must always be used in such a way so that removal is easy.

Wrap poles with polythene or cling film to prevent the dry wood absorbing moisture from the clay and thus drying out and cracking the sculpture. If you are using barbecue sticks, soak them thoroughly in water before you start instead of wrapping them in polythene. They will then have the same moisture content as the clay. If you are modelling a small sculpture, such as a figure up to 30cm (12in) high that will not need to be hollowed out prior to firing, you can leave these sticks inside to burn out during the firing process. Turn them gently from time to time when modelling and while the sculpture is drying out to prevent the clay contracting around them and so fracturing as it dries out.

When using this type of armature, the best clay is one with "grog" (small particles of fired clay) already added. It has a greater structural strength than fine clay. Although kiln firing involves certain restrictions, you will still be able to make an exciting piece of sculpture.

Stylized torso
This stylized torso is worked in clay, based on a drawing taken from a photograph. It is modelled on a large ARMATURE and hollowed out before firing.

YOU WILL NEED

broom handle • prepared modelling board • cling film • tape • clay (with added grog) • water spray • polythene • modelling tools • mole grips/pliers • clay cutting wire • clay slip • bradawl

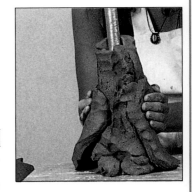

1 Pack the clay tightly around the armature pole. Following your drawing, build up the clay to develop the basic shape of the torso. The combination of the armature and the grogged clay produces a very stable foundation for the sculpture, allowing you to concentrate wholly on modelling.

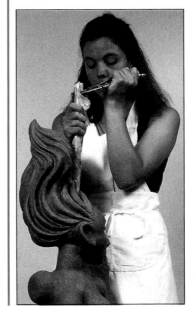

5 Get help to move the sculpture onto a lower level. Fix the mole grips tightly around the exposed part of the armature pole, then gently rotate the pole, clockwise and anti-clockwise. After a while, the pole will be turning freely in its hole. Continue to rotate it, at the same time starting to lift it up. You will find that it will lift out remarkably easily but take great care not to damage the sculpture.

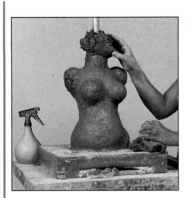

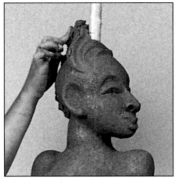

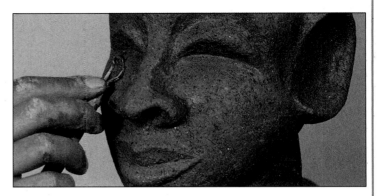

2 Work the clay upwards, developing the form of the sculpture as much as possible as you proceed. Don't let the clay dry out – keep it sprayed with water, especially in hot weather. Turn the armature pole gently from time to time. When you are not working on the sculpture, spray it all over with water and cover it tightly with polythene to retain the moisture content.

3 5cm (2in) of armature needs to be left exposed above the top of the sculpture so you can pull it out at the end. You will need to take special care when modelling the hair because it goes off at a diagonal from the vertical armature and has no internal support. The grogged clay has sufficient inherent strength to support itself in this case.

4 By now the modelling of the sculpture is complete, save for any fine tuning needed on the surface. Let the clay dry out slightly by leaving the sculpture uncovered overnight. Be careful not to let it dry out too much – it just needs to lose enough moisture to make the clay structurally sound and able to stand without the aid of the armature pole. Whilst the clay is in a leather hard state is a good time to develop a consistent surface over the whole sculpture. Use a wire modelling tool to break the surface and reveal the bits of grog which are in the clay.

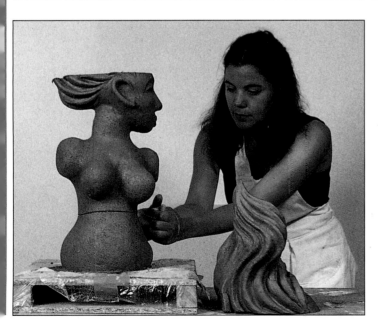

6 Now the clay has dried out slightly, the sculpture is able to stand by itself. The next task is to hollow out, which means slicing the sculpture into three sections. Using a clay cutting wire, slice horizontally through the clay. Don't pull the wire too hard and take care that the uppermost section does not topple over. Before you separate the two sections, make a couple of marks, which cross the cut line, either side of the sculpture. These are location marks to help join the sections back together. This dismembering of the sculpture may seem rather alarming after all the time and effort that has gone into the modelling – but don't worry, everything will be put back in its place.

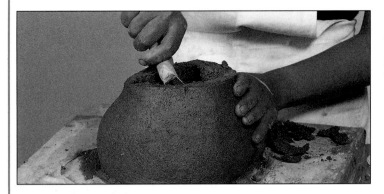

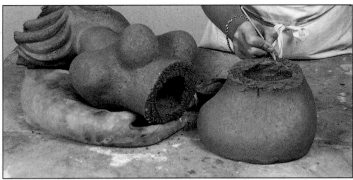

7 The inside of each section of the sculpture is now hollowed out to clay walls 12–20mm (½–¾in) thick. The thickness of each clay wall is determined by its structural function. The walls at the bottom of the sculpture will need to be thicker than the walls at the top of the sculpture. The clay walls of the neck need to be thicker still, because they have to support the weight of the head and hair, which have the thinnest walls. Make sure you take out the base area inside the bottom section of the sculpture to create an escape passage for the expanded hot air during firing.

8 Once all the sections have been hollowed out, you can join them together using a clay slip. This is clay that has had an excess of water added to obtain a consistency of double cream. Score straight lines on both of the surfaces to be joined and brush on the slip.

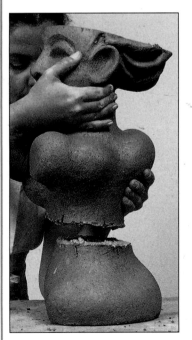

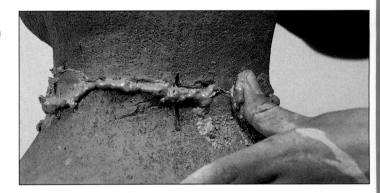

10 Line up the location marks and push the top section down into place, firmly bedding the two parts together.

11 Clean the excess slip from the join with your finger and remodel the surface so there is no evidence of the join. Join the top section to the main section in the same way, filling in the hole on the top of the head that was left by the removal of the armature pole.

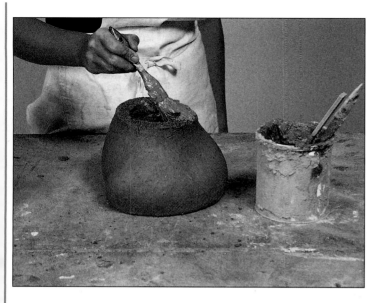

9 Work the slip well into the surface to produce an even consistency. Be careful not to make these areas too wet as this will weaken the sculpture at the join.

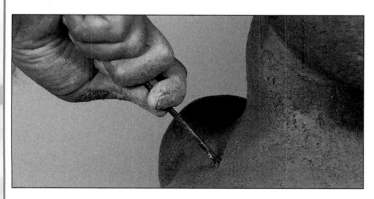

12 Using a small tool such as a bradawl, make air escape holes in the sculpture, especially around enclosed areas, such as the head, and the thicker walls of clay, such as the neck. This establishes an unobstructed flow of air through the whole of the sculpture. Push the tool through gently and slowly. Withdraw, taking care not to damage the surface. The sculpture now needs to be left to dry out. Don't be surprised if this takes three or four weeks. When it is completely dry, the sculpture can be fired. Take care when placing it in the kiln, as dry clay is very brittle.

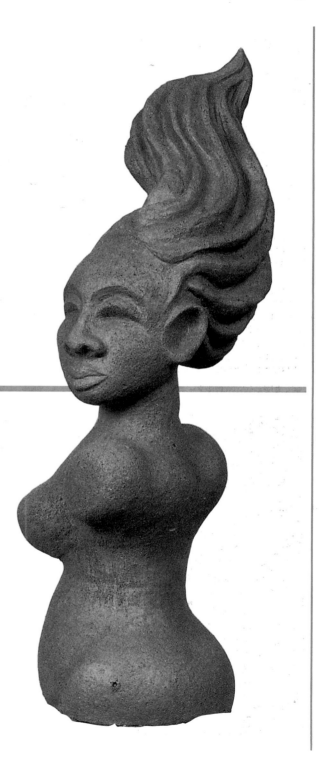

MODELLING

Modelling is an additive process in which the form of the sculpture is developed by adding material – the opposite of the other basic method of making sculpture, CARVING, where material is removed.

With all sculpture the material itself, to a certain extent, determines the form that the sculpture contains. A modelled sculpture is no exception. Modelling depends on the use of an inert and malleable material, usually clay. Wax, plaster and papier mâché can also be used (the latter two are used in DIRECT MODELLING). When modelling, the material itself has no form and is totally dependent on your manipulation of it to give it form. Modelling material has limited structural qualities and needs an armature, unless you are making a very small sculpture or maquette (see ARMATURE).

The golden rule when modelling is always to add material in small amounts. This keeps the development of the form under control.

Modelling is most suitable for making sculptures of the human form. There is a close affinity between clay and the substance of human flesh itself. In this section, two sculptures are made. One of a standing figure, one-third life size, and the other a life-size portrait head.

The armatures for both were made in the ARMATURE section. With the standing figure, measurements are taken from the model and reduced to a third to make the armature. For the portrait head, a standard head armature is used and measurements are taken from the model and transferred to the sculpture during the modelling.

ESTABLISHING PROPORTIONS

Although you can take as many measurements as you like, there are eight essential ones: A–B, B–C, C–D, C–E, C–F, C–G, C–H, H–H. However, measurements alone are not fail-safe, use your eyes as well!

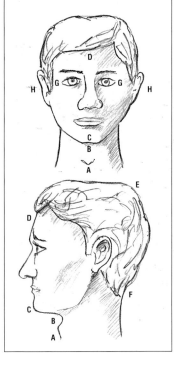

Portrait head

When transferring measurements from model to sculpture, always use the same corresponding points on each. Have your armature on a modelling stand at the same height as the model's head. Sit the model on a swivel chair so that the model can turn when you need to look at another part of the head – this saves you having to move the modelling stand and sculpture.

YOU WILL NEED

clay • head armature • modelling stand • calipers • matchsticks • wooden modelling tool • wire-ended modelling tool • water spray

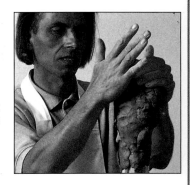

1 Pack clay tightly onto the aluminium wire of the armature, until you are able to cup both of your hands comfortably around it. Add some clay around the wood at the bottom of the clay.

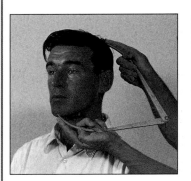

6 Measure the model from C to E. Transfer to your sculpture and mark the position of E with a matchstick. Push it in so that only the tip is showing.

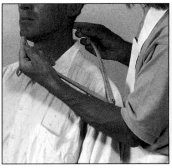

7 Take another measurement from C to F. Mark F on the sculpture with a matchstick. Now that the side profile is indicated, add enough clay to realise the shape of the head. Spend some time on the modelling so that you have a consistent curvature all over. From now on, don't depend on the measurements alone.

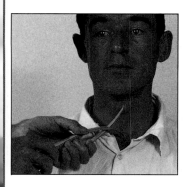

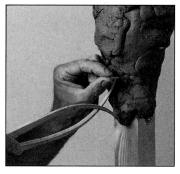

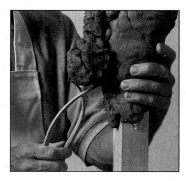

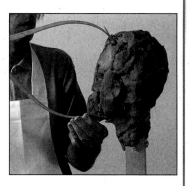

2 Decide which is to be the front and back of the sculpture – each should correspond with the flat planes of the vertical support. On the front, the midway point on the bottom edge of the clay corresponds to a point on the model's neck just below the Adam's apple. Cross your calipers so that the ends point away from each other. Position one end at A and adjust to measure to B.

3 Without adjusting the calipers, move to your sculpture and place one end on the bottom edge of the neck at its midway point and hold it in position. Where the other end of the calipers rests at the top of the neck, push a matchstick into the clay. Pack some clay on the front of the head above this point to begin establishing the chin.

4 Using calipers, measure from B to C on the model. Take the calipers over to the sculpture and place one end at the top of the neck. Add some clay to establish the depth of the chin. Next add more clay to the front of the head to establish a vertical plane from the tip of the chin to the top. Now add clay to the neck to produce a slight diagonal from the top to the base.

5 Measure from C to D on the model. Transfer this measurement to the sculpture and mark the top of the sculpture with the calipers. Using a modelling tool mark a line in the clay that divides the face in half from top to bottom.

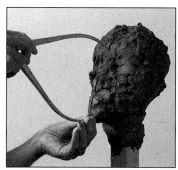

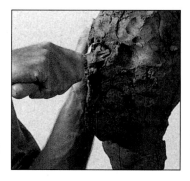

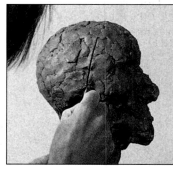

8 Measure the distance from C to G, placing your fingers over the sharp end of the calipers to avoid hurting the model. Check that the measurements are the same from the chin to the corner of each eye.

9 Being careful not to move the calipers, place one end of the calipers on the chin of the sculpture. Hold this point securely in position and draw an arc onto the front of the face.

10 Gouge out an area of clay with a wire modelling tool either side of the dividing line but just below the arc. This establishes the eye sockets and leaves a raised area of clay in the centre to which more needs to be added for the nose.

11 On each side of the head mark a centre line running from the top to the bottom to help you position the ears. As a general rule they lie at some point on this centre line.

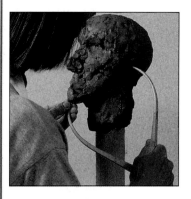

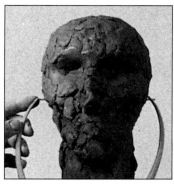

12 Take a measurement from C to H. Double check this measurement on the other side. On the sculpture, hold one end of the calipers on the tip of the chin and make a mark with the other end on the vertical line on each side of the head. Place matchsticks in these marks.

13 Measure the distance between the two points marked H on the model. Position the tips of the calipers just above the tops of the matchsticks and adjust the position of the ends of the matchsticks so that they just touch the ends of the calipers. You must now rely solely on your eyes to complete the modelling.

Life figure

In modelling this figure, clay will be added to the armature made in the ARMATURE section, so the major decisions regarding the size and relative proportions of the figure have already been made. The final sculpture, however, depends very much on using your eyes to look at the configuration of the pose and transferring this information to the clay.

clay • armature • pliers • tape measure • water spray • small modelling tool • cling film or polythene

1 Build up a base of clay on which the sculpture will stand. Once it has been built up to the level of the feet, they can be put in the position that corresponds with the pose of the model, whose left knee is bent slightly. Using pliers, hold the armature wire at the knee and bend the lower part back until you have a bend that relates to the pose of the model.

14 For the final modelling, line up your sculpture so that it is in the same position as the head of the model.

15 The hair is always a tricky part to model, and should be the last part of the head to be completed. Identify a significant form within the hair of the model and develop this form in clay. Use a modelling tool to finalize fine details.

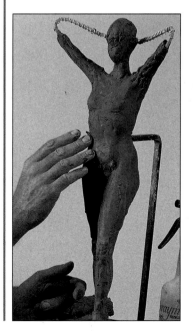

5 Make sure that the clay does not start to dry out. Keep a water spray handy and spray the sculpture from time to time as you are modelling, keeping the clay moist and workable. Do not overspray the sculpture or the clay will become too wet to work with.

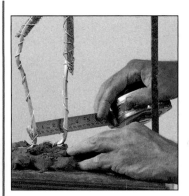

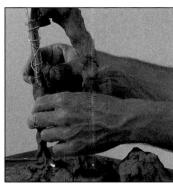

4 Constantly check the model to ensure that the forms you are developing are kept in proportion and do not grow too large.

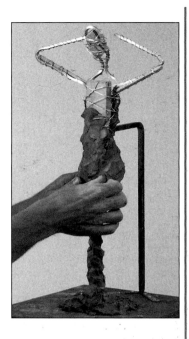

2 Measure the distance between the feet of the model and divide this measurement by three (remembering that you are making a one-third lifesize sculpture). Distance the feet on your sculpture accordingly, holding the legs in position by packing clay around (not over) and under the feet.

3 Working from the bottom, start to add small quantities of clay to the armature.

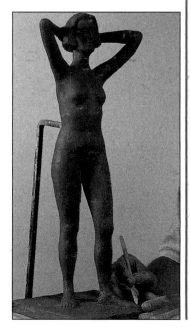

7 With the modelling complete and all the forms and features of the sculpture now finalized, use the modelling tool to level off the top and side edges of the base. Spray the whole sculpture with water and cover tightly with cling film or polythene. This will keep the clay moist until you are ready to make a mould of the sculpture.

6 Use a wooden modelling tool to shape those forms that are too small to be adequately modelled with your fingers.

MOULDMAKING

Clay, when left to dry out, quickly deteriorates and disintegrates. So when modelling a sculpture in clay, there are two options: either to reproduce or cast it in a more permanent material, or to fire it in a kiln (see KILN FIRING).

The first step in making a cast is to make a mould of the original sculpture. A mould is a negative impression of the original sculpture, the positive. And, using the mould, you are able to produce another positive – the cast of the original sculpture in another material (also see CASTING). Making a mould is a time-consuming and messy operation. However, it is also a vital one as the quality of the mould determines the quality of the casts taken.

The first consideration when making a mould is whether you will want more than one cast. If you require only one, you make a waste mould which, as its name implies, is a mould that is used only once. It is subsequently destroyed during the casting process. If, however, you want more than one cast, you will need a mould that can be re-used. This means that the mould must be easy to remove from the original sculpture and subsequent casts in one piece, without being damaged. A flexible rubber mould is best for this purpose.

Casting plaster is a basic sculpting material with a variety of applications when making sculpture, including mouldmaking. This plaster is available in various grades, reflecting the whiteness and hardness of the plaster when set and, of course, its cost. The type of plaster you choose will depend on the type of sculpture you are making. As a general rule, the basic grade casting plaster will be suitable for the majority of your needs. If, however, you are casting in plaster and want a hard and durable cast, you would choose a higher grade.

Waste moulds

Making a good mix of plaster is an important sculptural technique which will apply to any of the grades of plaster you choose to use. Two types of waste mould are shown being made in this section, each taken from sculptures modelled in clay. The first is a straightforward two-piece waste mould of a portrait head. The second is one taken from a life figure. Because an iron has been used to support the armature of the figure, it is a slightly more complex mould in three pieces.

The third is a flexible rubber mould. This mould is not damaged when separated from the original sculpture or its subsequent casts, so you are able to re-use it again and again. It is also worth remembering that, because of its flexible nature, this type of mould should be used when working with a sculpture which has undercuts. An undercut is the term given to concave parts of a sculpture or parts that protrude or overhang. When completely embedded in another mouldmaking material, such as plaster, these parts are difficult or impossible to separate from the mould without damage. Undercuts are very likely to occur in sculptures whose forms articulate against one another.

As making a mould is such a messy business, you need to work in an area separated from your main workspace, preferably with a wall surface behind the sculpture and with easy access to running water. If this is not possible, ensure that the area you choose to work in is adequately protected with polythene. Lastly, whenever you are working in plaster, don't forget to clean up as you go along, for the sake of your working area and your piece of work.

Mixing plaster

Plaster comes in a powdered form. When it is mixed with water, a chemical reaction takes place so the plaster goes off and sets hard. This reaction is exothermic – which means it gives off heat. As the plaster starts to go off, it becomes warm to the touch, and when it has cooled down, you know that the reaction has finished and the plaster has set.

The method of mixing itself determines the correct proportion of plaster to water, with the plaster always added to the water and not vice versa. However, the amount of water you start with always depends on the job in hand and, naturally, the level of water rises as plaster is added

SAFETY

- Work in a well-ventilated area where it doesn't matter if you make a mess. Alternatively, protect your working area with polythene or other suitable sheet material as much as possible.

- Always use barrier cream on your hands when working with plaster and wear a dust mask when mixing it.

to it. The final mixture will be about half as much again as the amount of water you started with. Plaster goes off very quickly, so never mix up too much at once. It is always better to mix less than more. When the plaster residue left inside your mixing container has set, you can break it free simply by tapping the sides and bottom of the plastic container. Any remaining small amounts of plaster are easily dislodged with a scraper. Never dispose of plaster by pouring it down a sink or drain, because it will set and block the pipework. It is useful to have a bucket of water near you when mixing, so you can clean your hands and tools.

YOU WILL NEED

casting plaster • polythene • barrier cream • dust mask • plastic bowl or bucket • scraper

1 Sprinkle plaster gently and evenly onto the surface of the water.

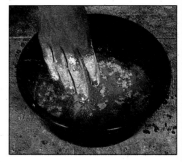

2 As you add the plaster, it will sink slowly to the bottom. Do not let it drop down in one place as this will impede its ability to break up and disperse in the water.

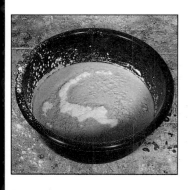

3 When the plaster starts to rise above the level of the water (or peak), enough plaster has been added to the water. A useful analogy to use is that of an iceberg, where the majority of its mass is underwater and only a small amount shows above the surface.

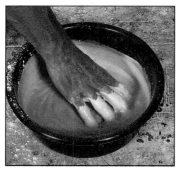

4 Allow the plaster to settle, to be certain the peaks will not sink into the water. While in this state, no reaction is taking place between the plaster and the water. When you are satisfied that the peaks have formed, mix the plaster well in with the water, making sure that any lumps are broken up.

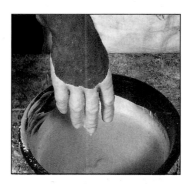

5 You should now have achieved a smooth and creamy mixture. A simple test can be carried out to ensure that you have a proper mix. Dip your fingers into the plaster and bring them up above the surface. The plaster should move slowly down your fingers but stop short of falling back into the container.

6 This test shows a weak mix of plaster, where insufficient plaster has been added. This mix is very transparent and falls quickly off the fingers. However, it is pointless to add more plaster – this will not rectify the problem. The weak mix will go off in time and can be discarded. Make another mix of plaster.

Head

This portrait head uses the most straightforward kind of two-piece waste mould.

YOU WILL NEED

shims (brass fencing) • scissors • plaster • powder paint • bucket • knife • plaster modelling tool • pliers • toothbrush

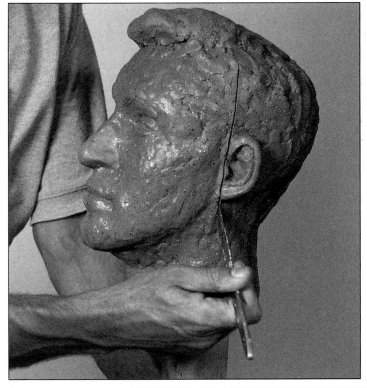

1 Mark a dividing line on the surface of the clay, bringing it down in front of the ears.

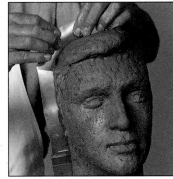

2 Using this line as your guide, insert brass fencing or shims, about 5 × 2.5cm (2 × 1in) long into the clay so that they rise 2cm (¾in) above the surface of the sculpture. Alternatively, you can use the aluminium from soft drink cans. Follow the line around the head, making sure that the tops of the shims remain level and overlap slightly so there are no gaps between them.

5 Sometimes you will have shims that do not fit neatly together. This is because the shims have not been pushed vertically into the clay. Any gaps that do occur can be rectified by bending over a small slither of shim as a clip to join the two offending shims.

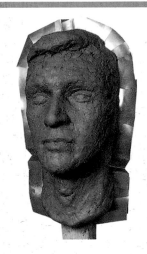

6 Trim the shims with scissors to establish a consistent height all around the sculpture, 2cm (¾in) above the surface.

7 Mix a small quantity of plaster adding some powder paint to make coloured plaster. This first coat of the mould, immediately adjacent to the surface of the cast, will prove a useful indicator during the casting process. You need to flick this coloured plaster mix onto the sculpture quickly before it starts to set. Scoop up some plaster with your index and forefinger and flick it as hard as possible onto the surface of the sculpture to prevent air pockets, which have the potential to weaken the mould.

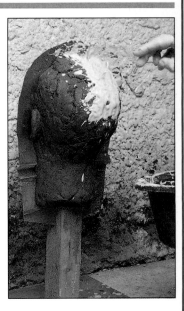

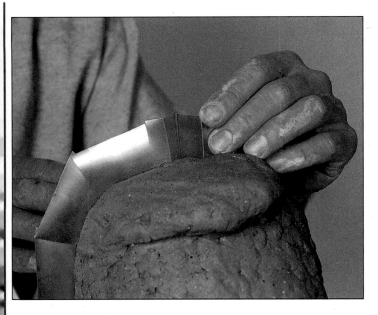

4 Continue all the way around the head. There will inevitably be a discrepancy in the height of adjoining shims, especially when going around the top – use smaller lengths of shim cut into a wedge shape at this point.

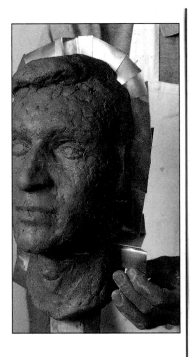

3 Place three shims, bent into "v" shapes on top of and either side of the head. These will provide positive and negative registration shapes along the seams of the mould and ensure that the two halves are fitted back together correctly.

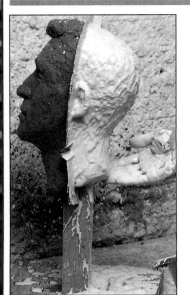

8 Cover one whole side of the sculpture with the coloured plaster. In any areas inaccessible for flicking, the plaster can be patted on tightly. Alternatively, let the first plaster mix set, then reposition the sculpture for easy flicking. For difficult areas – inside the ears and nostrils, for instance – blow the plaster into and around them.

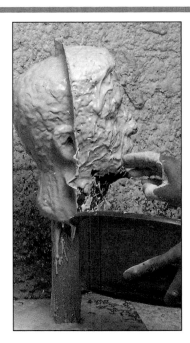

9 Now apply a first coat of plaster to the other side of the head, again making sure that no air is trapped between clay and plaster. Clean off any plaster from the tops of the shims before it has had a chance to set.

10 Using an ordinary mix of plaster, start to build up the thickness of the mould case. This thickness is determined by the height of the shims and must be consistent throughout, including high points such as the nose.

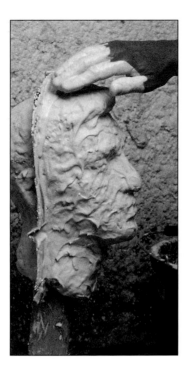

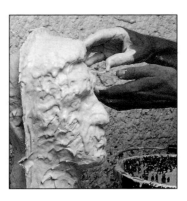

11 While the plaster is in this wet state, go over the details of the face. There is still a danger that air will be trapped and so weaken the mould, so do not let any plaster drip down and set.

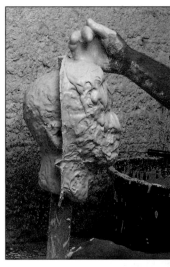

12 As the plaster starts to set, its state will change. As it starts to stiffen you can apply larger amounts, building up the thickness of plaster more quickly.

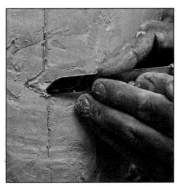

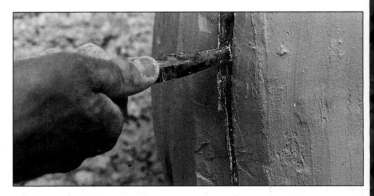

17 When both sides of the mould are complete, scrape along the seam which separates the two halves to reveal the top edge of the shims.

18 Pull the shims out of the mould with pliers. To get a grip, cut a bevel in the plaster either side of the shims all the way around the mould.

19 Take your pliers and grip the shims firmly, pulling at the same time. You should be able to extract the shims relatively easily.

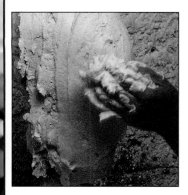

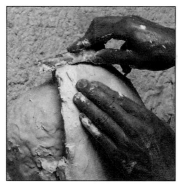

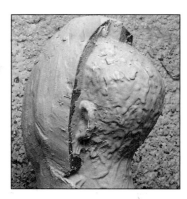

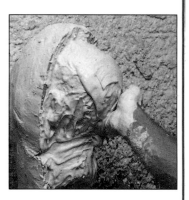

13 Compact the plaster tightly onto the surface to prevent air traps. Push plaster up to the shims without covering the tops. Then quickly add more plaster, compacting it tightly and moving away from the shims, continuing around the sculpture and maintaining an even thickness.

14 With one half of the mould made, the plaster needs to be cleared away from the shims, especially from the top. Scrape carefully along the top of the shims and mould case so that the top edges of the shims are revealed. It is much easier to do this while the plaster is in its cheesy pre-set state – it is extremely difficult to cut back excess plaster later.

15 An even thickness of the mould case gives it a consistency of strength. Any variation in the thickness of these walls will be a source of weakness.

16 Add the plaster to the back of the mould. Make sure that the plaster is compacted well in behind the ear.

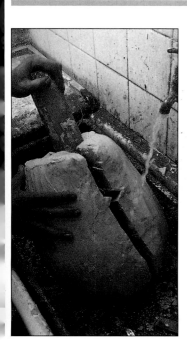

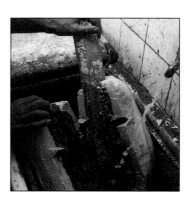

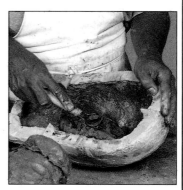

20 Unscrew the baseboard from the armature stand and place the mould under a running tap. Direct the water so it runs down into the slight gap left by the extracted shims. Turn the mould occasionally so that water runs evenly around the mould. After a while, the water will find its way in between the clay and the interior surface of the mould so that the mould starts to separate from the sculpture.

21 As the two halves start to separate, gently pry them apart. Take care not to apply too much pressure in case you break the mould.

22 Clean out the clay from inside the moulds and wash them out under a tap. Use a toothbrush, where necessary, to remove pieces of clay lodged in awkward crevices. The mould is now ready for casting.

Life figure

The mould for this life figure is in three parts. The mould for the front is made first and becomes the main part of the mould to which the two back pieces are attached. The clay wall technique can be used to separate the parts of the mould or, alternatively, see the previous technique of a mould for a portrait head. The mould for the life figure is made in the same way as the head, the main difference being that the life figure has far more detail in a much smaller area and so needs greater care when applying the plaster.

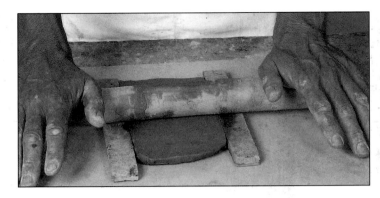

1 Roll out the clay to an even thickness. Cut the clay into strips 2cm (¾in) wide.

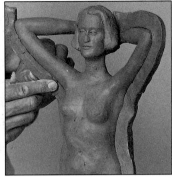

2 Place the strips of clay along the outside edge of the figure. The bottom front edge of the clay wall should separate the figure in half with no gaps between the bottom edge of the strip and the sculpture.

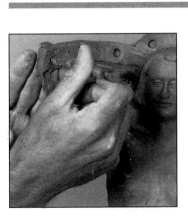

5 Using the end of a paintbrush, make a series of indentations into the clay wall at regular intervals. These are the location marks for fitting the mould back together satisfactorily.

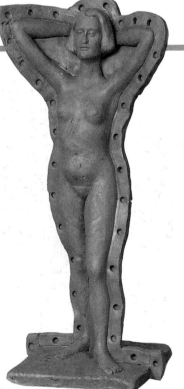

6 Cover the rear of the sculpture in cling film to protect it from plaster.

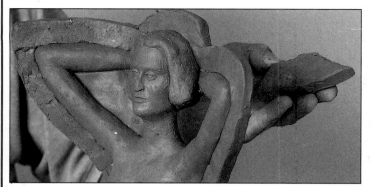

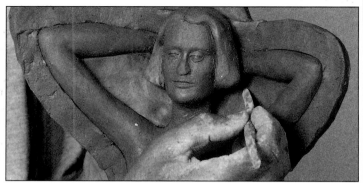

3 Fill in the openings between the arms and legs with clay. Roll out a slab of clay, and hold it up behind the opening. With a modelling tool, mark the interior profile of the opening onto the surface of the clay.

4 Cut the shape of the opening from the clay slab, then fit it inside the hole, squarely in the centre, making good and filling in any gaps.

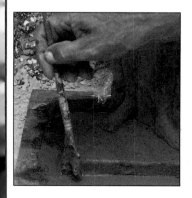

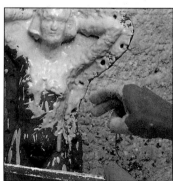

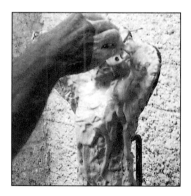

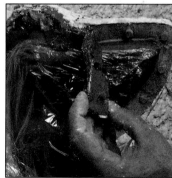

7 Paint a border of clay slip onto the base board, around the base of the sculpture to prevent the mould adhering to the base board.

8 Colouring the water with powder paint, mix up a small quantity of plaster. Flick the plaster onto the front of the sculpture. Make sure it gets into all the small crevices around the head and arms, blowing it in them, if necessary.

9 Cover the front of the sculpture with plaster. As it starts to set, build up the mould to the height of the clay walls all across the front of the sculpture. Do not cover the top of the wall with plaster – if you do, clean it off before it sets.

10 Once the plaster on the front of the figure has gone off, you can make the two pieces of mould for the back. Start by peeling off the clay wall and remove the cling film from the back of the sculpture.

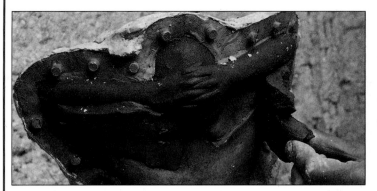

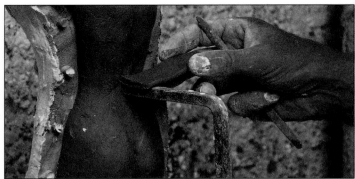

11 Gently remove the infills of clay from between the arms and legs. Dig the tip of a modelling tool into the clay slab near one of the edges and carefully lift it up and away without damaging any of the modelling on the figure.

12 Next, split the back of the sculpture in two, using the point where the armature iron enters the back of the sculpture as a dividing line. Roll out a slab of clay to the thickness of the armature iron and cut it into a 2cm (¾in) wide strip. Wrap some of the clay around the armature iron at its point of entry – this allows for a gap in the mould case. Place a strip of clay horizontally from the mould seam to the armature iron, either side of the sculpture.

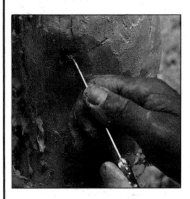

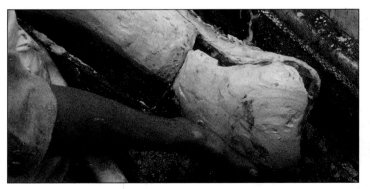

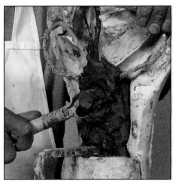

15 Cut back the plaster before it has set hard to reveal the seam all the way around the sculpture and the tops of the clay wedges. Take out these pieces of clay, together with the clay that was wrapped around the armature iron, using a screwdriver.

16 Place the mould, still fixed to the armature iron and base board, under a running tap and direct the water into the holes and seam around the top half of the back of the mould. Turn the mould occasionally so that there is an even penetration of water. As the back piece of the mould becomes looser, gently help it on its way – but don't pull too hard or you may break the mould.

17 Scoop out as much of the clay from the top of the sculpture as possible and pull the aluminium armature wire free from the mould. Place the mould under running water again, directing the water down between the two remaining parts of the mould.

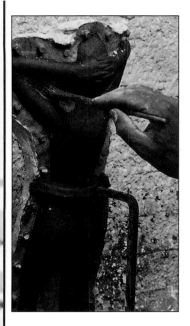

13 Paint clay slip onto the mould seams, including the areas between the arms and legs. Cut some clay wedge shapes 2cm (¾in) high and place three along either side of the plaster seam of the main mould and one along the top. Cover the top half of the back with cling film and make the bottom half of the mould, as in steps 8 and 9. When the plaster has set, remove the horizontal clay wall and the cling film. Make the last part of the mould, not forgetting to paint some clay slip onto the horizontal plaster mould seam of the bottom mould piece.

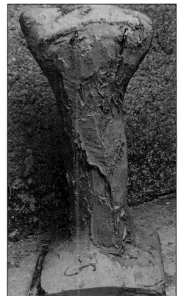

14 Because of the delicate configuration of the pose, the main part of the mould needs to be strengthened, using steel rod held in place by scrim and plaster. This also reduces the likelihood of the mould warping and distorting as it dries out. Place a steel rod horizontally across the arms and fix in place with scrim and plaster. Fix two lengths of steel rod vertically on the front of the main mould.

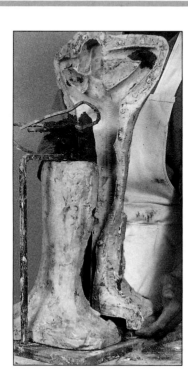

18 By now, these two parts will be working themselves free. Place the sculpture on the bench and gently wiggle the main part of the mould to and fro, gradually pulling it away from the back. Scoop out the clay and release the aluminium armature from this piece of the mould and from the armature iron. Clean the inside of all three pieces of mould under a tap.

19 Finally, because this mould is going to be used for a fibreglass cast, it must be completely dried out. To prevent warpage and distortion, piece it together and tie it up securely to hold the three parts in place.

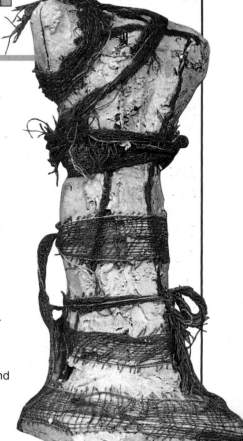

Flexible rubber mould

The great advantage of a rubber mould is that it is reusable, so you can produce more than one cast of an original in a variety of materials such as *ciment fondu*, resin and, in this example, plaster. In this section a hot pour rubber has been used. This comes in solid blocks and needs to be cut into cubes approx 2.5 × 2.5cm (1 × 1in) which are then melted in a thermostatically-controlled electric melting pot. Depending on the grade of rubber, it melts between 150°C and 170°C and should be poured around 140°C.

However, you can also use a pourable Room Temperature Vulcanising (RTV) Silicone Rubber for this technique. The rubber cures when you add a catalyst to it. The advantage of this type of rubber is that you need no special equipment to make it pourable. When using RTV silicone rubber, follow the manufacturer's guidelines on safe handling and usage.

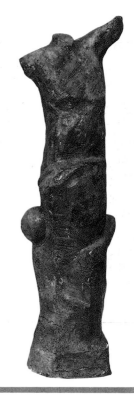

YOU WILL NEED
modelling board • clay • knife • modelling tool • paintbrush • plaster • shellac • vaseline • electric melting pot • hot pour rubber • gloves • respirator mask • goggles • barrier cream

1 Thoroughly clean the original fired clay sculpture and soak it in water to displace any air trapped in its slightly porous surface.

SAFETY
• Hot pour rubber should never be melted in a saucepan over direct heat and before you embark on this technique you need to familiarise yourself fully with the safe handling of this material.
• Always use barrier cream and/or latex gloves when handling the cold rubber.
• Wear leather gloves and suitable protective clothing when pouring hot rubber.
• A respirator is an essential item. The fumes are not toxic but they are unpleasant to breathe in.
• Make sure that you use a well-ventilated work area.

6 Trim off the excess clay where the top slab meets the clay bed.

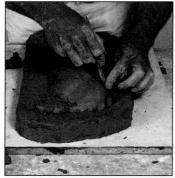

7 Work around the sculpture with a modelling tool, closing any joins between the clay slab and the clay bed, neatening as you go, so that you are left with a clay form that resembles the original sculpture.

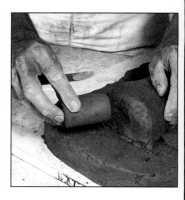

8 Cut some wedges of clay and evenly space them along the clay bed. Roll some more clay into a conical shape and place this on the clay bed at the bottom of the sculpture.

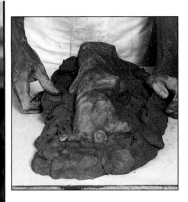

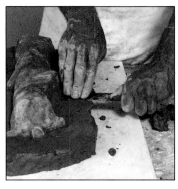

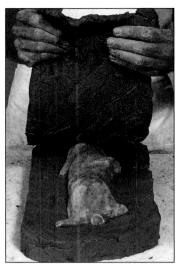

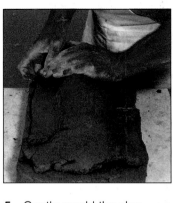

2 Lay the sculpture down onto a modelling board and submerge it halfway in a bed of clay.

3 Develop this clay bed until it is 5cm (2in) wide all the way around the sculpture. Level off and smooth the surface of the clay bed.

4 Roll out a slab of clay about 1.5cm (½in) thick, and cover the exposed part of the sculpture with it.

5 Gently mould the clay around the sculpture.

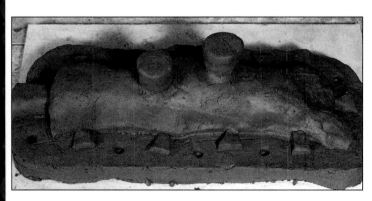

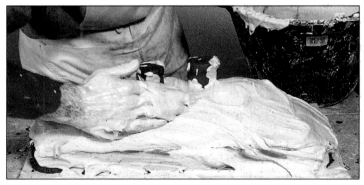

9 Roll two more conical shapes in clay about 5cm (2in) high and place them on top of the clay, one at the highest point – these will be the pouring holes for the rubber. Finally, make some indentations on the surface of the clay bed with the end of a paintbrush. These are the location marks for the two halves of the mould.

10 Mix up some plaster and cover the mould, gradually building up the thickness. Use the height of the clay cones as your guide, to produce a mould case that is 5cm (2in) thick all over. Be careful not to go over the edges of the clay bed at the sides.

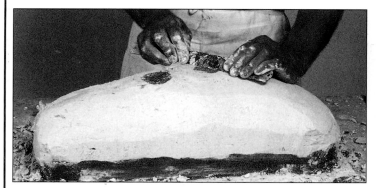

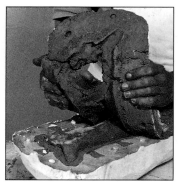

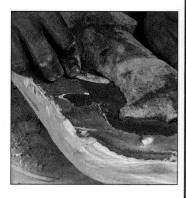

11 Wait until the plaster is in its cheesy state and quickly trim off any excess from the sides so you have a straight seam between the clay bed and the plaster case. Trim off the plaster from the area around the top of the clay cones.

12 Once the plaster has set, turn the mould case over and peel off the clay bed.

13 Clean up the surface of the original. Then, with a modelling tool, smooth the surface of the embedded clay up to the surface of the original.

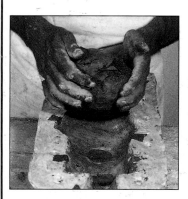

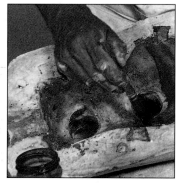

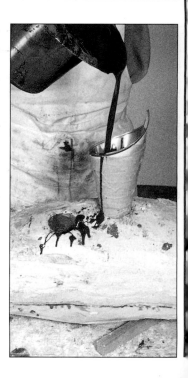

16 Take the mould section without the original and remove all the clay from its interior, including the pour holes.

17 Apply three coats of shellac to the inside of the mould. This will allow you to keep the rubber mould in the plaster case, as there is a danger that the dry plaster of the mould could in time draw some of the constituent oils from the rubber. Finally, block up the pour hole at the base of the figure with clay.

18 Place this half of the mould on top of the other, using the location points along the seams to position it correctly. Melt the rubber in an electric melting pot and gradually pour the hot rubber into the pour hole. The rubber will rise up to the brim of the hole. Gently tap the sides of the mould to dislodge any trapped air. Leave the rubber to cure (set) completely overnight.

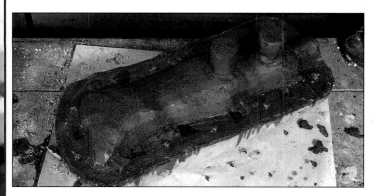

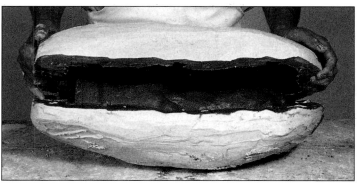

14 Paint the plaster seam of the mould case with three coats of shellac and smear on a layer of vaseline (petroleum jelly). Repeat steps 4–11 for this side of the exposed original.

15 When the plaster of the second mould case has set, gently insert a knife blade into the seam. You will be able to separate the two halves of the mould, with the original staying in one half of the mould.

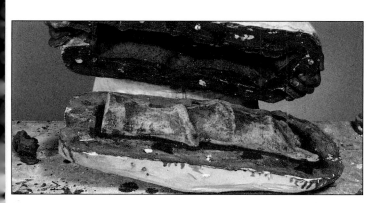

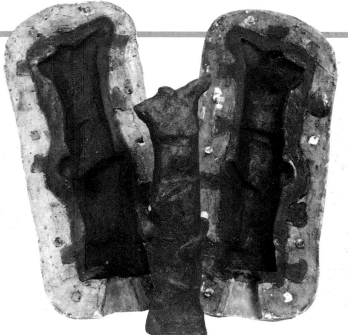

19 The next day, turn the mould over and lift off the top, making sure that the original stays in the rubber. Repeat steps 16–18.

20 After leaving the rubber to cure, the mould can be separated and the original removed.

RELIEF

A sculpture in relief is not totally "in the round" – it exists somewhere in between two and three dimensions. In relief, forms come out of and recede into a common ground, exploring aspects of real and illusory form and space. Relief can be *bas* (low) or *haute* (high) depending on the

distance between the highest point of the sculpture and the ground from which it rises. Relief is as old as sculpture's history itself. Its earliest use, by the ancient Greeks and Egyptians, was in architecture, where the interior and exterior surfaces of buildings would be carved with images. The introduction of coinage is an early example of modelling being used to make a relief.

Whether a relief is carved or modelled, a drawing is essential to enable you to plan the highest and lowest points. You then need to consider not only the restrictions of the relief format, but also those of the technique involved, whether carving or modelling. Relief does not involve only carving and modelling and is now frequently associated

with a construction technique – which, interestingly enough, also has architectural associations, particularly where the sculpture is hung on a wall. In the BRAZING section you will see an example of a constructed metal relief.

Two types of relief are shown here. The first, a stone carving, develops further the exercise in the CARVING section, using a harder and more resistant material, as well as examining the discipline of working within a relief format.

Another type of relief is made combining a moulding and casting technique. By referring to the MOULDMAKING and CASTING sections you will be able to find out more regarding these two techniques.

Plaster
In this abstract plaster relief, the impressions are made on the clay base using simple geometric shapes.

YOU WILL NEED

clay • rolling pin • plastic-coated board • two lengths of wood, of 2.5cm (1in) depth • tape measure • set square • knife • casting jig, made with 4 lengths of wood and 4 corner brackets • small paintbrush • soft soap • wooden block • plaster • bucket

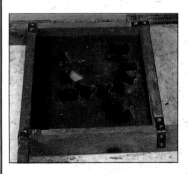

4 When you are happy with your impressions, you are ready to pour on the plaster. It can, however, be quite difficult to imagine what the resultant plaster cast will look like, because the plaster cast will, of course, be a negative impression of the clay bed.

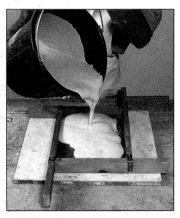

5 Make good any imperfections in the clay bed and then pour the plaster out of the bucket and slowly onto the clay, aiming for the centre and letting it flow out towards the sides.

6 Gently shake the base board from side to side to disperse the plaster evenly. This will also get rid of any pockets of air that have been trapped. Do not shake the base board too much or the casting jig may become dislodged and the plaster will spill out.

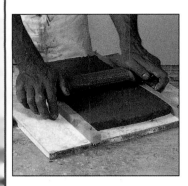

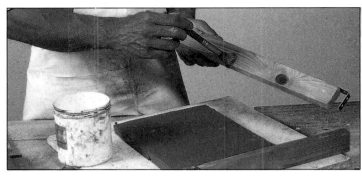

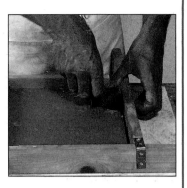

1 Roll out a bed of clay to a consistent thickness of at least 2.5cm (1in). Use a plastic-coated board or one that has been lined with polythene or cling film on which to roll it out and place two strips of wood, of the right depth, either side of the clay to measure the thickness. Roll out the clay with a rolling pin to the required width with each end of the rolling pin resting on the strips of wood.

2 Using a tape measure and a set square, cut the clay bed to shape with a knife. You now need to make an adjustable casting jig for the plaster. The height of the sides of the jig above the clay determines the thickness of the plaster. Screw a right-angled corner bracket on to one end of four pieces of wood. Slot a fixed bracket over another piece of wood at right angles to it to construct a square box. You can adjust the size to fit the cast you require. Paint the interior surfaces of the wood with soft soap, so it will be easy to release. Position the casting jig around the clay bed.

3 Press a wooden block into the surface of the clay, taking care not to push it in too far or the block will touch the base board. You will not be able to make an impression of any undercuts (see MOULDMAKING) with this technique. However, parts of most objects can be pressed into the clay and even a basic geometric shape produces a variety of impressions.

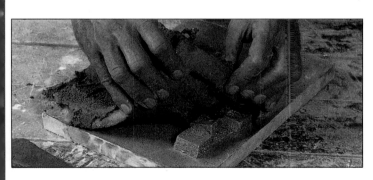

7 When the plaster has set, gently remove the casting jig. Then slide the clay and plaster to and fro until both are free from the base board. Turn them over so that the plaster is now on the bench and peel off the clay. The plaster can be washed with water to get rid of any clay residue left on the surface.

Stone carving

This relief is a stone carving and uses the techniques found in the CARVING section, as well as incorporating the special considerations of relief work.

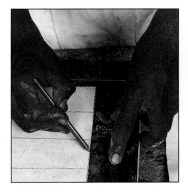

1 Make a drawing, the same size as the relief design. Measure and mark a grid on the drawing and on the stone. Transfer the design onto the face of the stone.

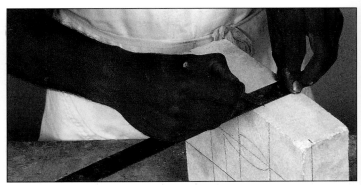

2 Work out the highest and lowest points of the design. The highest point is the mid-point of the scroll, while the lowest will be the background out of which the scroll emerges. Use a tape measure to mark the background depth on the four sides of the slab of stone.

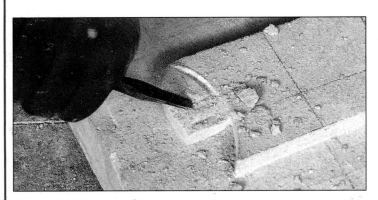

5 Begin carving the scroll, starting with the receding interior part. The straight edge of this area is just higher than the level of the background. The surface then rises gradually to a point just below the lower level of the exterior of the scroll. Take particular care when carving the undercut that runs under the edge of the scroll.

6 Carve both the straight edges of the scroll, gently rounding them off to a level just above the background.

7 The other side of the scroll is also an undercut and this needs to be carved out very carefully. Tilt the chisel at the required angle and tap it gently with the mallet.

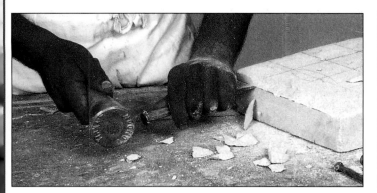

3 Wear your goggles and dust mask and keep a water spray to hand to keep the dust level down while carving. Start by disposing of areas of waste material, the biggest of which will be the background area. Using the mark made on each side of the stone, start cutting away the stone. Position the chisel horizontally and parallel to the bench and hit it with the dummy mallet with firm and consistent taps. It is good stone carving practice to keep up a rhythmic tapping of the mallet on the chisel. With this line cut away around the block, the depth of the background is established.

4 Start carving on the waste side of the drawn line which describes the scroll form and follow this line all the way around. This releases the scroll from the waste material. Make the surface of the background level with a flat chisel. Redraw the grid on this surface as a point of reference.

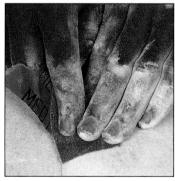

8 Use rifflers of various sizes for the final shaping. These tools will also be useful for levelling out any undulations on the surface of the background after smoothing with a rasp.

9 Finally, rub down with sandpaper, taking care to establish the sharp edges that run along the bottom and sides of the scroll.

However meticulously you follow a particular technique, inevitably you will need to repair or "make good" parts that have been damaged. Learning by one's own mistakes, though – and we all make them – is by far the best way. Never abandon a sculpture because of damage – you will find that everything is repairable and well worth the effort in the end.

Sculptures can be damaged in a variety of ways. Some are totally beyond your control – such as the cracks that occurred in the stylized torso during kiln firing. Others, such as the broken corner of the plaster carving, occur while working on the sculpture. The broken ear and nose tip on the *ciment fondu* cast happened as the plaster mould was chipped off the cast – a common accident. Parts of the seam in the resin cast figure have not joined together properly, and part of the wrist needs to be repaired. When taking a cast from a mould of this size, you will inevitably have to do some making good. The countersunk holes in the figurative wooden construction have to be filled as part of making it.

Portrait head

Epoxy resin putty behaves in the same way as clay, and so is a very useful material to use for repairing modelled sculpture. Wear rubber gloves when handling it.

YOU WILL NEED

epoxy resin putty • rubber gloves • sharp pointed tool • sand-filled rubber inner tube • angle grinder • clear goggles • dust mask • craft knife • riffler • water • modelling tool

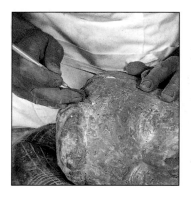

1 Pick out as much as you can of the plaster in the crevices of the sculpture. A sharp pointed tool will be useful for this.

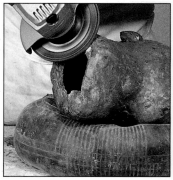

2 Position the head securely in a sand-filled inner tube and use an angle grinder to level out the edge of the opening to the neck. Always wear clear goggles and a dust mask.

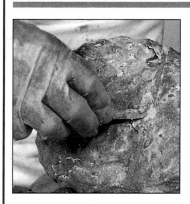

6 Fill in any holes with the putty and use a modelling tool to shape it to the sculpture.

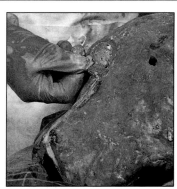

7 Use putty to model the section of ear that broke off.

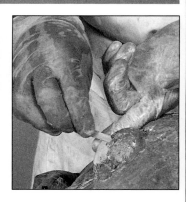

8 Finally, use the modelling tool to shape the putty so that it matches the rest of the ear.

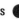

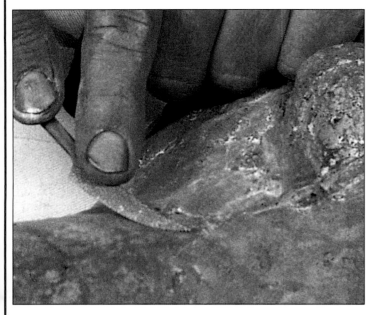

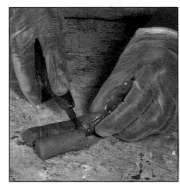

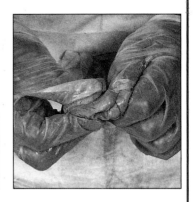

4 Cut equal lengths of the two parts of the epoxy resin putty with a craft knife.

5 Knead them together until you have an even coloured mix. Add a little water to the mix to make it more malleable and easier to knead.

3 There will be raised bits of *ciment fondu* around the join of the two halves of the cast.

File these down level to the surface with a riffler.

Figurative construction

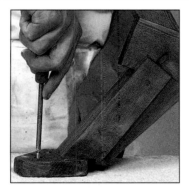

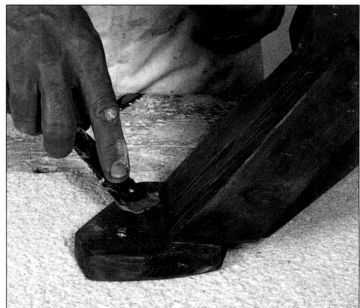

1 When the sculpture has been coloured, screw it down onto the base.

2 The countersunk drill holes will need to be filled with wood filler. Once dry, sand down, and restain.

Stylized torso

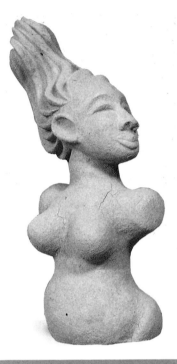

1 After firing, you can see that there are some small cracks on the surface of the torso.

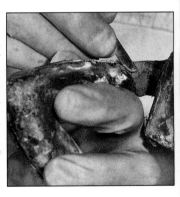

2 Mix up some decorating filler and work it into the cracks with your fingers.

Resin cast

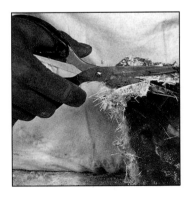

1 Trim off the excess glass fibre matting around the edge of the base with scissors.

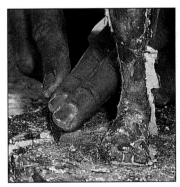

2 Use a riffler to level off the raised areas of resin, where the two halves of the mould were joined.

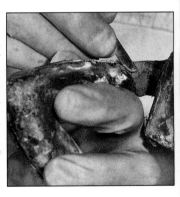

3 Use epoxy resin putty to fill any damaged parts of the cast or open seams. Leave to set.

3 When the filler has set hard, level off the filled areas with sandpaper down the surface of the sculpture.

Abstract plaster carving
PVA glue helps the decorating filler to adhere well to the plaster carving.

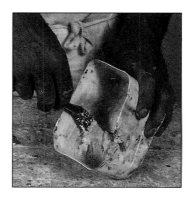

1 Add water to a small quantity of decorating filler and mix to the consistency of soft cheese.

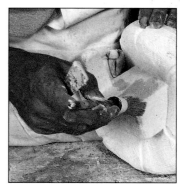

2 Paint some diluted PVA glue onto the areas to be repaired.

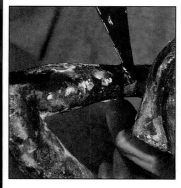

4 Apply a layer of bronze/resin gel coat mix over the putty. (Refer to the CASTING section for instructions on how to prepare a mix.) When the resin has the consistency of jelly, trim it back into shape with a modelling knife. Leave to cure fully.

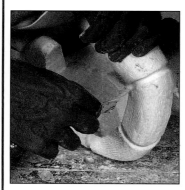

3 Load a filling knife with decorating filler and fill the holes. Draw the knife back over the holes to produce a level surface.

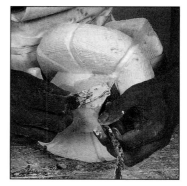

4 For a sharp edge along the corner section, hold the blade of a filling knife hard up against the face of the sculpture. Fill the corner area using another knife, then drag the blade back up the surface of the sculpture using the edge of the first knife as your guide.

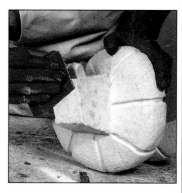

5 Fill any holes on the surface of the sculpture. When the filler has set, gently smooth it level with sandpaper.

RIVETING

Rivets are an extremely efficient and permanent fixing method for thin gauge sheets of steel or tin. Although it is an industrial technique, riveting is very suitable for constructed sculpture – either big or small – and a minimum of non-specialist tools and equipment is needed (see CONSTRUCTION). You can create voluminous geometric forms using flat sheets of steel or tin joined with rivets. Rivets are available in various lengths depending on the thickness of the material.

Plan out beforehand the form of the sculpture and work out how you are going to fix its various parts together. The sculpture in this example is composed of two volumes of four sides each. The sheet tin has been cut to size using card templates.

Mobile sculpture

Wear leather gloves throughout to protect your hands from any sharp edges on the cans.

YOU WILL NEED

leather gloves • empty tin cans • can opener • scissors • heavy weight (such as books) • soft leaded pencil • ruler • cardboard • hole punch • hammer • electric drill • G-clamp • wood • metal working vice • wooden mallet • 3mm (⅛in) pop rivets • rivet gun • 1.5mm (¹⁄₁₆in) diameter steel welding rod • pliers

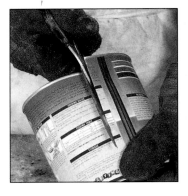

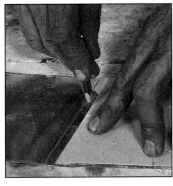

1 Remove the bottom of the can with a can opener, and make a straight cut down the side using scissors. Flatten out the can by placing a heavy weight on it – such as books – and leave overnight. It will retain its new flatter form and will not curl up at the ends.

2 Draw round the cardboard templates with a pencil to create the end panels for the top shape.

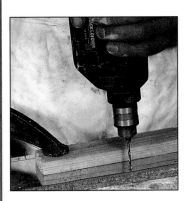

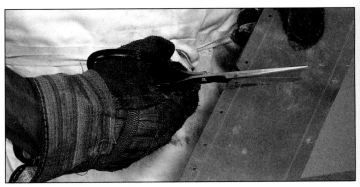

7 Clamp the tin sheet securely to your bench and drill a 3mm (⅛in) hole in each of the punched marks.

8 Cut diagonally across the corners of the tin where the inner lines of the margin meet. On one of the long edges of the bottom panel, mark the width of the top shape, equidistant from the ends. Cut out a wedge shape, so that the apex is on the inner margin line.

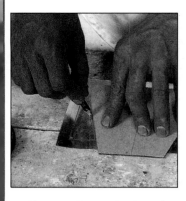

3 Use the diagonal edge of the template to mark the edge of the long panels for the bottom shape.

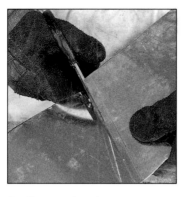

4 Cut out the shapes that have been marked with scissors.

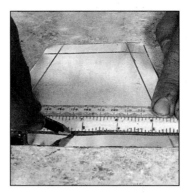

5 Draw a line parallel to each of the edges, to make a 1.5cm (½in) margin.

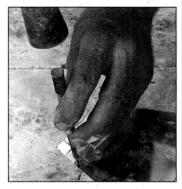

6 Mark points about 4cm (1½in) apart in the centre of the margin and, with the hole punch and hammer, indent the surface of the tin.

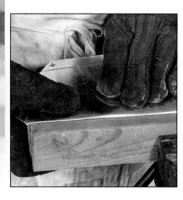

9 Sandwich the tin between two pieces of timber, lining up the inner margin on the tin with the top edges of the wood. Place the whole thing in a vice and secure tightly. Bend the tin back at right angles to the wood.

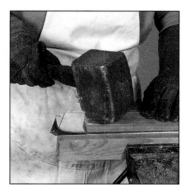

10 Place a piece of wood on top of the bend and tap with a wooden mallet to reinforce the right-angled bend.

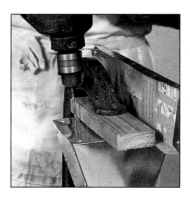

11 Clamp the top shape to the bench and place the bottom section on top of it. Make a mark on the underside of the top shape using the holes drilled in the bottom as your guide. Indent the tin with the hole punch, and drill the holes. Join the two parts together using pop rivets.

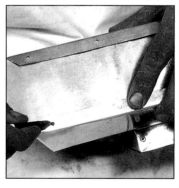

12 With the two sides of the bottom now fixed to the top, slide a strip of tin underneath the flanges of the bottom shape. Mark corresponding holes on this strip to those on the flanges. Clamp the strip of tin, with a piece of board underneath it, to the bench and drill holes.

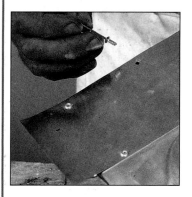

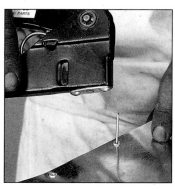

13 Place the strip on top of the flanges and line up the holes. Insert a pop rivet through both of the holes to fix it to the underside of the bottom.

14 Insert the wire length from the rivet into the hole in the rivet gun. Pump the gun a couple of times until the wire snaps. The underside of the rivet has been pulled up and the two pieces of tin are now fixed together.

15 Riveting is an extremely efficient technique for producing geometric sculptural forms. Note how the positioning of the rivets can play an important compositional role.

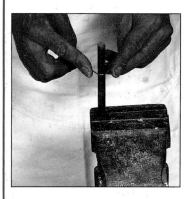

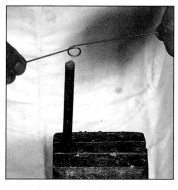

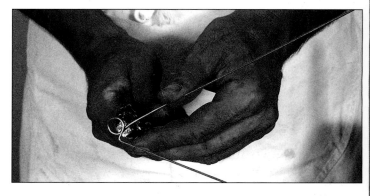

16 Place a length of steel rod into a vice, position a length of welding rod around it, and bend it towards you.

17 Bend it round to form a circle, then lift it off.

18 With pliers, bend the rod back at right angles to the circle. Cut the two ends off at 15cm (6in) from the right angle. At the ends, bend 4cm (1½in) up at right angles. This wire will be used to hang the sculpture (COLOUR).

WELDING

Welding is the technique of fusing together two pieces of metal by the application of heat. There are different welding processes for different metals and working conditions and this section deals with the welding of mild steel using the oxy-acetylene and electric arc-welding techniques. The oxy-acetylene safety precautions in the BRAZING section also apply to oxy-acetylene welding and further precautions are given below.

The other technique uses an electric arc-welding unit. The unit has an earth clamp cable and an electrode holder cable, as well as a dial to set the appropriate current. This will depend on the thickness of the steel to be joined. Consult the manual.

To make a weld, you clip the earth terminal onto your piece of work, or the steel bench upon which it is placed. Select the required current and switch on the electricity supply to the arc-welding unit. You will not be able to see anything through the welding mask, so position the welding rod just above and at a 70° angle to the area to be welded, before bringing the mask up to your face. Hit this area with the welding rod using one swift action and raise it immediately 3mm ($\frac{1}{8}$ in) above the surface of the steel to create an arc, which will light this area up. Move the rod slowly back and forth, keeping it above the surface of the steel, between the two points to be joined to make the weld. Knock off any slag that has built up on the weld with a chipping hammer. It takes a bit of practice to perfect the arc, but once you have acquired the technique, it will never be forgotten. You may find at first that the welding rod sticks to the surface of the steel. In this case, you have not raised the rod quickly enough. If this happens, release the jaws of the electrode holder, turn off the arc-welding unit, and remove the stuck electrode.

The steel armature made here is used in the DIRECT MODELLING section. The steel rod is heated up, bent into shape and the parts are then welded together using the oxy-acetylene technique.

An abstract sculpture, made up of pieces of steel of various gauges and sizes, is shown being cut, heated, bent, ground and welded to produce an homogenous composition. Arc-welding is a quick and efficient method of joining steel, allowing you to juxtapose different elements at quirky angles. The welded join is as strong as the steel itself.

SAFETY

- When welding, wear heavy duty boots or shoes, overalls, leather gloves and a leather apron. Avoid loose clothing and jewellery. Tie hair back.

- The intense light produced by the arc welder is harmful to eyes and exposed skin, so your whole body should be covered and an arc-welding mask should cover your whole face and have an area of darkened glass for the eyes. When looking through this glass under normal circumstances you will not be able to see a thing. It is only when the electric arc is produced that the area you are working on is illuminated. **NEVER ON ANY ACCOUNT LOOK AT THIS ARC WITH THE NAKED EYE.** Any other people watching also need to be adequately protected.

- When using the oxy-acetylene equipment, wear welding goggles. These have darkened glass so you can look directly at the flame without harming your eyes.
- After making a weld, the area around the join is hot, so always wear leather gloves. Let the earth clamp cool before moving it, and let the electrode holder cool before inserting a new welding rod.

- Beware of the potential risk of trailing cables and hoses, and do not let arc-welding leads come into direct contact with heat or water.

- Never weld on a wooden surface – a steel bench, a sheet of thick steel placed on top of a bench or a concrete floor is preferable.

- See BRAZING for other oxy-acetylene welding precautions.

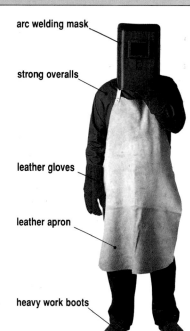

arc welding mask

strong overalls

leather gloves

leather apron

heavy work boots

Gas welding

YOU WILL NEED

6mm (¼ in) steel rod • oxy-acetylene equipment • molegrips • metal vice

1 Make a same size model from thin wire. Refer to this when using 6mm (¼ in) steel rod to make the three parts of the armature. Weld the legs and body sections together applying heat at the point of contact. Remember that the hottest part of the flame is at the tip of the cone. Apply the flame in an even circular motion. The steel welding rod should be held in the outer edge of the flame until it starts to heat up. After a while the area being heated by the

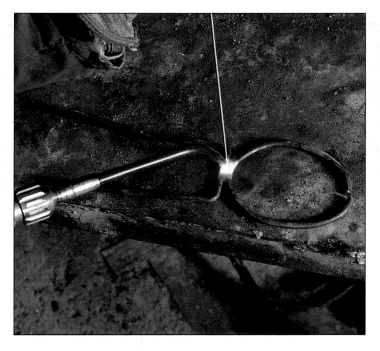

flame will start to puddle (i.e. the steel melts). Move the welding rod through the flame and dip it in the puddle. It will now be the same temperature as the other two pieces of steel and so will also melt into the puddle. When all three pieces of steel are fused together, withdraw the welding rod, turn off the torch and let the weld cool down.

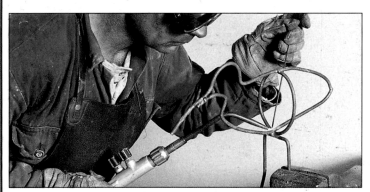

4 Remove the molegrips and weld the lower part of the body to the bird profile.

5 By using the minimum number of lengths of steel rod and welds, you can make an extremely strong and durable armature. This is an essential requirement for the DIRECT MODELLING technique.

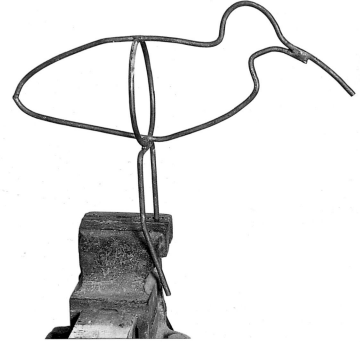

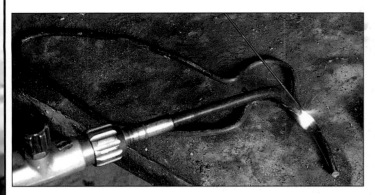

2 Weld the back section of the bird together.

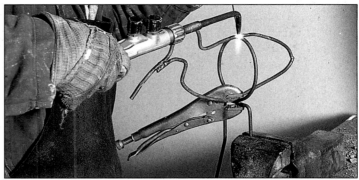

3 Clamp the leg and body section in a metal vice. Use molegrips to hold the bird profile in place at right angles to the body section and make a weld to join this section to the bird profile.

Gas cutting and bending

The cutting torch of the oxy-acetylene equipment produces a very powerful flame which will bring mild steel to red heat very quickly. Once the steel has reached this state add extra oxygen to the flame to cut the steel. The cutting torch can also be used to heat the steel until it becomes pliable and easy to bend. You must use suitable tools and equipment for this operation.

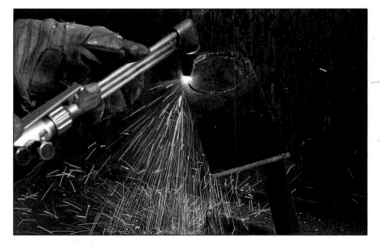

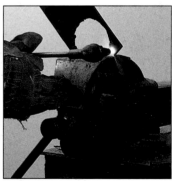

1 Cut a circle from the flat section of steel with the cutting torch. Always hold the torch at right-angles to the surface you are cutting, so that the tips of the flame cones just touch the surface. Keep the torch in this position, directing the flame downwards. When the steel becomes red, depress the oxygen lever on the cutting torch to release a stream of oxygen to blow away the molten steel. Slowly move the cutting torch around the circle, still with the oxygen lever depressed. When the circle has been cut out, release the oxygen lever and turn off the acetylene first and then the oxygen.

2 Place the tip of the steel plate in the metal vice, and heat up the steel with the cutting torch either side of the circle at a point just above the jaws of the vice.

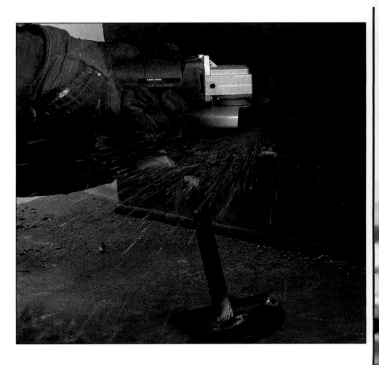

4 An angle grinder can be used to grind down the welded joins or to grind down part of the surface of the steel sculpture, but beware of the density and velocity of the sparks that occur. Always wear clear goggles and never work near anything flammable.

3 When the steel is red hot, turn off the gas, put the torch down and bend the steel at right angles to the piece held in the vice.

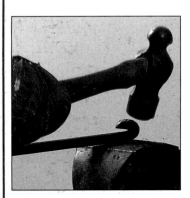

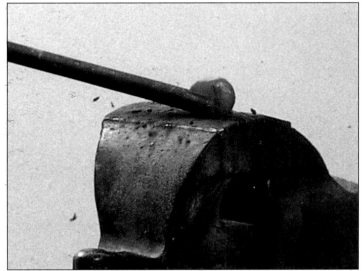

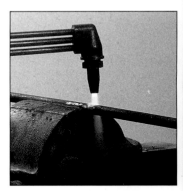

7 Continue hammering the end back. As it cools you will need to put it back in the vice and apply more heat.

8 When it is again red hot, hammer the end of the rod back on itself and start to hammer the tip of the rod flat.

9 Place the rod in the vice and heat up the middle section. When red hot, push the rod away from you to produce another bend.

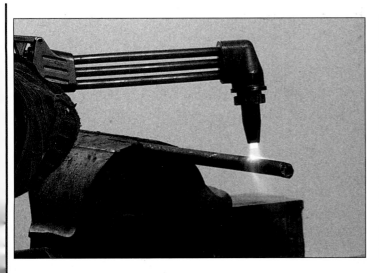

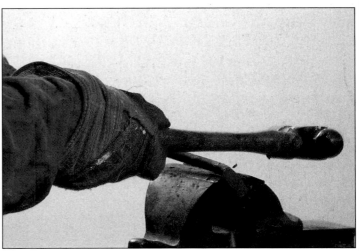

5 Hold a piece of steel rod in the vice and heat up the end until it is red hot.

6 Hold the rod on top of the vice and then hammer the end of the rod at right angles to the main length.

Electric arc-welding
Read the safety tips on page 119 before doing any electric arc-welding. Safety equipment is essential.

YOU WILL NEED

bent steel rod • electric arc-welding unit • molegrips • chipping hammer

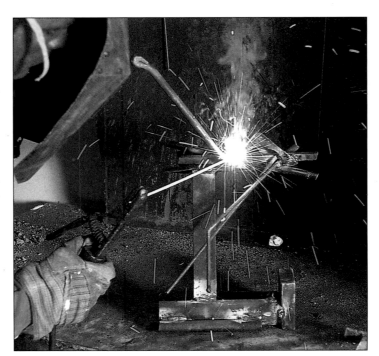

2 Knock the slag off the weld with a chipping hammer.

1 This bent rod is held in place with molegrips on top of the sculpture. Using the technique described in the introduction weld it into position.

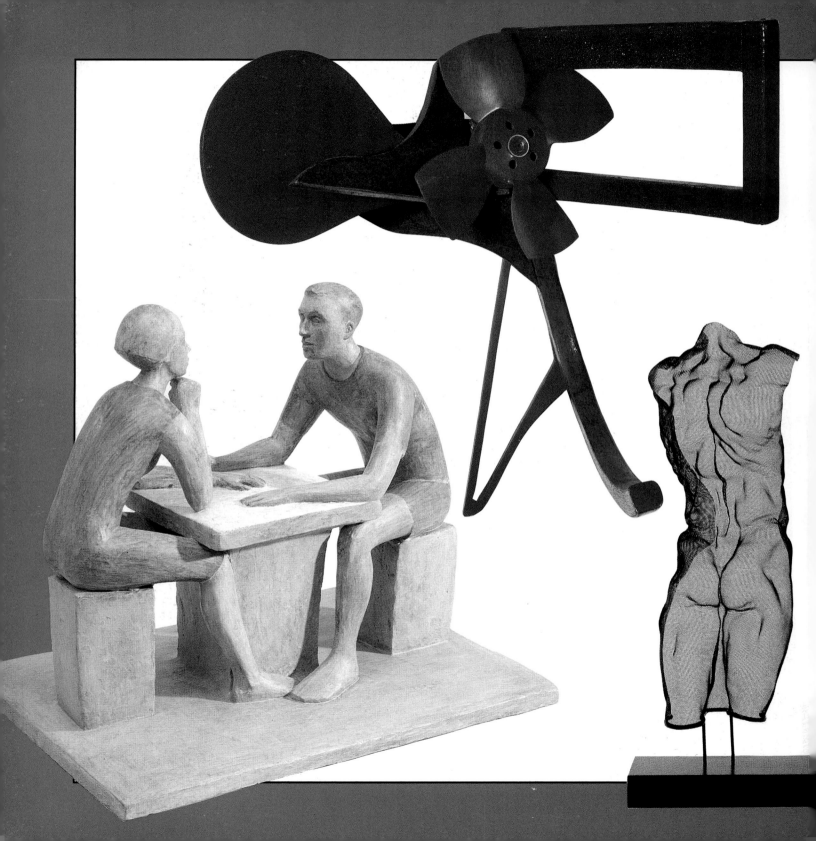

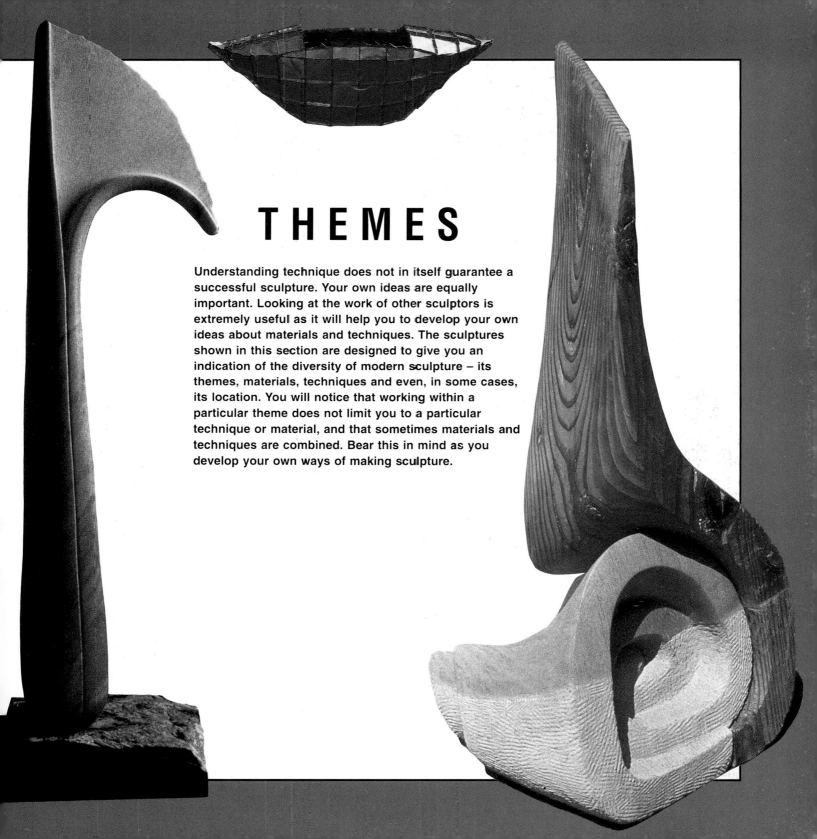

THEMES

Understanding technique does not in itself guarantee a successful sculpture. Your own ideas are equally important. Looking at the work of other sculptors is extremely useful as it will help you to develop your own ideas about materials and techniques. The sculptures shown in this section are designed to give you an indication of the diversity of modern sculpture – its themes, materials, techniques and even, in some cases, its location. You will notice that working within a particular theme does not limit you to a particular technique or material, and that sometimes materials and techniques are combined. Bear this in mind as you develop your own ways of making sculpture.

HEADS

There is a tradition in western sculpture of producing portrait busts of prominent people, the antecedents of which can be traced back to classical Greek sculpture. Originally, they would have been carved in stone but now they are more likely to be modelled in clay and then cast in bronze, sometimes in small editions. Portrait sculpture has always existed in other cultures, too. Egyptian, African and Mexican sculpture spring to mind, and, as these have all become accessible through museums and publications, they have had an enormous influence on twentieth century western sculpture by introducing new and different forms. Equally new and different materials are now available to sculptors. However, portrait busts still and will always continue to be sculpted within the classical convention, too.

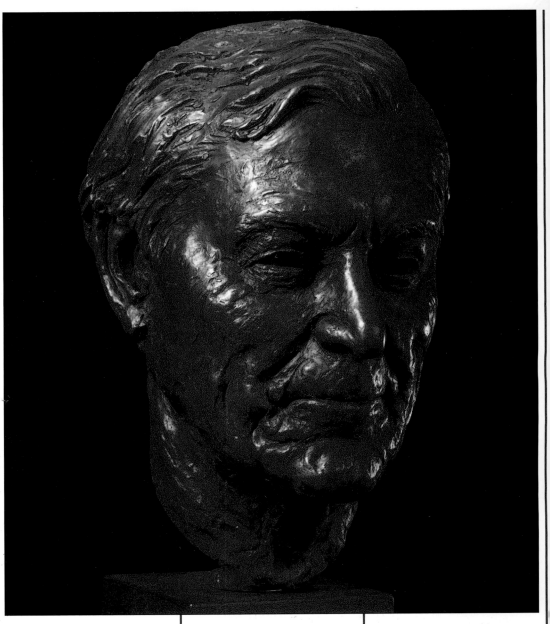

▲ PATRICIA FINCH • **Sam Wanamaker**
This cold cast bronze sculpture has all the attributes of bronze but the advantage of being much lighter in weight. It was modelled from life in clay and a plaster mould was made of the clay original. The mould was used to produce a resin and bronze cast, which has been mounted onto a block of wood.
Life size

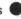

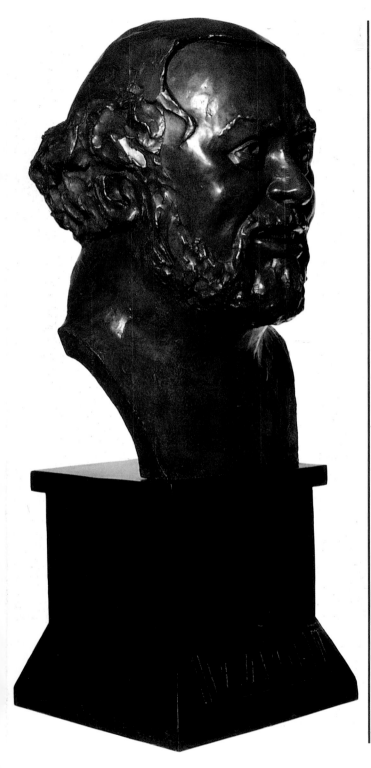

◄ GERALD LAING • **Portrait of Luciano Pavarotti**
This portrait of the opera singer has been modelled from life in clay. The sculpture is 1½ times life size. The clay original has subsequently been cast in bronze, a traditional sculpture material. The oversized head and the way it has been mounted give the sculpture a magisterial quality, in keeping with the subject and the classical tradition of sculpture.
1½ life size

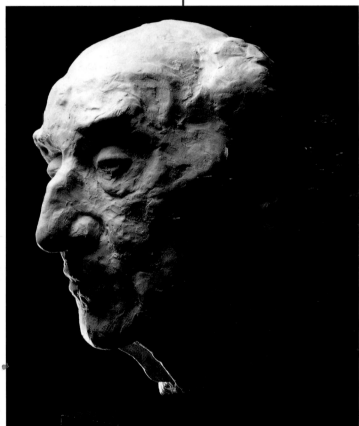

▲ MARTIN YEOMAN • **Sir Brinsley Ford**
A portrait of the sitter was originally modelled in clay, from which a rubber mould was made, and is shown here as a plaster cast of the original. It was later cast in bronze. Note how the surface of the sculpture highlights the depth of feeling and intensity which went into the clay modelling.
33cm (13in) high

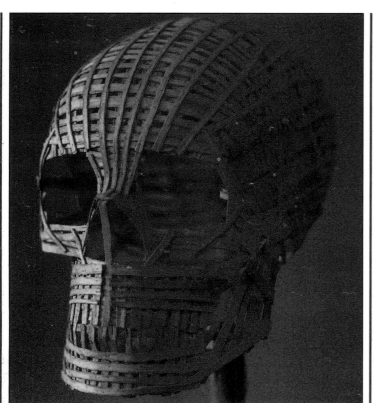

◀ CHRIS DUNSEATH • **Veneer skull**
Concentrating on the structure of the head, this sculpture is made from laminated ash veneer. Strips of the veneer were laid over a plaster skull, coated with wood glue and then covered with more strips and held in place with pins until the glue had set. This process was repeated over the whole sculpture. After removing the pins, the laminated sections were removed from the skull, and reassembled.
33 × 20 × 14cm (13 × 8 × 5¾in)

▶ PAUL BARTLETT • **Janus Variation from Metamorphosis Series**
A rubber mould was made of an imaginary head modelled in clay. This mould was used to produce plaster casts. Each of the cast heads has been given individuality by carving into the plaster surface. The heads have been arranged to produce a sculpture that takes its inspiration from Janus, the character in Greek mythology.
Each head 38cm (15in) high

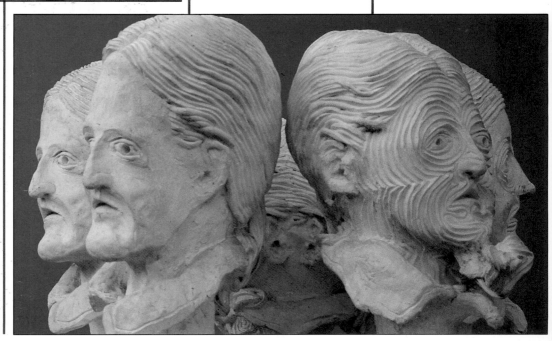

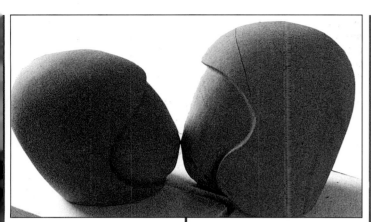

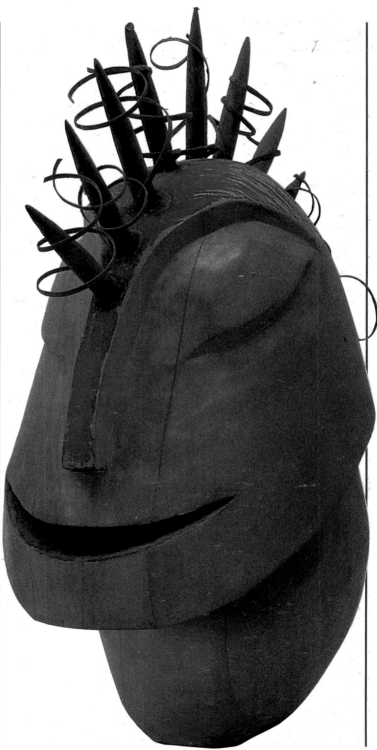

▲ MAX BARRETT • **The Kiss**
This sculpture relies on the positioning of the two forms for maximum effect. The stylized forms, which have been carved from sandstone, show the influence of art from other cultures, notably the Oceanic.
40 × 63.5 × 22cm
(16 × 27 × 8½in)

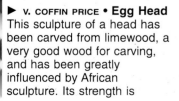

▶ V. COFFIN PRICE • **Egg Head**
This sculpture of a head has been carved from limewood, a very good wood for carving, and has been greatly influenced by African sculpture. Its strength is enhanced by the addition of wooden spikes wrapped in pieces of cane. Ink has been used to colour the surface.
33 × 28 × 15cm
(13 × 11 × 6in)

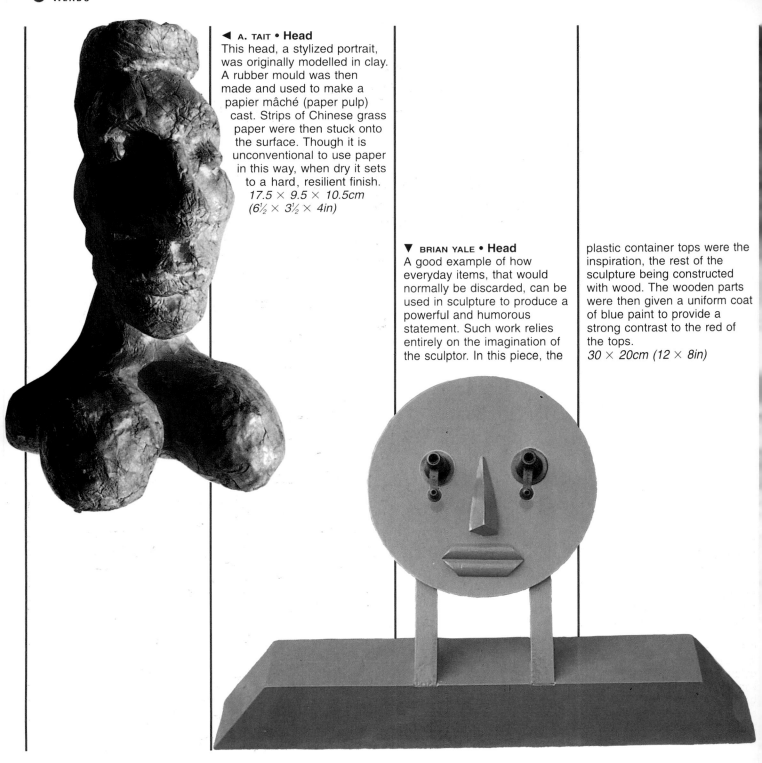

◄ **A. TAIT • Head**
This head, a stylized portrait, was originally modelled in clay. A rubber mould was then made and used to make a papier mâché (paper pulp) cast. Strips of Chinese grass paper were then stuck onto the surface. Though it is unconventional to use paper in this way, when dry it sets to a hard, resilient finish.
17.5 × 9.5 × 10.5cm (6½ × 3½ × 4in)

▼ **BRIAN YALE • Head**
A good example of how everyday items, that would normally be discarded, can be used in sculpture to produce a powerful and humorous statement. Such work relies entirely on the imagination of the sculptor. In this piece, the plastic container tops were the inspiration, the rest of the sculpture being constructed with wood. The wooden parts were then given a uniform coat of blue paint to provide a strong contrast to the red of the tops.
30 × 20cm (12 × 8in)

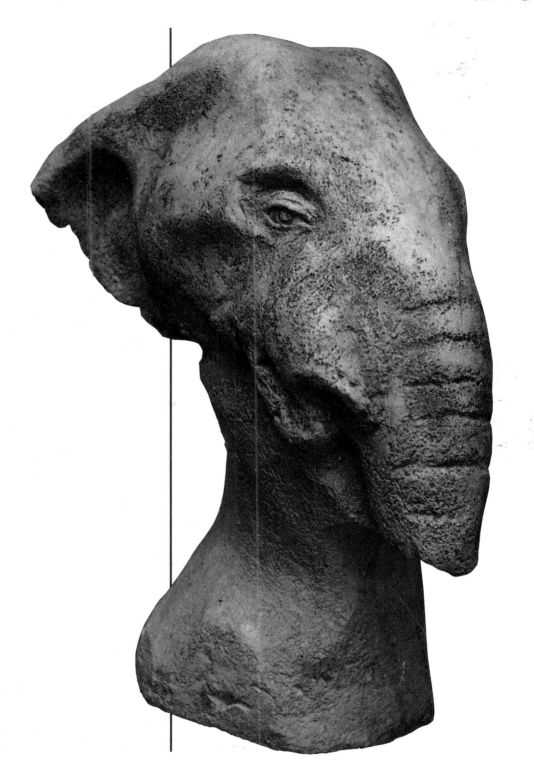

▶ **DEBORAH SCALDWELL** ●
Elephant Fossil
A sculpture whose inspiration came from the skull of an elephant, it was modelled in a coarse clay. A plaster waste mould was made to produce this plaster cast. Once the plaster had dried, the sculpture was sealed with shellac and coloured with oil paints to simulate the appearance of bronze. Although a small sculpture, its subject gives it a real sense of monumentality.
53.5cm (21in) high

FIGURATIVE

The human form has been the basis of art since the beginning of time, and across all cultures. The first figures were carved in stone and the tradition of figurative sculpture continues to this day. A diverse range of sculpture is made nowadays, ranging from the classically inspired to figures fostered by new materials and technology, as well as by contemporary issues which the artist wishes to address. There is still a tradition of figurative sculpture being made for public spaces, carved in stone or cast in bronze. Some contemporary sculpture incorporates casts taken directly from the figure. Much can be learned from direct observation of the human form, and there is a vital correlation between the structure of a figure and sculpture, whether abstract or figurative. This is particularly relevant when using an armature and a modelling technique, where you place the materials used under the same stresses and strains as occur in the figure itself.

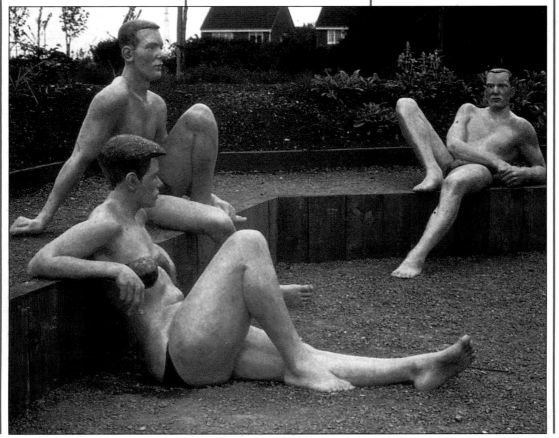

◀ JON BUCK • **Looking to the Future**
This sculpture is sited in a public space. Its figures were originally modelled in clay then cast in resin. Each figure is reinforced with a concrete core, and has been coloured to produce a very naturalistic appearance and this, coupled with natural relaxed positions, gives a sculpture which is the antithesis of the more common formal bronze or stone public figurative sculptures.
Over life size

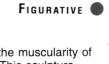

◀ **CHARLES HAZZARD** •
Connections
Each of these realistically modelled figures has been cast in resin with white pigment added to the first (gel) coat of the cast. Further colour has been added to the cast to emphasize the muscularity of the figures. This sculpture demonstrates the role that a base can play, defining an area within which sculptural elements can operate.
Life size

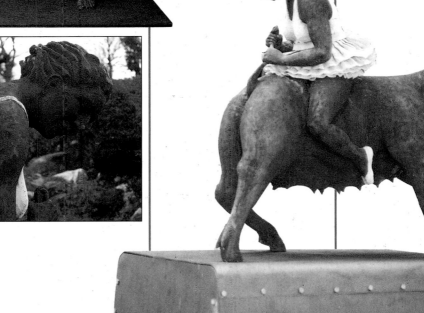

▶ JULIE WESTERMAN • **Bringing Home the Bacon**
Cast in *ciment fondu* this sculpture makes a striking contrast to the many sculptures of generals riding on horseback. The bodice of the tutu has been modelled with resin and bronze powder, the skirt is made from bronze mesh and the whole tutu has been patinated. An unusual surface has been obtained by coating the rest of the sculpture with a mixture of resin and iron filings. Exposure to the elements has caused the iron filings to rust.
Life size

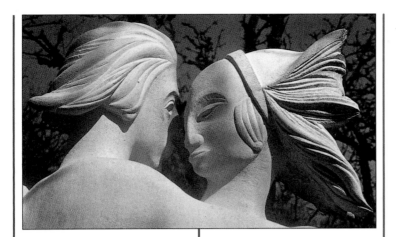

▲ ▶ JOHN SKELTON • Winter Dreams
This sculpture was inspired by the ballet of the same name to music by Tchaikovsky. From photographs and a life model, a full-size drawing was made of the sculpture and transferred to the block of Portland stone before carving commenced. Notice how the drapery has been used not only as a compositional device but also as a very important structural support for the sculpture.
200 × 63.5 × 30cm (80 × 27 × 12in)

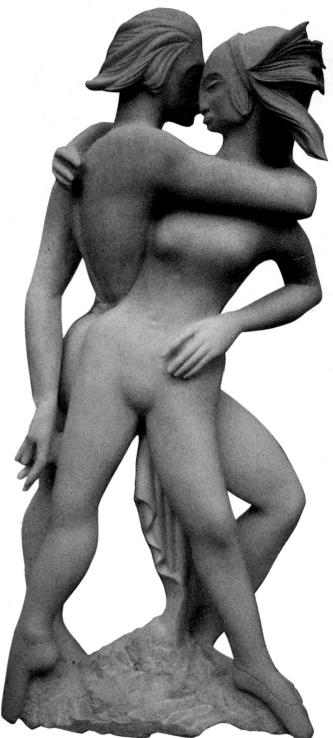

▼ ELIZABETH WATSON • Figures at a Table
This sculpture invokes that sense of intensity that can occur between two people seated at a table. The sculpture was modelled in clay and a waste piece mould was used to make a cast in *ciment fondu*. The sculpture was then lightly coloured with pigments fixed with polyurethane varnish thinned with white spirit. The base is an integral part of the sculpture.
38 × 33 × 44cm
(15 × 13 × 17½in)

▲ PHILIP COX • The Green Children
Papier mâché, made from recycled cardboard boxes, has been applied directly onto a cardboard armature in this work. The vivid colours of this dramatic sculpture are produced by adding small pieces of torn-up papers to the papier mâché mix.
Life size

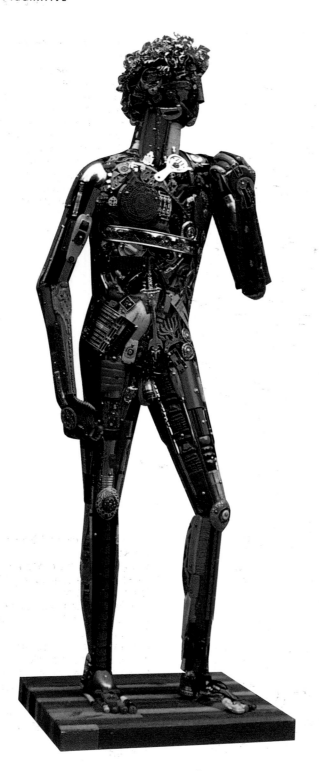

◄ LEO SEWELL • **Man**
Inspired by the stone carving of *David* by Michaelangelo, this assemblage uses found objects which have been screwed onto a wooden armature. All of the objects have been chosen and positioned with care to relate to a particular part of the anatomy.
Life size

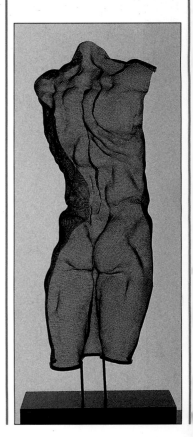

► DAVID BEGBIE • **Tight Truncus**
This torso of a figure is very much in the classical tradition. The subject matter, the figure, is solid and heavy though the material used, steel mesh, is light and airy. The mesh has been worked to produce the undulating surface of the human form.
83 × 32.5 × 21.5cm (33 × 13 × 8½in)

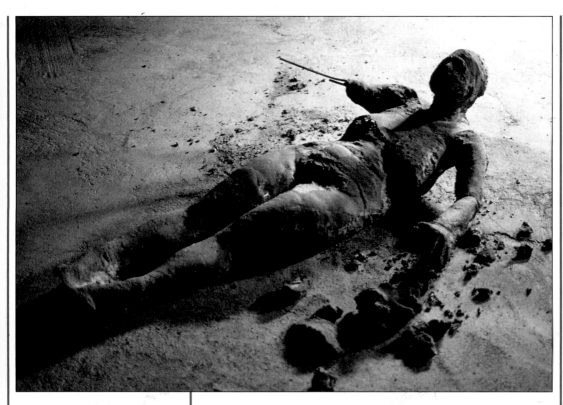

◀ LAURA DIMEO • **Remnants of Time**
A plaster cast was taken directly from the figure and used as a mould to make a concrete cast. The arm of the figure has been smashed to reveal the steel reinforcing rod, and the resultant debris becomes part of the final piece, suggesting the remains of some lost ancient culture one might encounter on an archeological dig.
155 × 43 × 100cm
(62 × 17 × 39in)

◀ KATE STEPHENS • **Strawberry Flesh**
Using plaster-impregnated bandage, this sculpture (which is an element of an installation) was cast, in two halves, directly from a figure. The two parts were reassembled, then plaster, scrim, and more plaster bandage were added crudely to the fine surface of the life cast. Part of this rough surface has been pulled back to reveal the smooth surface of the cast underneath.
Life size

▶ CORNELIUS GUISTE DE'JERSEY
• Hands on Earth

This sculpture was carved from a block of limestone, and great care was given to producing a naturalistic form for the two hands. The central stone column is used not only as a support but as a compositional device conveying a flowing movement through the hands. Fragments of stone are scattered around the base of the sculpture to reinforce this sense of movement. These are all pieces cut away from the original block.

65cm (25½in) high

▶ SHAUN WILLIAMSON ●
Medieval Knight
This large block of Ellel sandstone was carved directly, without any prior planning of the final form of the sculpture. This can be seen in the definite references to the original geometry of the block of stone. The sculpture takes as its inspiration the crusader knights of eleventh century England.
180 × 91.5 × 61cm
(6 × 3 × 2ft)

◀ JON BUCK ● **Bird Embrace**
This composition of stylized animal forms was modelled in clay and a mould made for a cast in plaster. This was worked further to develop the forms. Note how the relationship of the two forms draws the eye around the sculpture.
70cm (28in) high

RELIEF

Relief has its roots in architecture where it was used as a way to incorporate sculpture into the fabric of a building. Because stone and wood were the construction materials of buildings, relief sculpture is tied historically to the technique of carving, although modelling has also been used. Relief has only one viewpoint and uses three dimensional form combined with an element of spatial illusion that you would find in two dimensional art forms.

▶ DAVID HEATHCOTE ●
Tribhanga
This relief makes good use of real and illusory space. It was initially modelled in clay, and a mould was then made to produce a plaster cast. This was carved to refine and further define the forms and surface in an interesting combination of modelling and carving techniques.
71 × 35cm (28 × 14in) high

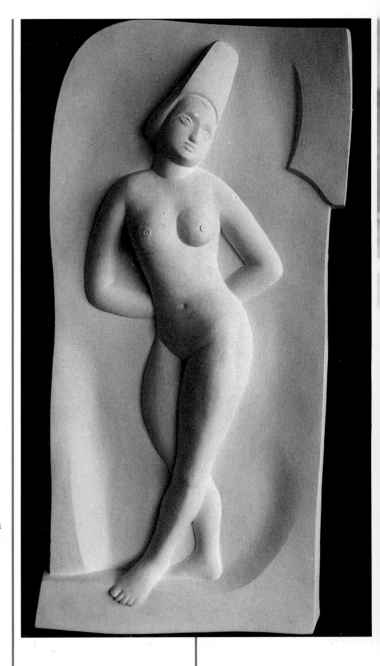

▶ PATRICIA COX • **Family Traces**

This mixed media relief sculpture explores aspects of the sculptor's family history. It is reminiscent of the niches one might find in a church. Noses have been cast from life, using plaster bandage, and placed in some of the openings. In the other openings are cast plaster slabs, which have had photocopies of family photographs applied to them. Each piece is back lit by a small light.
67 × 56cm (26½ × 22in)

▼ SASHA CONSTABLE • **Bath Piece**

This stone-carved relief shows good use of the high relief technique, some of the forms rising well above the surface of the background. The profile of the bath has been used as a framing device that is an integral part of this sculpture's composition.
7.5 × 72 × 35.5cm (3 × 28½ × 14in)

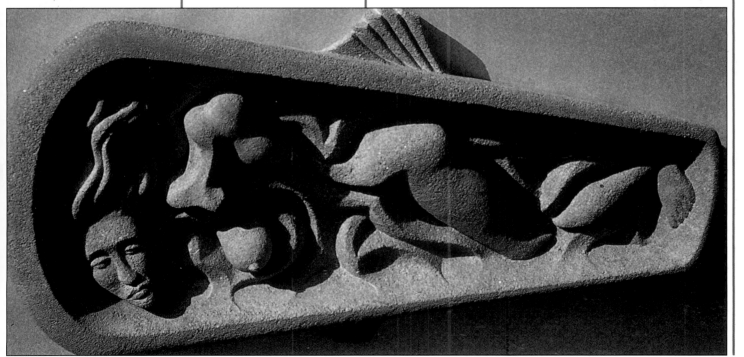

141

◄ ROBERT KOENIG • **Portal No. 5**
This relief, carved in wood, establishes a narrative within the overall composition, seen in the position of the figure at the base, the use of colour and the roughly carved motifs. This type of relief relies less on the relationship between real and illusory space and more on images and meanings.
28.5 × 1.45m (110 × 56in)

► ROBERT KOENIG • **Portal No. 7**
This relief alludes to a specific architectural function and relies for its overall impact on the symmetrical arrangement of a repeated motif carved into the wood. The use of colour is very skilful and, together with the marks left by the carving gouge, enhances and brings together the whole composition.
3.2 × 1.5m (124 × 61in)

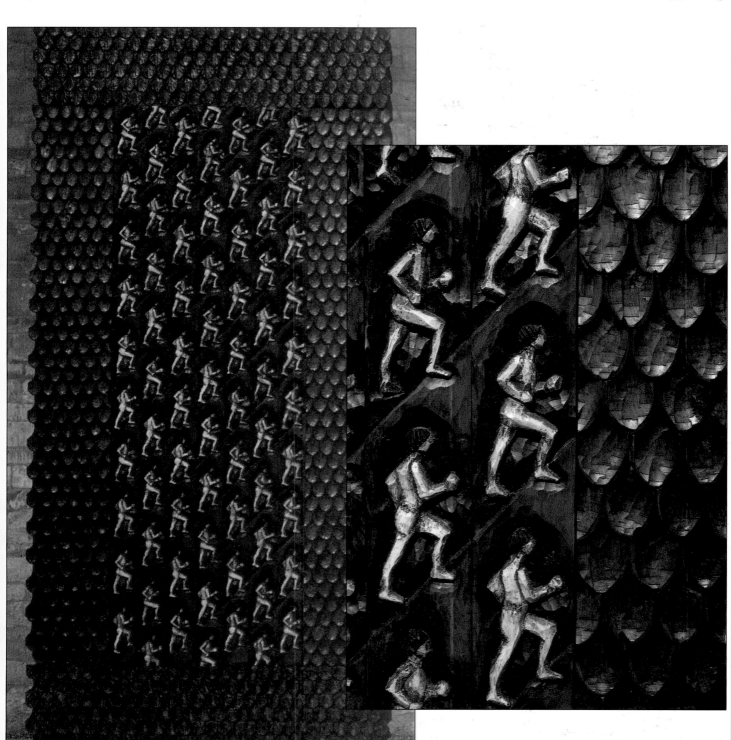

WALLHANGING

▶ BRIAN ORD • **Ikebena**
The success of this type of sculpture – an assemblage of found objects, made from diverse materials – depends a great deal on the choice of objects and the relationship they have with one another in the sculpture.
61 × 61 × 30cm
(24 × 24 × 12in)

Wall-hanging sculpture is a comparatively recent development using construction or assemblage techniques. A wall-hanging does not have the same emphasis as a relief on the relationship between three-dimensional form and illusory two-dimensional form. Its main concern is to focus attention on the relationships between parts that comprise the sculpture and this is facilitated by the limited number of positions from which to view it. A trend that is becoming more prevalent nowadays is to use the wall as an integral part of the composition.

▼ GUY TAPLIN • **Flying Sanderlings**
The seabirds have been carved from driftwood, which has been coloured and waxed. These have been combined with a fragment from a boat's hull found on the shore to produce a sculpture with a form which is in harmony with its material.
140 × 102cm (55 × 40in)

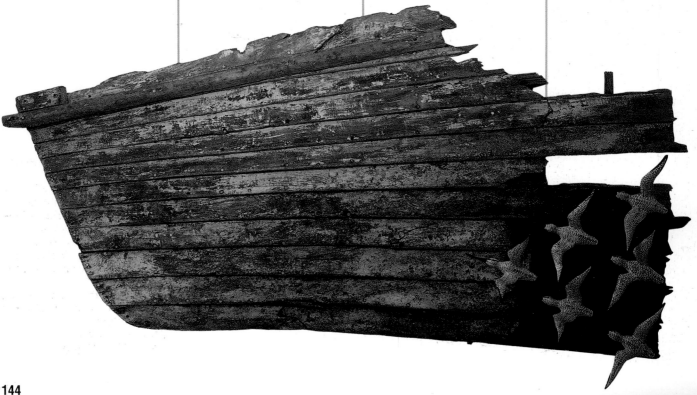

▶ ROSEMARIE McGOLDRICK • **In Memoriam: Kathleen**
A profile is painted onto a wall with graphite and, within this shape, are placed various forms made from welded mild steel sheet, derived from dress patterns, memorial stones, and English church interiors. Each form has been sandblasted to produce a rough pitted surface, as can be seen in the detail.
3.1 × 5.2m (10 × 17ft)

◀ DEAN WHATMUFF • **30 Years in the Bathroom**
This sculpture shows effective use of a ready-made object. It relies on the recognition of the identity of the basket and fabric and at the same time the contrast of their differing surfaces and textures. Notice how the direction of the dominant grain of the basket is used within the composition of the sculpture.
88 × 54 × 44cm
(34 × 21 × 17½in)

145

ANIMALS

Closely aligned with the figurative tradition, animal sculpture has always been popular, allowing for more freedom of expression, both in terms of materials and techniques and styles, whether representational, stylizations or abstract. Using an animal theme within sculpture means a greater range of forms is available – from animals kept as pets, like cats and dogs, semi-domesticated animals such as horses and birds or wild animals.

◀ PHILIP COX • **Elephant and Calf**

The success of this sculpture, directly modelled using laminated paper glued together, rests on the construction of a strong armature made from cardboard which delineates the main forms of the sculpture. Notice how the paper has been ruffled to mimic the texture of an elephant's skin. The tusks of the larger elephant have been painted white.

Life size

◀ DAWN BERESFORD • **Elephant**

This elephant sculpture is an assemblage of found objects. The strength of the elephant form over the objects is such that it is only on close inspection that you detect the beaten and bent dustbins, car hub caps, car exhausts and so on. As with all assembled sculpture fixing the disparate elements together is a problem, and in this sculpture a variety of techniques have been used – welding, riveting, brazing and wire.

152 × 183 × 91.5cm
(60 × 72 × 36in)

▶ DAVID KEMP • **Fire Chariot**

This welded steel constructed sculpture makes clever use of scrap metal and old agricultural machinery to produce a chariot and animal form with the appearance of a relic from the late Iron Age. The fire relates to those ancient mythologies where "chariots pulled the sun across the heavens".

2.3 × 2.1 × 1.6m
(91 × 83 × 63in)

147

▶ BEN JAKOBER and YANNICK VU • **Il Cavallo di Leonardo**
This dramatic piece of public sculpture in the form of a horse's head makes a direct reference to a drawing by Leonardo da Vinci and was the emblem of the 1993 Venice Biennale. It has been constructed in a regular grid-like format from steel tubing, very reminiscent of builder's scaffolding.
14 × 8.9 × 7.72m
(46 × 29 × 25ft)

◀ SOPHIE RYDER • **Blue Horse**
This truly animated sculpture gives a real sense of a horse rolling in grass. The piece has been made from bed springs and wire, which have been manipulated to focus attention on the naturalistic forms of the sculpture. Once made, the sculpture was galvanized – an industrial process whereby a zinc coat is applied to metal objects – then painted.
Life size

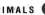

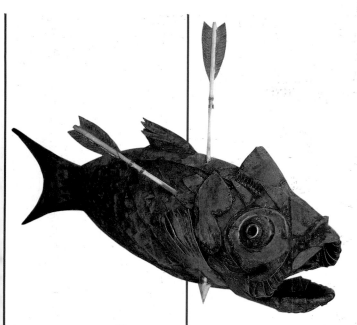

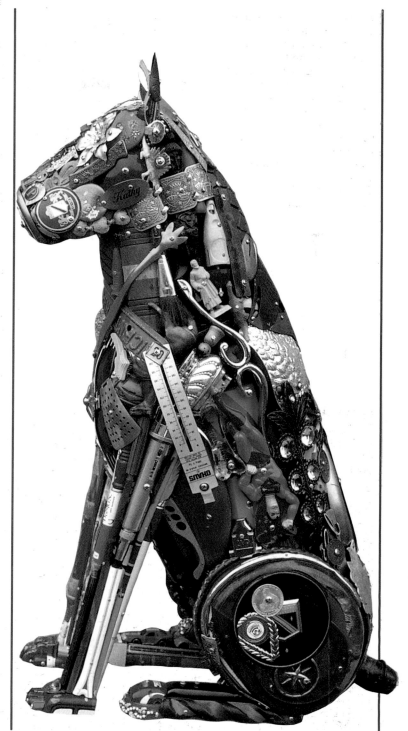

▲ MARTIN RAYNER • St Sebastian's Fish
Copper sheet is an extremely malleable and flexible material, easy to bend and cut into shape. The copper sheet used in this sculpture was taken from old water tanks and joined using pop rivets – the most efficient way of joining sheet material.
111.5 × 4 × 7cm
(44 × 1½ × 2½in)

▶ LEO SEWELL • Boxer
As with any assemblage sculpture of this type, the strength and stability of the armature is all important. In this sculpture of a dog, the armature is a discarded piece of furniture, onto which the found objects have been screwed firmly into place. These have been selected not for their identity but for their role in describing the form of the sculpture.
78.5 × 28 × 56cm
(31 × 11 × 22in)

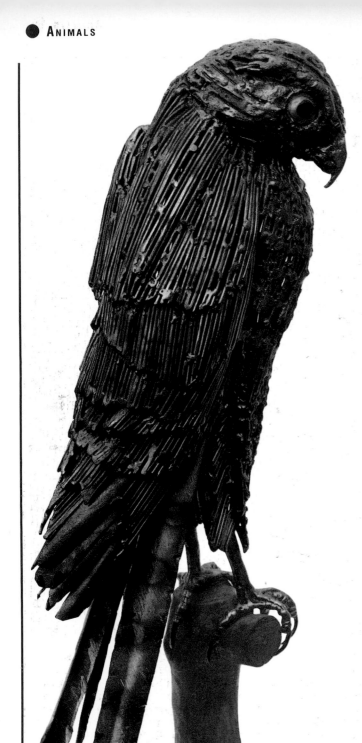

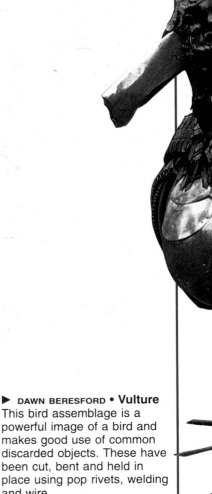

◄ HAMISH GILCHRIST ●
Sparrowhawk
This naturalistic representation of a sparrowhawk has been constructed using mild steel rod and sheet, joined together using oxy-acetylene and MIG welding techniques. The claws have been made from brass and a texture has been applied to the bird using copper that has been melted and then dropped onto the surface. These techniques both take full advantage of the low melting point of copper and brass.
40cm (16in) high

► DAWN BERESFORD ● **Vulture**
This bird assemblage is a powerful image of a bird and makes good use of common discarded objects. These have been cut, bent and held in place using pop rivets, welding and wire.
183 × 91.5 × 91.5cm (72 × 36 × 36in)

▲ ANTHONY STEVENS • **Kate's Bears**
Sited in a school, this sculpture cannot help but bring a smile to our faces. After being modelled in clay, a mould was made of each of the bears and then a resin cast made. The first coat of resin (the gel coat) had black pigment added. The sculpture was given a final coat of black epoxy marine paint.
2.1m (7ft) high

TOTEMIC

"Totemic" is a term used to group together sculptures which have a definite vertical configuration. Its origins are the standing figures within most sculptural traditions. A totemic sculpture may be abstract or contain abstract forms but it will still refer to the figure. Most likely to be carved from a vertical block, it is a format that brings limitations to construction or assemblage where you have to be sensitive to the pull of gravity when joining disparate objects or forms together. The use of a base can greatly help this problem, however, providing stability and support for a sculpture that may otherwise fall over.

► LAURA WHITE • Meditation
Ancaster stone has been carved into a spiral form, which continues, as though unravelling, into the carving of the pitch pine wood. There is a clear demarcation line across stone and wood, one side rough, still showing traces of the tool marks, the other smooth. The stone is pinned to the wood, enabling it to stand vertically.
76 × 33 × 35.5cm
(30 × 13 × 14in)

◄ ANTONY DENNING • Woman from Wardour
This elm wood carving makes good use of the original vertical format of its wooden block. It is an abstraction of the female figure, the base of which has been carved to give maximum stability. The surface has been rubbed down and polished to enhance the grain and emphasize the verticality of the sculpture.
90cm (35½in) high

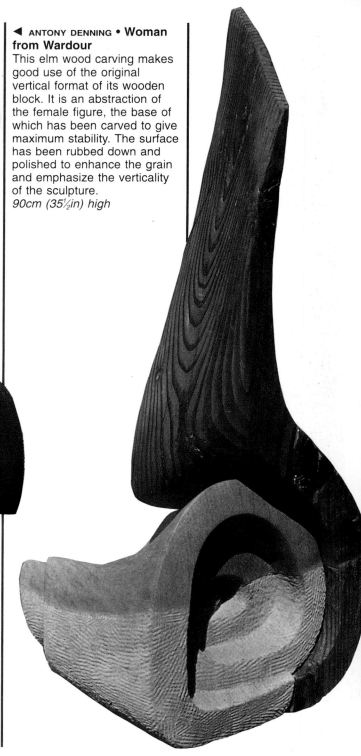

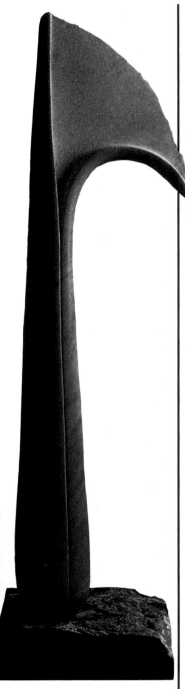

◀ JAYA SCHUERCH • IV
A wonderfully evocative carving of a flower form in Portuguese marble, it has been very delicately carved, especially around the top edge. The surface has been rubbed down and polished to highlight the colouring of the outside surface, providing an interesting contrast with the inside. The sculpture's vertical format is entirely dependent on the base on which it stands.
26 × 24 × 96cm
(10.2 × 9.5 × 38in)

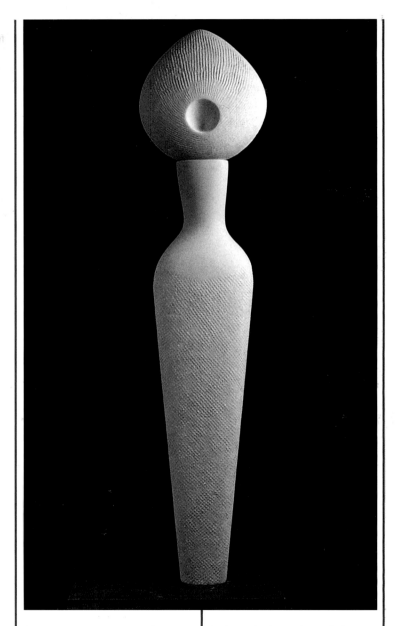

▲ BARBARA HODGKINS •
Sentinelle 11
Two pieces of green marble have been carved to produce this vertical abstract form. The top section looks precariously balanced but is, in fact, attached to the main part. The tool marks have been left on the surface and provide a contrast with the polished interior surface of the top section.
111 × 30 × 45cm
(44 × 12 × 18in)

USE OF COLOUR

Because only traces of colour can be found on classical sculpture we have no idea of their finished effects. For centuries after, the main materials of sculpture were bronze or stone and colour never played a part. It is only during this century that colour has again become a part of the sculptor's vocabulary, due partly to the influence of coloured sculptures from non-western cultures and partly to new materials and techniques. In sculpture, colour can enhance a particular form. It can act as a compositional device, a single colour uniting disparate elements. Colour can also be used to heighten the drama inherent in a sculpture.

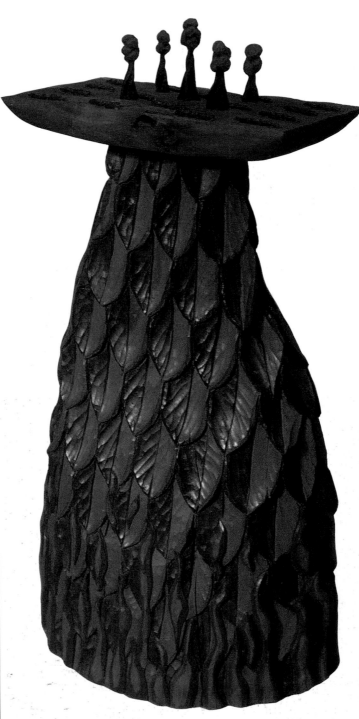

◄ **ROBERT KOENIG • Sacrifice**
Limewood is carved into an altar form, the base of which has stylized leaves and flames carved into and around the base. Colour has been used here to differentiate between the leaves and flames because of their similarity of form. The stylization of the sculpture becomes complete with the addition of colour to the trees on the altar itself.
126 × 64 × 36cm
(49½ × 25 × 14in)

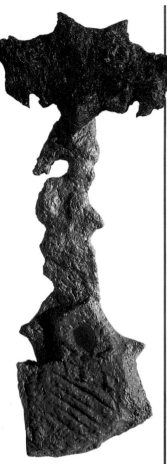

◀ **A. TAIT • CUAF collageN**
This wall-hanging sculpture was inspired by a collage of cut paper and paint and developed into three dimensions by adding papier mâché to a cardboard profile of the original collage. The sculpture was coloured to correspond to the colours in the original collage.
51 × 22 × 4.8cm
(20 × 8½ × 2in)

▼ **V. COFFIN PRICE • The Fishpond**
This sculpture started life as a block of expanded polystyrene, carved into the shape of a bowl, to which plaster was added. The plaster on the exterior of the bowl has been smoothed into shape, while the interior required more detailed modelling and shaping to define the forms of the water and the fish. Colour has been used to highlight and differentiate the various forms contained within the sculpture.
40 × 119 × 119cm
(16 × 47 × 47in)

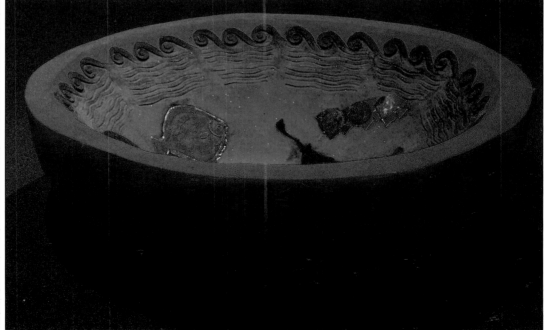

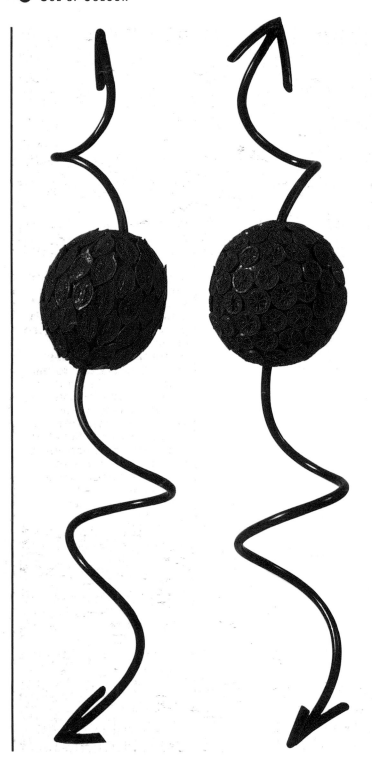

◀▲ AMANDA LORENS • **Skin and Flesh Lemon Zest**
You feel this sculpture has no chance of standing up – until you realize that it is supported by a line to the ceiling. The colour combines with the form to produce a very dramatic sculpture indeed. The spiralling orange arrows are made from plastic tubing. The spherical resin and fibreglass shapes have been built up around a balloon. Resin casts of lemon slices have then been added to the shapes. Bright yellow pigment in the resin gives this very vivid colouring.
1.8m (6ft) from floor

▶ AMANDA LORENS • **Fruits of Fire**
The steel chain used in this sculpture looks very improbable, a form that gives the impression of defying gravity. The small ball at the end of the chain is fibreglass resin. The large supporting spherical shape was made by first welding a mild steel framework together onto which plaster has been applied.
1.8m (6ft)

▲▼ JEZ NOOND • **The Natural History of Viruses**
In this comment on the ills of present-day society, the main part of each section is a found object, an aluminium hemisphere. One has been lined with plaster cast to the interior form, while the other has had a steel rim added. The artist has made very effective use of the colour of the cut cable and PVC which, when massed together inside each of the hemispheres, make for a dramatic visual experience.
Each piece 66 × 33cm (26 × 13in)

159

ORGANIC

Naturally occurring forms
have long been a source of
inspiration for sculptors. This
is particularly true of abstract
work. Organic sculptures have
the feel and look of naturally
occurring forms, rounded or
soft edged. There is a vast
array of such forms which are
sculptural in their essence, or
have the potential to be
developed into sculpture. By
observing nature, we are able
to understand the complexities
of these forms and the
relationships they have with
one another. The sculptor's
eye is able to discern those
aspects of plant life, rock
formations, seed pods or
vegetables that can be
translated into sculpture.

▼ LAURA WHITE • **Untitled**
This piece, modelled in clay, is
a maquette for a larger
sculpture to be carved in
stone. The forms make a
direct reference to plant and
animal life. The curled shape
on top is reminiscent of a leaf
and the segmented form puts
one in mind of a fossil.
*25 × 18 × 15cm
(10 × 7 × 6in)*

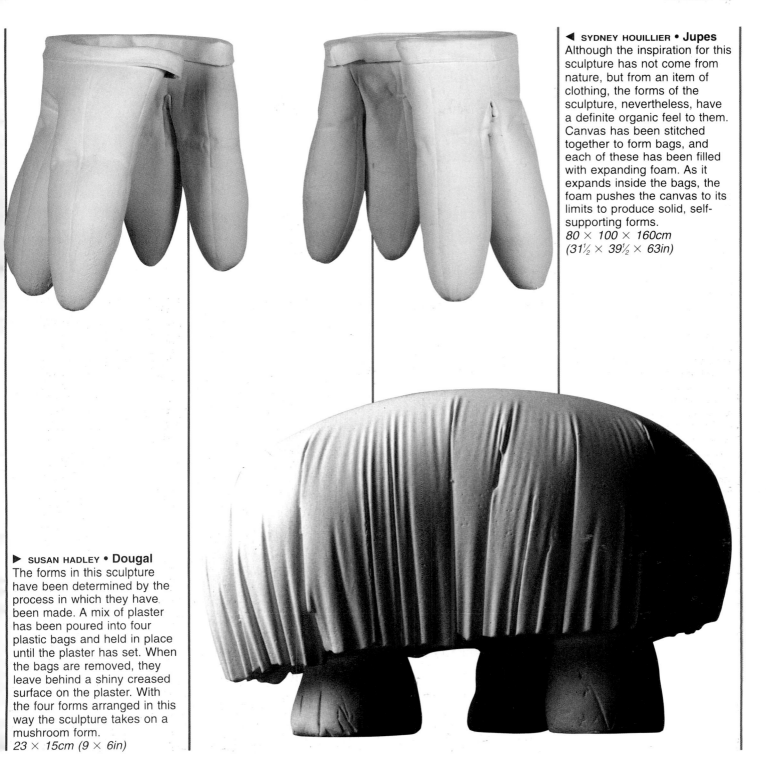

◀ SYDNEY HOUILLIER • **Jupes**
Although the inspiration for this sculpture has not come from nature, but from an item of clothing, the forms of the sculpture, nevertheless, have a definite organic feel to them. Canvas has been stitched together to form bags, and each of these has been filled with expanding foam. As it expands inside the bags, the foam pushes the canvas to its limits to produce solid, self-supporting forms.
80 × 100 × 160cm (31½ × 39½ × 63in)

▶ SUSAN HADLEY • **Dougal**
The forms in this sculpture have been determined by the process in which they have been made. A mix of plaster has been poured into four plastic bags and held in place until the plaster has set. When the bags are removed, they leave behind a shiny creased surface on the plaster. With the four forms arranged in this way the sculpture takes on a mushroom form.
23 × 15cm (9 × 6in)

161

LANDSCAPE

In urban areas we are used to coming across a piece of sculpture, sited in a shopping mall or a public square. But more and more sculpture is being made specifically to be sited within a landscape setting. In some cases the setting itself will have been the source of inspiration for the sculpture. Sculpture can also be made which would interrupt or interfere with the natural order of the landscape to produce a new order. In both cases, there is no doubt that some sculpture benefits from being exhibited outdoors in a natural rather than an urban environment, where it enhances or complements the beauty that surrounds it.

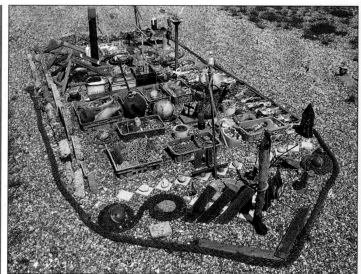

▲ BRIAN YALE • **The Mrs T.**
The subject matter of a ship fits in well with this assemblage made on the seashore. The profile defined by the rope has been filled in with a variety of found objects, some of which were thrown up on the beach by the tide.
9.2 × 3.6m (30 × 12ft)

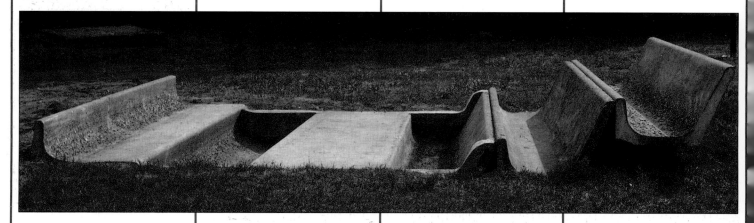

▲ DEREK HOWARTH •
Mashonack Deep
The natural order of the landscape has been interrupted – cast concrete forms and a steel construction have been submerged in the ground to produce a sculpture that contrasts the natural with the human-made.
3.1 × 2.4m (10 × 8ft)

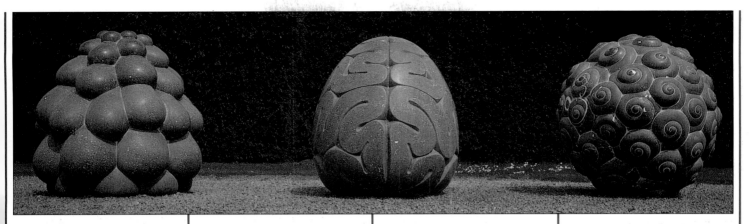

▲ PETER RANDALL PAGE • **Fruit of Mythological Trees**
These three organic forms have been carved in Kilkenny limestone to form one piece of sculpture. Each carving refers to naturally occurring forms that you would expect to find in a landscape setting, without making a direct reference.
Tallest 117cm (46½in) high

▼ PETER RANDALL PAGE • **Secret Life III**
The rough, naturally hewn exterior of each piece of this carved granite sculpture fits in well with the surrounding landscape. At the same time, it provides an interesting and dramatic contrast with the carved interior forms which have been smoothed to a high-polished finish.
114cm (45½in) high

▶ IAN MIDDLETON • **A Seat for the Princess**
This sculpture uses a repeated form to great effect, producing an upward moving sensation that complements the environment in which it is situated. The basic cushion form is a Portland cement cast reinforced with glass fibre. This was cast using a resin and glass fibre mould.
243 × 43 × 43cm (96 × 17 × 17in)

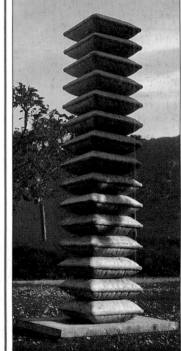

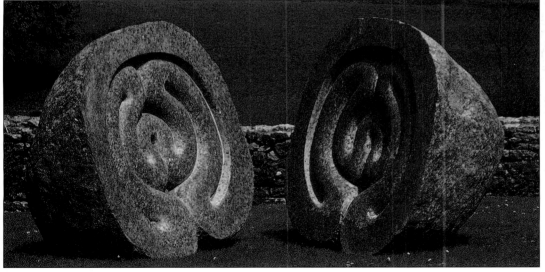

CONSTRUCTION

A development in sculpture dating only from this century, construction sculpture is not tied to the use of a specific material, and crosses the boundaries of all techniques and materials. It allows the sculptor great freedom of expression and has greatly added to the variety of sculpture that is now made. As its name implies, it basically involves joining materials together. Although usually associated with abstract sculpture, this technique often makes specific references to the world around us. Inevitably, constructed sculpture will contain forms that lean more toward the geometric than the organic.

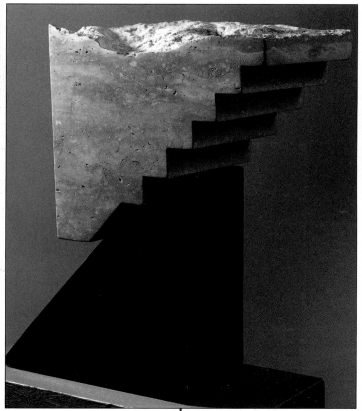

◀ SUBIRACHS • **Mil Lenari**
A sculpture carved in Calatorao stone and travertine, its two pieces have been joined together to very dramatic effect. The sculpture has an architectural element emphasized by the use of stone as a building material, the steps that have been carved on the top and the crisp, sharp, geometric forms of the sculpture.
*53 × 47 × 25cm
(21 × 18½ × 10in)*

▶ JOSEPH WESNER • **Yoken**
This abstract constructed sculpture is made of reclaimed wood which has been screwed, nailed and glued together. The sculpture forces you to focus on its purely physical sculptural qualities. This includes the nature of the material used, its rough hewn quality and the dynamic created by the ring of pieces holding the vertical stack together.
*43 × 99 × 81cm
(17 × 39 × 32in)*

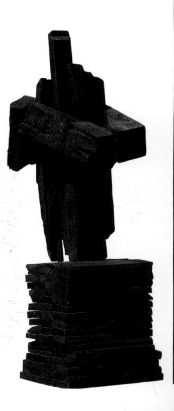

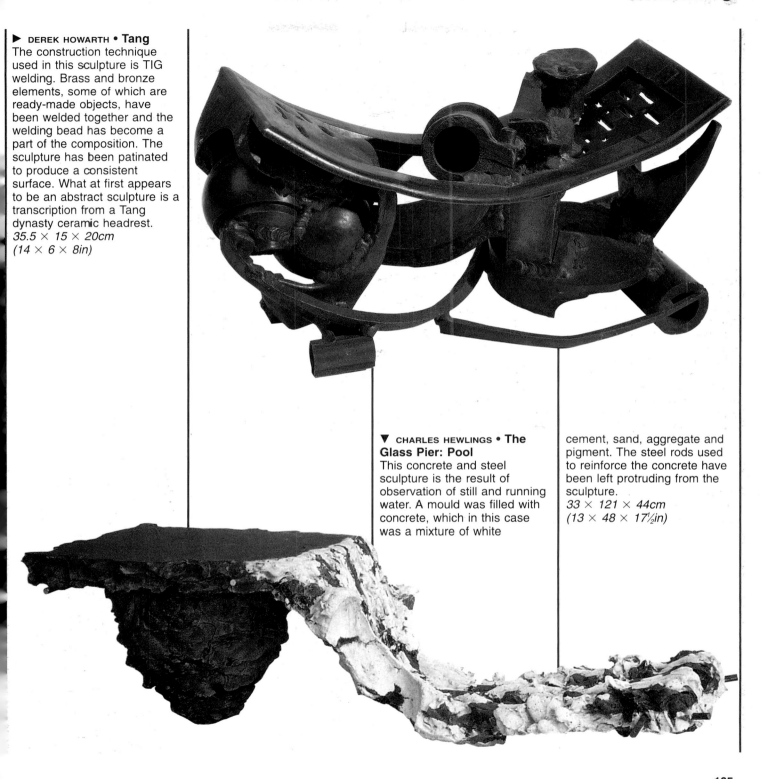

► DEREK HOWARTH • **Tang**
The construction technique used in this sculpture is TIG welding. Brass and bronze elements, some of which are ready-made objects, have been welded together and the welding bead has become a part of the composition. The sculpture has been patinated to produce a consistent surface. What at first appears to be an abstract sculpture is a transcription from a Tang dynasty ceramic headrest.
35.5 × 15 × 20cm
(14 × 6 × 8in)

▼ CHARLES HEWLINGS • **The Glass Pier: Pool**
This concrete and steel sculpture is the result of observation of still and running water. A mould was filled with concrete, which in this case was a mixture of white cement, sand, aggregate and pigment. The steel rods used to reinforce the concrete have been left protruding from the sculpture.
33 × 121 × 44cm
(13 × 48 × 17½in)

◄ GORDON McINTOSH • **Keeping Your Balance**
Vivid colouring and a variety of forms have been used to produce a playful, enigmatic sculpture, constructed mostly of wood, which has been cut and carved to shape and joined using nails. The nails also have a part to play in the form of the sculpture and it is interesting to see how the rope has been threaded through a piece of wood and then unspliced.
1.6m (5ft 4in)

▼ MICHAEL MARRIOTT • **Span**
This arch which grows out of and returns to the earth uses two geometric elements which alternate with one another to produce a specifically abstract sculpture. Each has been cast in resin, then painted and fixed to a central steel spine.
3 × 1.25 × 1m
(9ft 10in × 4ft × 3ft 3¼in)

▶ BRIAN ORD • **Defenestration of the Heart**
The familiar and the abstract are to be found in this sculpture constructed from wood and aluminium. The piece alludes to the workshop where the sculpture would have been made. The base takes the form of a saw bench, on top of which there have been constructed intersecting geometrical planes. These have been interspersed with real tools such as hammers and dividers.
1.2m × 1.2m × 91.5cm (48 × 48 × 36in)

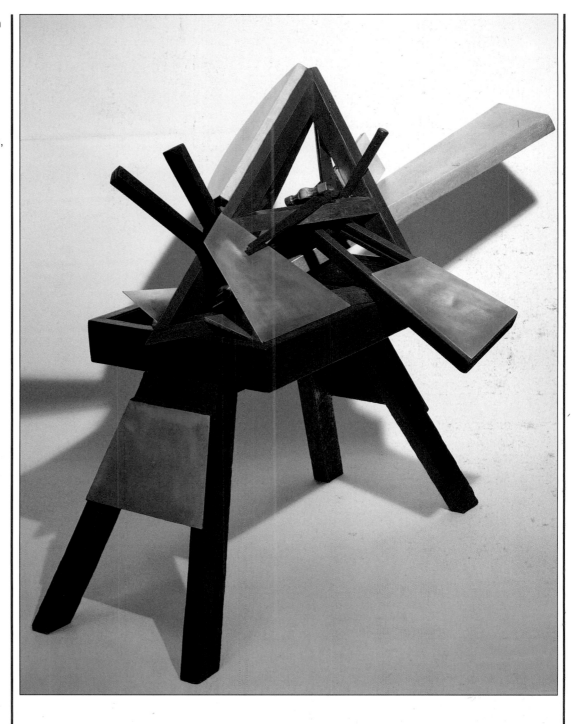

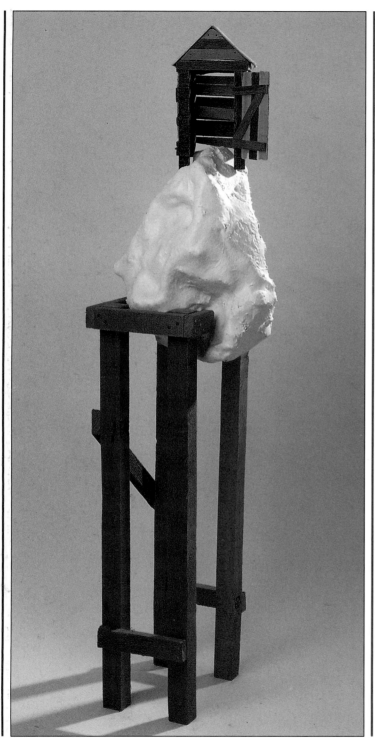

◄ WAYNE LLOYD • **Untitled (Journal)**
In this interesting combination of materials and techniques, the central mass is made from glass fibre, resin and pigment laid over a chicken wire armature. The table-like structure has been cut from sawn timber nailed together. The hut form has been put together from strips of wood.
*150 × 30 × 30cm
(3ft × 1ft × 1ft)*

▼ CHRIS LILLYWHITE • **Untitled**
This bringing together of found objects results in an enigmatic sculpture, which after prolonged study can be seen to allude to a figure, with the lightbulb and the vertical pole rising out of the roughly shaped tree trunk suggesting a body.
*61 × 25 × 25cm
(24 × 10 × 10in)*

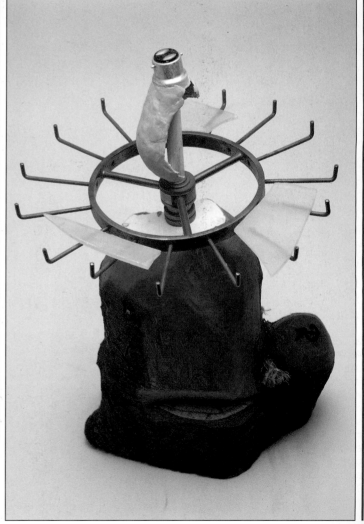

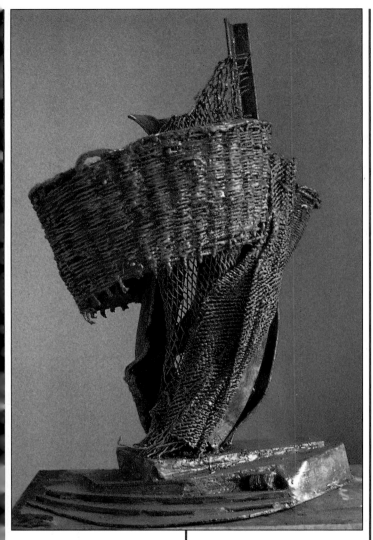

▲ JOSEPH WESNER • **Huanghe**
A variety of media have been
used in this construction
including steel, steel mesh and
wickerbasket. The objects and
materials used have been cut,
shaped and manipulated to fit
in with the composition. The
emphasis on the textures and
contrasts results in a tactile
abstract sculpture.
*107 × 71 × 61cm
(42 × 28 × 24in)*

▼ HILARY BROWN • **Thinking
Woman (The Wheel)**
Steel and recycled wood are
used in this sculpture whose
point of reference is the
traditional pose of *The Thinker*.
Each piece of wood has been
shaped, and then jointed and
bolted together. Sheet steel
has been bent and bolted onto
the wood.
*122 × 152 × 91.5cm
(48 × 60 × 36in)*

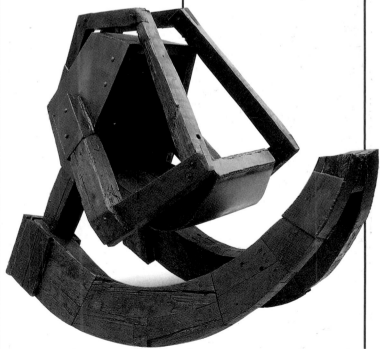

OBJECTS

It is possible to make a sculpture of an object or derivation of an object, even though the sculpture itself is, of course, an object in its own right. Such a sculpture does not depend solely on traditional sculptural attributes, such as form, surface, proportion, or space for a successful reading of it. Nevertheless, very interesting sculptures are made where, for instance, a particular technique or process may lend itself to making a particular form, or we may be drawn to admire the technical virtuosity that went into making the sculpture.

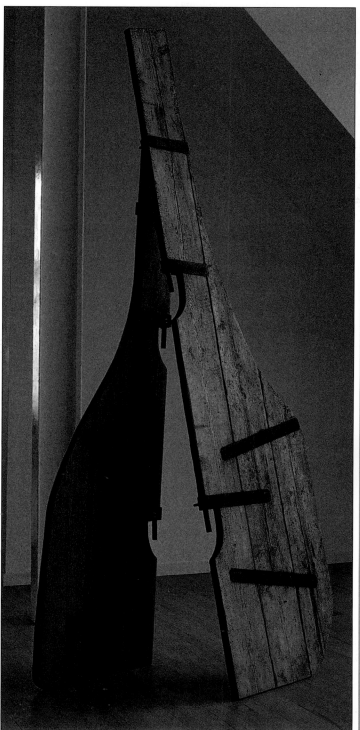

◄ ROBERT CALLENDER • **The Wooden Rudders with Rust**
They may look like found objects but they are not – the two huge rudder forms that make up this sculpture have been made from driftwood cut to shape. The pieces of wood are held together by strips of steel bolted on. The sculpture was left outside to allow the steel to rust and the wood to weather.
268 × 107 × 51cm
(106 × 42 × 20in)

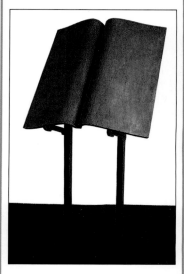

▲ DEAN WHATMUFF • **Untitled**
Objects have been used to make an object which in turn becomes another object – the sculpture. Two cupboard doors have been reversed and joined together, to produce what appears to be an open book. A lectern has been made from wood for the book to rest on and this has been coloured with wood stain, while the pages of the book have been bleached.
166 × 98 × 72cm
(65½ × 38½ × 28in)

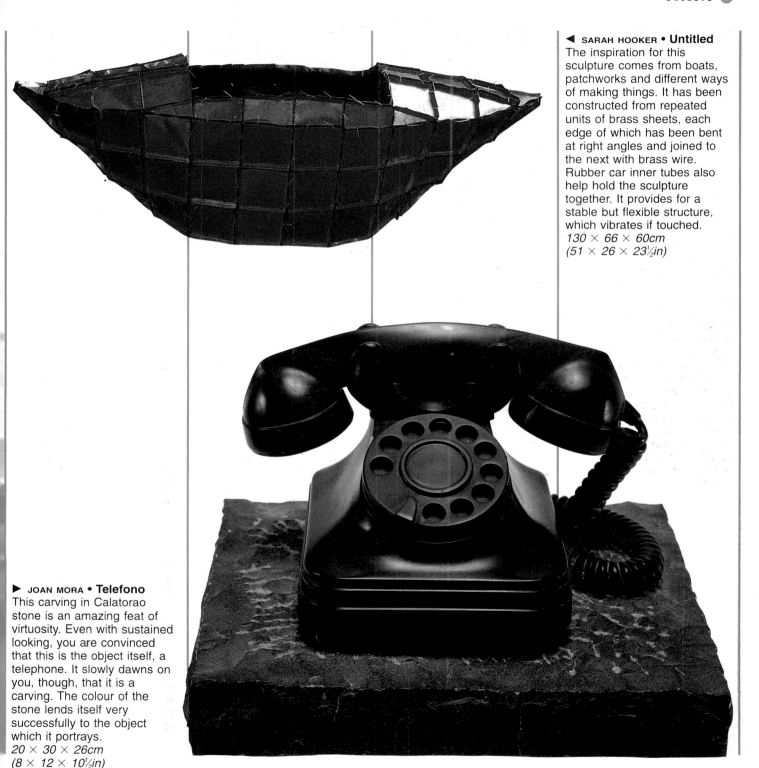

◄ SARAH HOOKER • **Untitled**
The inspiration for this sculpture comes from boats, patchworks and different ways of making things. It has been constructed from repeated units of brass sheets, each edge of which has been bent at right angles and joined to the next with brass wire. Rubber car inner tubes also help hold the sculpture together. It provides for a stable but flexible structure, which vibrates if touched.
130 × 66 × 60cm
(51 × 26 × 23½in)

▶ JOAN MORA • **Telefono**
This carving in Calatorao stone is an amazing feat of virtuosity. Even with sustained looking, you are convinced that this is the object itself, a telephone. It slowly dawns on you, though, that it is a carving. The colour of the stone lends itself very successfully to the object which it portrays.
20 × 30 × 26cm
(8 × 12 × 10½in)

INDEX

CREDITS

The author would like to thank the following individuals whose sculpture has been shown in some of the step-by-step techniques:

Katherine Fanthorpe 44–5 (brazing), 86–89 (stylized torso); Cornelius Guiste de' Jersey 110–1 (stone carving); Derek Howarth 122–3 (electric arc-welding); Nick Kubicki 92–3 (life figure); Alice Ramm 104–6 (hot pour rubber); Liz Watson 90–1 (portrait head)

Greg Harrington for modeling

and Nicola Streeten for her help and encouragement during the preparation of this book.

Quarto Publishing would like to thank all the sculptors who kindly submitted work for inclusion in this book.

We are also indebted to the following agents and galleries: Clive Adams, Ashwell, Herts; Differentiate Ltd, London; Bridget Fraser, Henley-on-Thames, Oxon; Sala d'Art Artur Ramon, Barcelona, Spain; Andrew Usiskin Contemporary Art, London; Rainyday Gallery, Penzance, Cornwall and Wolf at the Door, Penzance, Cornwall.

The following photographers have work reproduced in the book: Warwick Baggaley *135* above; Stefano Baroni *153* left; Bob Berry *168* above; Jerry Hardman-Jones (shot at Wenlock Priory) *163* below; Jerry Hardman-Jones (shot at Yorkshire Sculpture Park) *163* above and Lu Jeffrey *146*.

Quarto would also like to thank Morley College, London for allowing us to use their facilities during photography shoots; The Royal Society of British Sculptors, 108 Brompton Road, London SW7 3RA for their invaluable assistance; Professor Glynn Williams, Royal College of Art, London; and Dorothy Frame for the index.

Finally Quarto would like to thank the following suppliers who kindly provided materials and equipment for photography:

Alec Tiranti Ltd, 27 Warren St, London W1P 5DG
BOC Gases, Hackney Cylinder Centre, Eastway, Hackney, London E9 5NS
Carlos, 131 Cloudesley Rd, London N1 0EN
The Colour Centre, Church Works, Offord Rd, London N1 1EA
Eltham Welding Supplies Ltd, 2–12 Parry Place, London SE18 6AN
Franchi Locks & Tools, 278 Holloway Rd, London N7 6NE
John Bell & Croyden, Dispensing Chemists, 50 Wigmore St, London W1H 9DG
Southern Site Services Ltd, 87–90 Victoria Dock Rd, Silvertown, London E16 1DA